MAKING GREAT GAMES

MAKING GREAT GAMES

An Insider's Guide
to Designing and
Developing the World's
Greatest Video Games

MICHAEL THORNTON WYMAN

AMSTERDAM • BOSTON • HEIDELBERG • LONDON • NEW YORK • OXFORD
PARIS • SAN DIEGO • SAN FRANCISCO • SINGAPORE • SYDNEY • TOKYO

Focal Press is an imprint of Elsevier

Focal Press

Focal Press is an imprint of Elsevier
The Boulevard, Langford Lane, Kidlington, Oxford, OX5 1GB, UK
30 Corporate Drive, Suite 400, Burlington, MA 01803, USA

First published 2011

British Library Cataloguing in Publication Data
Thornton Wyman, Michael.
 Making great games: an insider's guide to designing and
 developing the world's greatest video games.
 1. Video games—Authorship—Case studies. 2. Video games—Design—Case studies.
 I. Title
 794.8-dc22

Library of Congress Control Number: 2010934101

ISBN: 978-0-240-81285-4

For information on all Focal Press publications visit our
website at focalpress.com

Printed and bound in the United States

10 11 12 11 10 9 8 7 6 5 4 3 2 1

CONTENTS

ACKNOWLEDGMENTS

A project like this rests squarely on the shoulders of its contributors. I feel unbelievably fortunate to have had the privilege to visit with so many wildly talented (and astoundingly busy) people who are creating some of the world's greatest video games. Without their willingness to share their insights and expertise, this book would not exist. For their openness, honesty, and generosity, I am deeply indebted to J. Allen Brack, Ron Carmel, Ian Cummings, Rich Curren, Richard Dansky, Tim Fields, Kyle Gabler, Clint Jorgenson, Jason Kapalka, Rob Kay, Stephen Kearin, Greg LoPiccolo, Peter McConnell, Wade Mulhern, Siobhan Reddy, Stefan Sinclair, Mark Skaggs, Bruce Straley, Chris Trottier, Robin Walker, Robyn Wallace, Don Walters, and Eric Zimmerman.

While their words don't appear in the text, several games industry leaders were also extremely helpful to me with this endeavor. A huge thank you to Patrick Buechner, Robert Cogburn, Phillip Holt, Steven Meretzky, Brian Robbins, and Jessica Tams.

Thanks also to my tireless development editor, Beth Millett, and to Laura Lewin, Chris Simpson, and Anais Wheeler at Focal Press.

And, of course, thank you to my family — Evelyn, Jules and Leisy — for putting up with all of the early mornings and late nights it took to ship this one.

INTRODUCTION

Look around. Increasingly, video games are becoming more and more a part of the fabric of our day-to-day lives. The debate regarding what should be considered the world's first video game continues, but since the medium's inception some time in the middle of the twentieth century, video games have continued to march forward and defy predictions as to their role in our society and our lives. The 'hard-core' gamer population has continued to grow, pouring more and more of their dollars into console titles and Massively Multiplayer Online Role-Playing Games (MMORPGs). Games on Facebook have brought an entirely new, enthusiastic demographic into the fold. Legions of stay-at-home moms have discovered and embraced casual games. Services like Xbox Live have broadened the experience and potential of games and have made real-time head-to-head competition, collaborative play, and large-scale interactions like those found in Microsoft Game Studio's *1 vs. 100* commonplace. In addition to dedicated game consoles, video games are played on mobile phones, iPads, portable game devices, online through services like Facebook and MySpace, and, of course, the personal computer.

People play video games at home, at school, on the train, and, yes, at work. Video games have caused marriages and, inevitably, divorces. Cycling to my office to finalize this introduction, I was nearly taken out by a bus promoting *Red Dead Redemption*, the latest release from Rockstar Games. By any measure — cultural relevance, revenue, per capita measurement of play or awareness of video games — games represent an ever-expanding phenomenon, and there is no sign of this trend slowing down any time soon.

In a nutshell, video games comprise a huge and growing piece of the entertainment industry. They are also relatively new to the table, and the video game industry remains in some respects immature. Floating somewhere in the space between art and commerce, video games are a cultural, economic, political, and even philosophical singularity. Compared to other, better-established entertainment genres, like film, there is relatively little published information about the actual processes of how video games are produced. While more mature analogous industries such as filmmaking have a wealth of research and published materials of this nature, there is currently a shortage of books that examine the process of creating interactive entertainment and address the commonalities and best practices of high-performing teams making video games.

That's where this project steps in. This book explores the process of making video games from soup to nuts. This exploration is endeavored through a series of authentic 'postmortem' case studies – detailed behind-the-scenes tours with the leaders of the teams that have made some of the most popular and critically acclaimed video games of the modern era. I had the opportunity to visit with key creative leaders from the teams that made these games and to ask them to look back at their processes and reflect on what went right and what went wrong. By examining some of the world's most popular and profitable video games in this fashion, this book allows you to peek behind the curtain and get an honest, genuine look into the process of making video games from concept through production.

The second half of the book offers specific tools and advice directly relevant to those striving to make their own great games. Interspersed throughout is a series of interviews with contributors in key roles on development teams shipping some of the world's greatest video games. Through these interviews, a representative of each of the key roles on a typical, large-scale video game development team shares his or her insights and expertise regarding what factors are critical to the practice of making great games.

Drawn from scores of interviews, postmortems, and my own personal experience making games for the past 15+ years, my hope is that this book will serve as a resource for all those interested in video games, whether personally, academically, or professionally. It is my goal that the book offers specific tools and relevant advice to the growing numbers of people working directly on game design or production, or to those aspiring to work in these fields. At the same time, I hope this book offers something of value to anyone who simply loves video games, and has wondered how the world's greatest video games get made.

How to Use This Book

Feel free to turn to your favorite game. This book is not meant to be read cover to cover. Each of the case studies is fascinating and offers unique insights as well as a particular window into the process of creating great games. Read them in whatever order you please. The analysis chapters tie together common themes from the case studies, and suggest how these best practices can be applied to video game projects moving forward. The team role interviews speak to the ins and outs of the varying jobs that different people do in order to make games.

If you are new to video game development, you might want to begin by glancing through Chapter 14, "Applying These Learnings

to Your Game Projects", for an overview of the team roles and phases of video game development. Again, I encourage you to jump around based on what you find interesting and useful.

Visit the companion website (http://makinggreatgames.com) for more up-to-date information as well as to share your thoughts and communicate with other readers in our forums.

Above all, this book is about making games, so please — have fun!

Why These Games Were Picked

Pop into GameStop and take a gander. Browse BigFishGames. com, where a new casual game is released every single day. The array of currently available video game titles is mind boggling. Driving sims, shooters, arcade classics, kids' games, sports sims, RPGs, fitness games, rhythm games. Games made in Japan, North America, Europe, Australia. The lists go on and on. There are literally thousands of new games out there, with dozens released each week. This is completely subjective and unscientific, but it feels to me that, on average, there is something on the order of one 'great' game released at least every couple of months. So how to pick a handful for deeper exploration? With the games presented here as case studies, I am hoping to represent with a tiny fraction of examples some larger truths about the whole.

This is certainly not meant to be a comprehensive volume, and I'll bet there is a pretty good chance that your favorite game is not included in this book. I set out to incorporate a small group of games that represent variety, based on size (both of game and development studio), type, and platform, whether it's a sequel or something brand new, whether it comprises licensed intellectual property or something started from scratch. I feel exceedingly fortunate to have been able to include some of my personal favorite games, as well as some of the biggest franchises in video game history. Are there other games I would have loved to include? Believe it!

What to Expect

Part 1 of this book comprises the case studies — postmortems recounted by key contributors to some of the world's greatest video games of our era. Each chapter is focused on a specific game, and is made up of an extended interview with a key leader of the team that created the game, as well as screen shots and (often) concept art from the game, and data points related to launch platform, team size, development timeline, awards garnered, and the like.

Part 2 of the book teases out the shared themes and principles that emerge from looking at the successful game projects presented in the case studies in Part 1. In Part 2, thorough and detailed analysis of common, proven best practices as well as missteps give you specific 'nuts and bolts' tools to implement at any phase of your game project, from concept development to prototyping, production, testing, and launch. This analysis section provides real-world, hands-on advice that you can start using immediately to make your own games better.

A series of interviews with industry leaders across the spectrum of roles on a modern game development team rounds out the volume. In these candid interviews, interspersed throughout the book, experts who have worked on several of the world's most acclaimed game franchises share their insiders' knowledge, advice, and opinions about the magic of making great video games.

This book was a blast to research and write. I hope you find it interesting and illustrative, regardless of where you are in your relationship to games, whether you're a rabid or casual fan, someone hoping to get started in the industry, or a veteran with dozens of shipped AAA titles under your belt. At the end of the day, I hope you enjoy reading the book as well as get something out of it.

I look forward to playing your next great game – do keep in touch!

Michael Thornton Wyman
michael@makinggreatgames.com

PERMISSIONS

LittleBigPlanet™ images reproduced by permission of Media Molecule and Sony Computer Entertainment Europe.

World of Warcraft® and *Wrath of the Lich King*™ are trademarks and/or registered trademarks of Blizzard Entertainment, Inc., and *World of Warcraft*®: *Wrath of the Lich King*™ is a copyrighted product of Blizzard Entertainment, Inc., and hereby used with permission.

Diner Dash™ images reproduced by permisson of PlayFirst, Inc.

Uncharted 2: Among Thieves™ images reproduced by permission of Naughty Dog.

Rock Band™ images reproduced by permission of MTV Games.

The *Rock Band* chapter includes excerpts from the "Rock Band Postmortem" originally printed in the May, 2008 issue of *Game Developer* magazine. Reproduced with permission of UBM Techweb.

FarmVille™ images reproduced by permisson of a Zynga Game Network Inc.

Half Life 2™ images reproduced by permission of Valve Corporation.

Bejeweled Twist™ images reproduced by permission of Pop-Cap Games.

Images from *Madden NFL 10* used with permission. © 2010 Electronic Arts Inc. EA, EA SPORTS and the EA SPORTS logo are trademarks of Electronic Arts Inc. The mark "John Madden" and the name, likeness and other attributes of John Madden reproduced on this product are trademarks or other intellectual property of Red Bear, Inc. or John Madden, are subject to license to Electronic Arts Inc., and may not be otherwise used in whole or in part without the prior written consent of Red Bear or John Madden. © 2009 NFL Properties LLC. Team names/logos are trademarks of the teams indicated. All other NFL-related trademarks are trademarks of the National Football League. Officially Licensed Product of NFL PLAYERS. Visit www.NFLPLAYERS.com.

World of Goo™ images reproduced by permisson of 2D Boy.

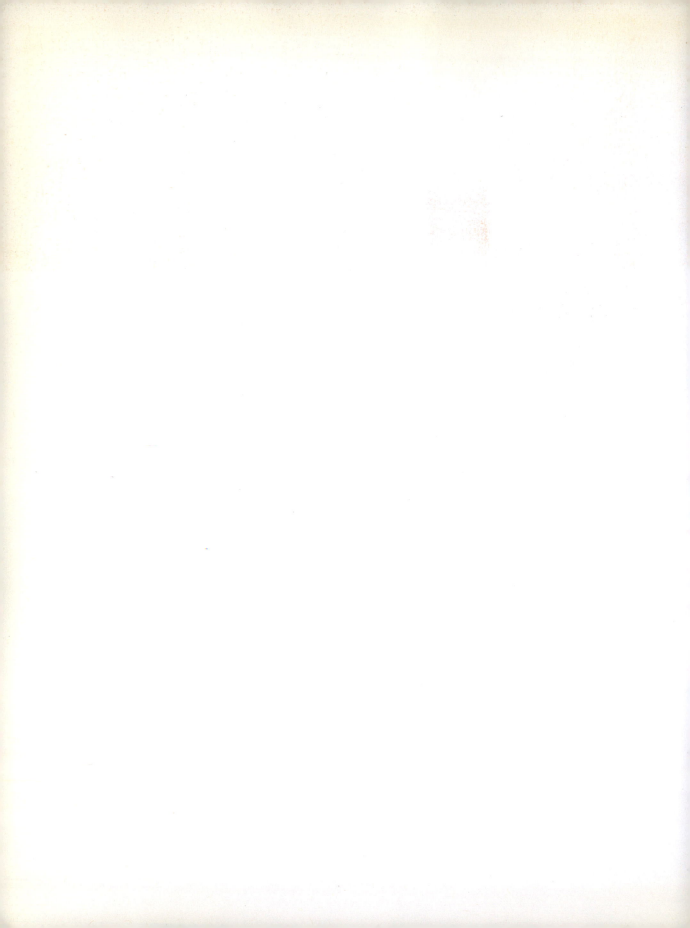

THE GAMES

LITTLEBIGPLANET

A PlayStation 3 exclusive title, *LittleBigPlanet* was the first game created by Media Molecule, a development studio started in 2006 in Guildford, England. *LBP*, as *LittleBigPlanet* is commonly abbreviated, was published by Sony Computer Entertainment Europe, with a North American release on October 27, 2008. From the game's first public presentation by Sony executive Phil Harrison at the Game Developers Conference in the spring of 2007, *LBP* has garnered almost religious fervor among fans for its genre-bending style and gameplay. *LittleBigPlanet* offers a distinctive, fresh, and decidedly unconventional approach to what a console game can be.

At its core *LittleBigPlanet* is a classic side-scrolling platform game, but it is original in almost every conceivable fashion — from the game's main character (Sackboy, Sackgirl, or Sack-person) to the game's physics, presentation style, audio, and perhaps most importantly, the extensive incorporation of user-generated content (UGC) into the player experience. A major component of the game, and no small measure of the game's widespread and passionate appeal, user-generated content plays a starring role that in the *LBP* experience. The revolutionary 'Popit' functionality within *LBP* that enables players to quickly and easily customize their character as well as their own levels has resulted in over 2 million user-generated levels being published as of this writing. The game's tagline: "Play. Create. Share." perfectly sums up what legions of the game's fans are doing within *LBP* each and every day.

I spoke with Siobhan Reddy, Media Molecule's Studio Director and Executive Producer of *LBP*, about the challenges of building a studio and a game at the same time. "Guildford is a small pocket of games development in England," she began, "and I had been working at Criterion there for seven years when the Media Molecule founders — most of whom had been working together at Lionhead Studios, also in Guildford — asked me to come aboard as Executive Producer. I set myself a challenge to develop a different kind of studio — one that had a great culture that was very complementary to creative people, but that was also commercially and creatively

Making Great Games. DOI: 10.1016/B978-0-240-81285-4.10001-7

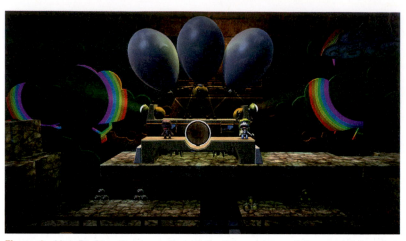

Figure 1. *LittleBigPlanet* represents a distinctive, unconvential approach to what a console game can be.

successful. Basically we all hoped to develop the kind of place where we could create something that we ourselves all loved."

Data Points

Developer: Media Molecule
Publisher: Sony Computer Entertainment Europe
Release date: October 27, 2008
Release platform(s): PlayStation 3
Development engine(s) used: None — everything was created from scratch.
Game development timeline: 3½ years; started January 2006
Development team size: 27 (maximum)
Awards, honors, sales thresholds, etc.: *LBP* appeared on multiple 'best of' lists for 2008, and the game has won numerous awards, including many 'Game of the Year' honors; the team is most proud of the 2008 BAFTA award for Artistic Achievement.

What Went Right
Hired the Right People

Finding great people is always a challenge, and starting from scratch with a new studio makes this process especially tricky. Reddy viewed building a great core team as a primary challenge upon joining Media Molecule. She realized that they were setting out on a very unconventional course: rather than utilizing a centralized, single-person team leader for their game, Media Molecule's co-founders — Mark Healey, Dave Smith, Alex Evans, and Kareem Ettouney — were planning to collaboratively direct

the company's creative efforts. Establishing the right culture where this format could work proved a significant challenge, and a key piece of the puzzle was making sure, especially as they added more and more people to the team, that they were bringing on the right people.

It took fine-tuning to get to the point where Reddy and her team felt that they were hiring effectively. Put more bluntly, early on the team churned through several people who didn't work out. At the end of the day, though, Reddy points to these hiring decisions, and honing their hiring process at Media Molecule, as critical to their game's success. "When I look at *LittleBigPlanet* I can see pretty much everyone from the team; I sort of see each and every person's personality in the game itself. The general direction of *LBP* is very forgiving in that it is almost like a blank canvas that allows people to get their individual style onto it, yet it still hangs together. This was by design — we always wanted people to feel like we had all made the game together. A good example of this is Kareem, our Art Director, whose role really evolved into working with all of these fantastically talented artists, and instead of 'directing' them to conform to an established style, which is the more traditional way of making games, he set a framework when choosing the craft look and each of the world themes. As Art Director Kareem then encouraged his team to maintain their unique styles and personalities. He jammed with them to ensure that their individual styles all fit into the game. *LBP* is the kind of game that allows this to happen more than others."

It may seem like a counterintuitive notion to inject 'personality' into a commercial enterprise, but Reddy pointed out that at Media Molecule they actively look for talented people who have a strong personality and a drive to manifest this commercially. "It can be difficult to find people who are aligned with this but they are worth the wait. I feel there has been a mismatch in perception that if one is working on a commercial product, then there is no room for personality. But going all the way back to Michelangelo, who was after all working for the church — and if you think about it, what he put up there in the Sistine Chapel is really pretty cheeky — even Michelangelo put his personality into his work, and that is why it has stood the test of time. This philosophy is part of our culture — we wanted to create a studio where a small group of people can continually get better at their craft, explore different things, and just be fabulous. Of course, the reality is that all of this is underpinned by the fact that we are shipping products, and we need to have milestones; it can't be all chaos and fun. So figuring out how to determine which artists and programmers could fit into this system really helped us build the game (and ultimately the studio) that we wanted to build.

"Looking back, I can see that we are a very optimistic bunch of people. Rather than looking at the issues that inevitably came up during production as problems, we saw them as challenges. One of the other most interesting things in terms of common personality traits that I see among the people that have worked out for us is humor. I know that I can have a laugh with pretty much everyone in the studio. And believe me, that really helps us in difficult times."

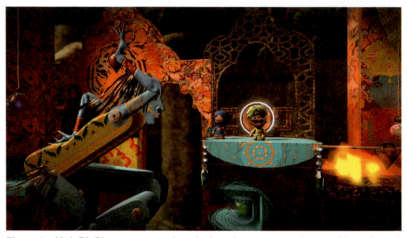

Figure 2. *LittleBigPlanet* was a project designed to accommodate a wide variety of styles, and the game strongly reflects the individual personalities of the people who created it.

Crafted Our Culture

Starting a new studio from scratch meant that Media Molecule could carefully control the studio culture as it was being created. For Reddy, this was critical and a focus of her efforts from the very beginning. She feels that this culture that they all worked so hard to cultivate had an important hand in the success of *LBP*. Reddy highlighted the emphasis that she and the team placed not only on processes, but also on the physical environment of the studio. "This is something I think about a lot," explains Reddy. "Whenever I travel to a show or event, I try to go and visit other studios. At this point I've been to loads of studios, in the U.S., Japan, all over Europe. I find them ever fascinating, and I feel they can tell you a lot about how a team works."

Reddy brings her analysis to bear on decisions about the physical environment at Media Molecule. "One of the things we do here is that we use the environment to communicate to everyone where we are with the game, both internally for ourselves as well as for anyone who is here for a meeting or site

visit. We have an open floor plan, and everyone sits together in one big room. We have tons of open wall space, and we try to utilize our walls as 'working walls,' with loads of art and diagrams posted all over them. These are useful for the artists and creators themselves, but also great because they allow the team to see what's going on in other areas. I've seen other studios designed around noise levels, or functionally. And it's not like there's one correct way to do this, but for us, we wanted to make it really easy for folks to jam with the other people they're working with." Jamming is an important aspect to creative life at Media Molecule; we'll hear more about that shortly.

Reddy also emphasized the importance of communal, non-work areas in their space. "This is something that I think most game teams will identify with," explained Reddy, "as when you make a game you end up spending a lot of time together — at some points more time than you spend with your friends. We had an area where we could all eat together. It might sound trivial, but I think it was really important. There were long periods of staying at the office, working late, and we had a very nice kitchen table, and really nice food. In fact, some folks would wait around just for the food, even though they weren't working late on that particular day. I truly believe in 'the family that eats together, stays together' philosophy, and we lived that — we were like a family, getting together for dinner to discuss the day's events. It depended on the phase of the project, but a lot of the work that needed to get done were the kinds of thing where people are thinking and creating, drawing or writing code, and so needed to be in 'the zone,' with the headphones on, so eating together at the end of the day allowed us to come together and visit and kind of recap the day." Media Molecule eventually outgrew their space, and this meant they no longer had an area that would accommodate a table large enough to seat the entire team together. "We're moving in a month, and we have made sure that our new space has an area large enough for that really nice kitchen table that's going to be big enough for our family dinners and lunches again."

Molecular Structure

The team at Media Molecule that created *LBP* organized into what they refer to as 'molecules,' small interdisciplinary groups, each responsible for a specific part of the project. "This was pretty much directly inspired by Valve," recalls Reddy. "We all read their Gamasutra piece on their Cabal structure, and we thought that sounded perfect for the kind of studio and game we were planning to make. So we took that as our inspiration and tweaked it to fit our own needs. At the beginning, we were all one big group, but we eventually got to the point where it was too many people to be

in the same meeting, so it was time to 'moleculize' into multiple, smaller groups. After the greenlight period we formed these groups, almost like bands, of people working together. It was up to these small groups, always working with one of our four creative directors, to come up with their own goals for the specific area of the game that they were focused on.

"This felt very natural to me, and was in fact how I had been working at Criterion. The benefits of cross-pollination are incredible, to have smaller groups of people put together with a common goal. In fact, it kind of felt like a 'no-brainer' for us, but again that's probably because it's so perfectly suited to the style of game that *LBP* is. And for us, one other important detail is that these groups do change over time, and also a person can be part of more than one molecule. This is especially true for producers, who may work with multiple molecules to help these groups make their plans visible to the team. But the molecules themselves have to come up with their own plan. They need to birth it and own it − this should not just be up to production. And having that ownership within the molecule has been really successful for us. The molecule owns the conception, and also the delivery. Production's job is to track what the molecules are doing, and to hold the big picture of how each molecule's efforts are fitting together to hit the overall goals for the project, as well as to look after the other aspects of bringing the game together such as QA, localization, and the generation of PR/Marketing assets."

I wondered which 'molecule' came first, the company name or the label of their process. "The company name definitely came first, and I think that was just a coincidence," Reddy replied with a chuckle. "We were brainstorming what to call this process, and a Producer who used to work here came up with the name − it's really just a coincidence that it's our company name as well."

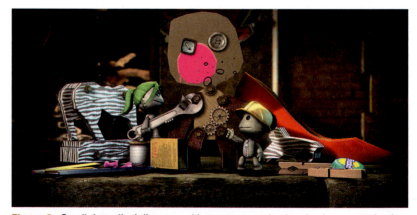

Figure 3. Small, interdisciplinary working groups, or 'molecules,' were perfectly suited to making a game like *LittleBigPlanet*.

'Game Jam' Design Style

A lot has been written about Media Molecule's 'game jam' design style. Reddy feels that this method of working together was a perfect fit for the kind of game they were trying to make with *LBP*. "If you try to make a game as if you're conducting an orchestra – directing from the front, and everyone in the back has their plan – well it just doesn't work. To us, and our style of creating together, it feels much more like you're a band, and you're jamming together, and then hopefully you get something good out of it.

"When Dave, Alex, Mark, Kareem, and I were talking about this early on, and kind of stumbled on this band metaphor, I found it to be a very natural way to think about it. It just really fit the work style that the founders have and therefore was going to be the way the company worked. One of the challenges is that every time you make a new game it's an experiment. You're never really sure if it's going to work or not. Until we went to the Game Developers Conference in 2007 we truly didn't know how people would react, and to be honest before release we really didn't know if *LBP* would work at all, but we embraced it as the experiment that it was. Even when we were about to press the final disks, and we finally turned on the beta test with real users, we were watching and really not knowing if it was actually going to work."

Reddy feels strongly that the game jam design process allowed them to reach that point, and to be successful with such a grand experiment. "Some of the best meetings I've ever been in are the ones where instead of everyone needing to agree with everyone else, we just kind of riff off of each other. It's like: 'OK right, we're a group, we're a team, we know everybody can pull their own weight – let's just jam together and trust that something good will come out of it.'"

I wondered about implementing controls to make sure that this process didn't lead the team down rabbit holes. "Well, another way to think about this is ground-up design, rather than a top-down way of working. We had used our greenlight period to figure out the concept and so we had a framework to work within. The ground-up approach allowed for experimentation within that framework. Because I do not have a specific, hands-on role in the game, I am one of the few people who get to see the whole project as a big picture. At certain points production needs to look at it from the top and make sure that the molecules are all synced up. The ground-up approach is complemented by the times when Mark and Dave, the co-designers, zoom out from their hands-on work and make sense of what we have. This takes different forms depending on the phase of the game and what there is to see. Obviously the best way to figure this stuff out is to play the game.

The further we get into development the more often we do this, but it really is the bread and butter of figuring out what you need to do to finish a game. I mean, we're not jamming to be a Sunday afternoon band; we're trying to generate hits; we're a commercial band trying to make lots of money. But this comes back to the hiring aspect — who do we have in the band? We need to have the confidence that the right people are doing the jamming, a kind of insurance that what comes out the other end will be worthwhile. And there are other ways of making sure that we're not going off in a wrong direction. One example of this is our relationship with Sony, which has been great. They really only did it a few times with *LBP*, but when they did a major check-in they gave us really useful feedback. Look, you can't listen to nobody; ultimately we all want to make a game that will be creatively successful, and commercially successful, so you have to listen to people outside as another way of keeping it all honest."

At the end of the day, Reddy won't be abandoning the game jam design style anytime soon. "There's nothing like jumping off into the abyss. Sometimes you land somewhere lovely, and sometimes you don't, but you only live once, right?"

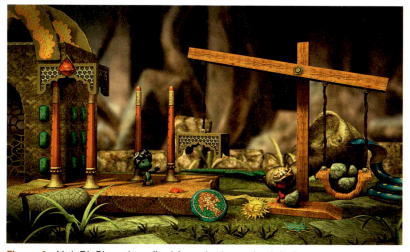

Figure 4. *LittleBigPlanet* benefited from the 'game jam' design process employed at Media Molecule.

We Were Bold

"This is something we got right and wrong," began Reddy. "I would say even still it's not something that we're amazing at, but rather more of an aspiration for us. We very much want to be bold with our ideas. Being bold is like being determined, in a way — having the intent to manifest something, to finish

something, to have a really crazy idea and to not dismiss it, but to find a way to show it to other people. There is so much out there to be done, and this is what excites me the most about Media Molecule — we've got a great group together now and we're really living this out.

"We want people to take risks here, and to be willing to make things, and show other people things, to present their ideas. And we expect people to be willing to listen, even to the point where it means listening to other people knock their idea down and making them prove to these doubters that their idea is strong. And this is where I would say we're not perfect, in that people will have ideas, and maybe they'll get shot down too early. But our goal is to be a studio that continues to innovate, and to do that we need to continue to be bold and to be brave."

Reddy wants to encourage other game teams to work with this model, and sees a lot of potential to turn over new stones in game creation. "I would like to see the industry evolve as a creative industry, and sure, not everything is going to sell immediately, but that's not always the entire point. It's a shame when great ideas aren't explored, especially now where there are so many platforms to explore and create for — Facebook, iPhone, DS — there's just a lot of room for new ideas out there right now."

What Went Wrong
Building Game and Studio Simultaneously

This is a significant challenge for all new games studios, since they are faced with a twofold task of creating a game, as well as a company that will (hopefully) outlast the production period of that first game. While Reddy spoke of the great opportunity this challenge provided her and her team above, not everything worked out ideally during the process. "While Mark, David, Kareem, and Alex had all worked together at Lionhead Studios, I had not worked with them before, and they had not worked together in this particular capacity. We all wanted to create an environment where we were happy to work, but there were lots of new things to think about. It took us a long time to hire — in fact it still does — mainly because we are looking for the right fit, the right types of people who can fit into our system and thrive here. Over time we've worked to improve our programmer and art and design and audio tests, but early on these processes were not established and it resulted in a number of incorrect hires. We had to let a lot of people go in our first year after a probationary period, and that's never a fun thing to do."

This was especially hard early on, a side effect of there not being a lot of definition around the studio, or the game they

were making. "When we were first starting out, it was hard because we didn't really know what the game would look like in the end, or what the studio would look like over time. Add to that all of the processes that weren't in place, so had to be established and honed for our purposes. And I'll be honest, there was a lot of interpersonal conflict and an incredible amount of drama that first year — just getting used to each other's style but also creative conflict. And now, what's helped with this, is we pretty much have our team, we have our culture, and we've learned how to work really well together. We've become more trusting of each other, and we know what we need out of our studio space. So now it's like we're almost ready to make a whole new set of mistakes."

Figure 5. Building a game and a studio at the same time added significant complexity to the process of creating *LittleBigPlanet*.

Managing Processes and Technologies as a Small Team

Media Molecule has stayed true to their initial commitment to remain small. The game jam style is really suited to small teams, and Reddy admits it would be hard to continue to work effectively in the fashion they do if the team were to grow significantly. While staying relatively small has obviously allowed the team to reap amazing benefits, it has also presented significant challenges, particularly after the fantastic reception at the Game Developers Conference made things real. Reddy highlighted several areas of challenge related to this.

First, Reddy spoke of the difficulty of effectively testing *LBP*. "Our game was enormous to test, and we didn't get started on this until way too late. We were so busy getting the studio set up, by the time we realized the mountain we were facing with QA testing it was too late. So, we didn't have our own internal QA department. We ended up using an external partner called Testology — and they were absolutely magnificent — but not having QA here with us, combined with how hard *LBP* was to QA, was a nightmare. We have been working with Testology since that moment and their experience coupled with the fact that we have finally hired a QA manager means I am hopeful I won't be talking about this issue in my next postmortem!"

Reddy also spoke of challenges around the huge community of fans the game created. Media Molecule hadn't ramped up in order to be able to meet the demands engendered by their success. "When we shipped *LBP* we didn't have in-house community managers! It sounds insane, but we hadn't found the right people. This worked out for the best as we hired Tom Kiss and James Spafford after seeing the efforts they had put into their *LBP* fansite, LittleBigPlanetoid.com. Still, we weren't prepared for what was going to happen. These guys are really integrated into the development of *LBP2* and so I am happy this isn't a mistake we are making a second time."

Another specific area Reddy felt could have gone more smoothly was around the server technology used for *LBP*. "This part was tricky because we wanted to try something new. Specifically, we wanted to innovate with UGC (user-generated content) on the PlayStation 3. Sharing is a key component of *LBP*, and this means asking the shared back-end technology to do things it wasn't designed to do. And because we didn't have the perceived experience to be able to launch our own server, this meant that we had to use what was there. And, of course, this was a compromise at the end of the day — we didn't get everything we wanted, and Sony probably ended up doing some things to accommodate us that they weren't thrilled about." The results

speak for themselves — *LBP* is renowned for pushing the envelope in terms of the game's ability to allow players to crate and share content. Moving forward, though, Reddy and her team at Media Molecule are prepared to take on this challenge themselves. "At this point, we're going to be able to lead this aspect in partnership with the different departments within Sony, and we're really looking forward to pushing the boundaries here."

Figure 6. All of the unknowns surrounding the extensive use of user-generated content were a contributing factor to making *LittleBigPlanet* a major challenge to QA test.

Tutorials Crunch

With such an unprecedented style of gameplay, so heavily focused on user-generated content, introducing players to *LBP* presented a significant challenge as well. Reddy realizes in hindsight that they could have been better prepared for the amount of work it was going to take to get players successfully up and running with the game.

"We did our best to ship the game on time, as this had been a central focus for us for a long time, especially as a new, unproven studio," explained Reddy. "Well, we underestimated the amount of tutorials we were going to need — we really discovered this from player reviews during alpha testing, when we realized we needed to do a better job teaching players the basics of 'Popit,' the in-game editor." Turning the small team's focus on to the tutorials and all they entailed — videos, scripting, voice recording, localization — meant something had to give, and Reddy and the team made the difficult decision to cut a full theme from the game rather than risk the schedule slipping, or the theme not being up to snuff from a quality standpoint.

"We came up with a full set of teaching levels, and wanted a full set of videos to accompany these to train players on how to make and use UGC, which is so central to the *LBP* experience." Reddy and her team also ended up turning to two external resources, Maverick and Side, to help with some of the heavy lifting of creating what turned out to be 60 teaching and training videos that became part of the game. "We had lined up Stephen Fry to record the voice-over for all these videos, and we were all excited about that. But that meant we needed scripts for all the videos, and that meant we needed the visuals as well as the functionality finished, and fairly bug-free. This put an enormous amount of pressure on the process of finishing Popit."

Media Molecule also had to rely on Sony for some late-stage help in optimizing video performance on the PS3. "Maybe this is always the case, but in a perfect world, we would have had more time, or at least would have allowed for more time to focus on the tutorials in our schedule," concludes Reddy.

Learning to Work with Sony

Media Molecule was formed out of a relationship with Sony, and their partnership has had incredible results. To wit, Sony Computer Entertainment Europe recently acquired Media Molecule, solidifying and formalizing their partnership. From the beginning, interacting with Sony, while on balance obviously a huge net positive, has not been without struggles.

"One of the challenges we had was trying to make our game on our own terms, but at the same time needing to fit within various stages or the overall processes with Sony or other external part-ners. Honestly, people at Sony were worried about whether chaos was reigning at Media Molecule. It took a while for people to understand our style and ways of doing things, and at times we sensed that they felt we were not being forthcoming. We were just trying to protect our culture and processes so we could get on and make our game. We could have done a better job making our progress visible externally. Thinking about this, it really has less to do with Sony and more that we were doing something new, that we were not a studio that had delivered. We didn't have a track record with Sony, and so they didn't know if we would deliver or not — how could they?

"On top of this, we wanted to try lots of things, and we needed help to do so, because we were so small and ambitious. For the most part, people were helpful, but there were challenges for us — and I have to add that we didn't always get it right in terms of how we communicated with people, either. Now, I feel like we've really learned how to be a small team that's willing to push innovation in a large company. We're nimble and fast and we

change our mind. It's a good, mutually beneficial relationship. At the same time because we're small, we're slow in other ways. Sony is fast in some ways — but when it comes to innovating, well that's harder within a larger team."

Figure 7. The enormous success of *LittleBigPlanet* represents a terrific collaboration between Media Molecule and Sony Computer Entertainment, but it took time for both parties to grow into their relationship.

We Were Bold

As Reddy mentions above, doing so much new proved to be both a blessing and a curse. In working so hard to establish a new way of doing things and a new culture, there were growing pains within the studio. For one thing, it was by nature impossible to find people out there with experience in the Media Molecule way of doing things and just drop them into the program. Furthermore, *LBP* at various stages had to be plugged into Sony's development timeline and processes.

"We were being bold, but our challenge was: How do you make games in this new way we've developed, that tries to keep creative people in 'the zone' for as much time as possible, but still have a schedule up to date at all times? How do I facilitate that process without designing it or becoming a schedule nag? It feels like maybe we had a bit too much micromanagement going on during the making of *LBP*.

"On top of that, being bold and ambitious means that you're never totally satisfied. It feels like we were trying to achieve all of these things at the same time. The points above are the main ones, but then there were lots of other small things that made things imperfect as well. However, being bold means that we will always have a set of ambitions we are working towards, and this

will always be hard! I guess this isn't so much a 'what went wrong' as much as one of those things that just added and continues to add to our challenges. Yet here we are several years later and the company has grown to 37 people and we are working on *LBP2*. Creating games is challenging, being bold is challenging — all of these things are but we got through it and shipped our game. I wouldn't swap it!"

Figure 8. The bold approach to creating *LittleBigPlanet* included significant challenges, but ultimately resulted in an incredibly fresh gameplay experience.

Wrap Up

Reddy emphasized that while Media Molecule has established a very successful model for making the kinds of games they want to make, she feels that there isn't one single way to organize a studio or team in order to make great games. "Every studio is unique, and while we may all need to solve similar technical problems, we're going to go about it in different ways, and that's fine. Sometimes it feels that everybody is making games better than you are! I like to visit other studios — I loved going to Grasshopper and Naughty Dog, for example, and seeing how they make their games — I see some things that I feel would work for us and that we can apply here, and some things that won't.

"Of course, our environments are different, our cultures are different, so much is different that we're never going to make games like someone else. And that's as it should be. After all, making games is a creative process that relies on things that are hard to formalize — ideas, communication, design, and the like.

The point is to try things out, to be intuitive and inventive and to find what works for the people on your team and in your company."

I asked Reddy for any parting thoughts. "Don't rush the creative process. A seed needs time to grow before you can determine if it's a weed."

Figure 9. *LittleBigPlanet* has been a huge critical and commercial success, as well as an important title for the PlayStation 3.

Team Role Interview: Lead Game Designer

Please introduce yourself and your role on a game you've worked on that you'd like to discuss.

My name is Chris Trottier, and I was Lead Game Designer on *Spore*.

How did you get your start in the games industry? How did you come to be a member of the *Spore* team?

On the verge of going to law school, I had a middle-of-the-night realization that I was on the wrong path. I called Children's Television Workshop (the people who make *Sesame Street*) shortly thereafter, to ask where their grads came from. They turned me on to interactive media as the place where new things were happening. I studied with a professor who did evaluation of children's software, and at a conference we attended, I met Mark and Ragni Pasturel, a married couple who made their own children's software titles. After I did a summer internship with them they introduced me to Maxis, who were publishing their games at the time, and I joined the team there making simulations for children.

Shortly after joining Maxis, they cancelled their children's line (children's software in general had stopped making money). So I got put on a team with Will Wright, working on early research and development for what turned out to be *The Sims*. From that point on, Will and I became design partners. Pretty much whatever Will made, I made!

Describe your role on *Spore*.

My job on *Spore*, as on other games I had worked on with Will, was to understand his vision and to make sure it was realized through all aspects of the game. Yes, the Lead Designer *definitely* has a voice on the team. In fact, it's one of the Lead Designer's main jobs to make sure that other people do as well!

What can a Lead Designer do to ensure that the game you are working on is great? What is your part of the process, and how do you make sure that you're contributing to a great game?

Will liked to describe me as his 'architect,' meaning the person who sees and describes the big picture but then breaks it down and puts it into a framework where many, many people can contribute to it. An awesome Lead Designer/ Creative Director (we're called different things at different companies) describes the vision in such a way that everyone on the team is inspired to help realize it. And then they help keep people honest as the details come together.

I believe there are two keys to being a strong Lead Designer. (1) Vigorously work through the low-level details but constantly relate them back to the big picture. Know which ones matter and which are distractions. (2) Know the team members and what they're capable of. Plenty of developers are able to stretch beyond what their strict job definition is. Basically, fill the team members with religion, and then let *them* be the stars.

What was the most satisfying aspect of the work you did on *Spore*?

The early days of *Spore* were crazy awesome. The first time Will mentioned the idea to me it was something like: "I want people to understand the unbelievable improbability of life on earth. How impossible it is that a sun formed, oxygen formed, bacteria formed, etc." But when he talked about the gameplay, he described a series of failures, one after the other — kind of an epic bummer.

But the nugget was already there and it was something he was deeply passionate about. The challenge was to find a game that would give people that epic sense of scale and wonder and awe… and would be classically fun to play. Once we knew he wanted to take people on a journey from paramecium to galactic domination, it was thrilling to think through what choices a player would make that would ultimately have galactic consequences. And what 'rules of the game' tend to apply at every scale.

We went through a period of awesome fun where in a given day, we'd talk through radically different ideas for gameplay at a given scale… playing it out with Legos or toy cars on the floor… playing fake versions on the whiteboard

(Continued)

Team Role Interview: Lead Game Designer—Cont'd

where we could… and then once our calculators wore out, pulling together a quick working prototype within the next week. Really, it was a game designer's dream. In a way, we felt like scientists or explorers ourselves… searching for something fun and contained in this fairly virgin territory.

I also absolutely loved working on the early pre-visualization and early sound work. Through Electronic Arts, we were set up with an artist named Christian Schuerer, who does visualizations for Hollywood films, and it was unbelievably cool to be able to throw on a nugget of an idea and have a total genius riff on it and bring back something mind-blowing. Likewise, thinking through the music and what kind of 'mood' we wanted to set on any given level of the game was great and fun… We spent a lot of time finding clips to play for each other, things we each found inspirational and the right mix between awe and wonder and something that you wouldn't mind listening to over and over.

Also, I've got to say: if you're going to be taught Drake's equation by someone, you're lucky if it's Will Wright. He is so excited by this stuff, and his enthusiasm is very infectious. Beyond that, working with him as a designer is very rewarding, as he is extremely respectful, curious, and collaborative.

And how about the least satisfying aspect of working on *Spore*?

Well, it's tricky. Because obviously, trying to make a game that spans several levels of play is a tough challenge. Different scales of play (and the different game genres they suggest) tend to have their own laws of physics: camera controls, player point of view, selecting/controlling units, what level of detail matters and is controllable, etc. So there was a huge (arguably impossible — and Will *does* love the impossible) challenge of designing a game that takes you on a journey across *all* of those levels and yet still feels like one cohesive experience.

At the same time, we brought on some team members with very new thoughts about how to approach game development. This felt like proposing a return to the days where one talented Renaissance man or woman could roll their sleeves up and get into the design problem and the code problem and the art… and let a solution emerge from the intersection of those worlds. So we tried a somewhat experimental thing on *Spore* where we basically enabled each team member to follow their passion, based on what they were learning and seeing on the ground each day.

These two things, both very interesting, may not have been a natural fit for each other. On one hand, we had this game challenge that desperately wanted a clear framework so that it would cohere. And at the same time, we were trying an experimental 'bottom-up' design process. You can see where that might make the challenge of creating 'one game' quite challenging. And it was.

Could you highlight a few key areas of success during your period of involvement with *Spore*?

There are so many things I love about the way *Spore* turned out, and I do think many of these are the natural outgrowth of extremely talented individuals who were given lots of space to explore and innovate.

First, the creativity tools are plain awesome. The fact that someone came up with a 3D creature editor that is as simple to use as *Spore*'s still blows my mind. Chaim Gingold, who actually started working with Will while still a student at Georgia Tech, is a genius with making complex things intuitive. He is one of these people who is both technical and intuitive, and his results are incredible. Actually, that whole team was just packed with crazy talent.

I'm also in love with the game's sound design. It changes dynamically as you zoom in and out … as you pan around the globe and encounter different biomes and civilizations… or as you pan around a solar system and encounter very different planets. And this whole transition is nearly seamless across the ambient noise, the sound effects, and the music. So Kent Jolly is another person whom I revere: he's both strongly technical and deeply talented as an artist. While he was lucky enough to be able to work with Brian Eno, who provided very cool stuff, Kent himself

Team Role Interview: Lead Game Designer—Cont'd

really figured out the technical structures and provided the bulk of the content. Every time Will and I went in to catch up with him, we left speechless. Which is, if you know me, not very common.

I also really love the way the game enabled and then made use of its players' creativity (creatures, planets, buildings, vehicles, etc.). Will was adamant about having players seamlessly encounter the work of others as they explored the galaxies, and I think this works very, very well in the game. It is a total delight to see the kinds of things people come up with.

On the other side of that coin, could you highlight areas of difficulty with *Spore*, and what you would do differently next time?

As I mentioned, I think we took the 'bottom-up' experiment further than was ideal for achieving a cohesive game experience. It was a pretty risky move, and we lost a lot of the thinking from our early game prototypes when we kind of handed over the reins to 100 different people.

I also think we failed to correctly identify the target market for *Spore* early on. On the heels of *The Sims*, there was a lot of enthusiasm behind making Will's next game a 'mass-market wonder.' But I think realistically, *Spore*'s theme was meant to appeal to the kind of players who were drawn into *SimCity*, not necessarily the kinds of players who played *The Sims*.

As we moved into development, we identified what we believed the game's key risks were and focused development time disproportionately on those high-risk areas. At the time, we identified those risks as (1) making the creature editor dead-simple to use, while allowing players to create an amazing breadth of results, and (2) procedural animation (the means by which we could animate any creature that a player created). While I still believe that those two key areas were both risky and critical, I daresay we close to nailed them. In hindsight, I think we might have put gameplay into the same category and given it more upfront devotion.

Any parting thoughts?

I'd say the longer I'm in this industry, the more it becomes clear to me that making great games is not about having a big killer idea of your own, or even great solutions of your own. It's about collaborating well with a group of very talented people. One of the biggest revelations for me, and I think I've matured into this role a little, is that two people can disagree vehemently and both be right. Knowing what to do from that point forward is the art of it, I believe.

2

WORLD OF WARCRAFT

With over 11 million monthly subscribers, *World of Warcraft* is currently the world's most popular Massively Multiplayer Online Role-Playing Game, or MMORPG. In fact, as of this writing, *World of Warcraft* holds the Guinness World Record for the most popular MMORPG of all time. Initially released in November of 2004, the game has seen several major expansions as well as dozens of updates and patches over its history to date, with each successive version bringing more players into the fold.

World of Warcraft, or *WoW,* as it is known to its legions of fans, takes place in the *Warcraft* universe, a long-running fantasy world built over three major releases from Irvine, California-based Blizzard Entertainment, the game's creator. Gamers were first introduced to this world with the 1994 release of *Warcraft: Orcs & Humans*, and two subsequent single-player releases grew this highly acclaimed and wildly popular series over the next 10 years. *WoW*, the first foray into massively multiplayer games for Blizzard, was released on the 10th anniversary of the series' original release.

While there was some technology sharing with earlier Blizzard titles, notably the 3D graphics engine, for the most part creating *WoW* was an entirely new challenge for Blizzard. Taking over 4 years to develop, launched simultaneously for Macintosh and PC, the game represents an amazing design and engineering feat. While anticipation for the initial release of the game was incredibly high, Blizzard was shocked by the astounding immediate success of the game and was forced to play catch-up for over a year in order to try to meet the unprecedented demand for an MMO that *WoW* engendered. *WoW* has spawned a series of comic books, board games, television commercials, and scores of references in mass media.

I had a chance to catch up with J. Allen Brack, Production Director on *World of Warcraft*, to learn what went right, and what went wrong, in the design and creation of the world's most popular MMORPG. I asked Brack to start by telling me a bit about the origins of *WoW*. "The original seeds of *WoW* came from *Nomad*, a secret project Blizzard had been working on for over a year, that was intended to be another single-player game,"

Making Great Games. DOI: 10.1016/B978-0-240-81285-4.10002-9

Figure 1. Zeb Halek in Grizzly Hills, from *WoW* — the Guinness World Record holder for the most popular MMORPG of all time.

Brack began. "Eventually, we realized that we wanted to make a different breed of MMO. Many of us on the creative team had played a lot of the then-available MMOs — *Ultima Online*, *Everquest* — whatever we could get our hands on — and while these are cool games, they just weren't finding the right stride for us. So we sat down and had a heart-to-heart: If we were to start today, what game would we want to work on? What game would we want to build? Would it be a single-player game? No, it would be an MMO." This is where the light bulb went off for the team. "An MMO in the *Warcraft* universe! We had a good technology base from *Nomad* — which was expanded on from the tools we used to create *Warcraft III* — a base rendering engine, an asset loader, a rudimentary asset system, etc. So, we simply forked the code early and got to work."

Data Points

Developer: Blizzard Entertainment
Publisher: Blizzard Entertainment
Release date:
- *World of Warcraft*, 11/23/04
- *World of Warcraft: The Burning Crusade*, 1/16/07
- *World of Warcraft: Wrath of the Lich King*, 11/13/08
Release platform(s): PC, Mac

Development team size: At launch, approximately 60 developers; currently, approximately 130 developers
Development engine(s) used: Internally developed engine technology, some of which was shared with *Warcraft III*
Awards, honors, sales thresholds, etc.: Over 11.5 million subscribers

What Went Right
Blizzard History and Best Practices

Brack spoke about his deep appreciation for the culture at Blizzard and their well-earned reputation for releasing high-quality games. The *WoW* team was able to lean into this general attitude toward the craft of games and translate that to the MMORPG world with *World of Warcraft*. "Before *WoW*, MMOs had the reputation of being pretty crappy, buggy, and just generally problematic. The overall level of quality was significantly lower for MMOs, and this was just kind of generally accepted by gamers. In fact, many gamers felt compelled to wait for several months before jumping into an MMO, while the expected glitches were worked out. There was just a lower standard for MMOs, which in

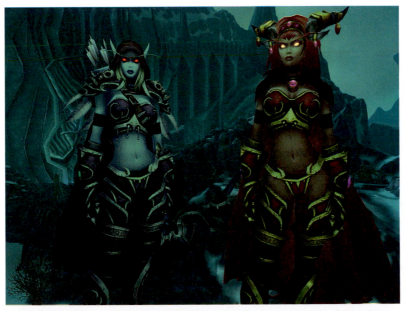

Figure 2. *WoW* drew on some technology components, and loads of lore, from earlier installments of the Warcraft universe. Lady Sylvanas (on the left), the leader of The Foresaken, dates from Warcraft III and the Dragon Queen, Alexstraza (right), was introduced in Warcraft II (although according to Warcraft lore, she has been around for over 30,000 years).

our opinion meant they were kind of placing themselves into more of a niche market — hard-core gamers would be accepting of these defects in the game, but more mainstream consumers would not." The *WoW* team took a different approach. Brack continues: "Blizzard had the attitude of 'this is going to be a Blizzard game' — which for us meant it would achieve a certain level of quality, and playability, from day one. We were able to share that focus and vision because we were familiar, from our previous experiences together, with what that 'Blizzard' level of quality meant."

Tapping into this shared understanding provided a common, guiding vision for the development team — to make the game a 'Blizzard' game and all that entailed — and proved to be a key success factor in how the final product turned out.

Concept of Quests Proved Key

Brack spoke about the quests system introduced in *WoW*, and what the team's goals were in creating this system, which proved to be one of the most compelling features of the game, and at least partly responsible for the MMO's incredible success. "We always knew that we wanted to present an easy, accessible UI(user interface) for players in *WoW*. We wanted to strike a balance — providing an 'open world' feel where players could

Figure 3. Ulduar and Constellation figures from *Wrath of the Lich King*. In *WoW*, players learn key elements of the extensive back story from quests in specific locations; later, they may return to the same scenes in large groups, or guilds, to conduct raids.

set their own goals, as it were, and kind of wander around and do whatever they liked. On the other hand, and maybe for other types of players, we wanted them to feel like they could spend a lot of time in the world and not run out of things to do. This was the kernel for the idea of quests — which are basically bite-sized tasks, with rewards, that players can complete very quickly. Our hunch, and hope, was that players would experience the 'I want to do just one more' feeling. We saw that as a key hook for the experience, and I think we struck a good balance there and this worked out well."

The Rest System

Another success factor Brack highlighted has to do with balancing the needs and desires of hard-core players against those of more casual gamers. In setting out to try to appeal to such a wide range of players, it is often a challenge to balance these competing player profiles — especially when you're creating a world wherein these players must be able to interact with each other. Brack pointed to a key component of this: "We came up with the concept of the Rest system as a way to deal fairly with different levels and types of players. In the game, you experience this, as an example, when you leave your character at a tavern if you're going to be offline for a while. While your character is resting in this fashion, he's storing up double experience points, so when you come back the next day, your character can still 'keep up,' as it were, with hard-core players who have been playing all night. Of course, these points do not affect experience earned from 'real' quest rewards or other experience rewards given in the game. We feel like this is really a great, fair system to reward more casual players but not punish the more hard-core players."

Iterating on the Raiding System in the Game

Raids are one of the key activities for guilds (self-forming groups of *WoW* players) to complete in order to gain rewards and level up. Brack talked about how the raiding system has evolved over the life of the game. "Raiding mode has changed significantly in every expansion pack we've done," Brack makes clear. "You'll notice that every raid now has both 10- and 25-person versions. This wasn't always the case, and this is something we struggled with a lot internally. This, also, was a question of balance between how to reward the efforts required for putting together and operating a larger guild versus, again, the more casual-leaning 10-person groupings. We worked hard to develop and implement a system of tiered rewards, something that would adequately reward those players willing to do the harder work of putting

Figure 4. Naxxramas, shown here, was part of the original *WoW* release, but was only seen by a tiny portion of *WoW* players, as access required 40-person guilds when part of the original raiding system. Re-releasing as a 10- and 25-person raid area in *Wrath of the Lich King* enabled a much larger percentage of the *WoW* player population to experience this area.

together and operating as a larger unit, but not too severely punish those operating in smaller guilds. Our current philosophy is that every raid has both versions — meaning a set of challenges and rewards for 10-person squads, as well as one for 25-person teams. This is working well currently, and is the result of successful iteration on these ideas."

Testing was Paramount

"We did an unbelievable amount of testing," recalls Brack. "Even within the company, we had a great test bed because, although we had tons of core game players, the MMO pieces of the game — subscription fees, monthly fees, all that stuff — were all very counter to most of our employees' philosophy, who were coming more from the $50 console product perspective. Many people had not tried MMOs, so we conducted tests to help us figure out how many quests made sense, how to level up, how to teach players new abilities." This is something the team has continued to refine while working on both *WoW* expansions and other new projects. "In fact, we're currently doing another pass at the whole introduction of the game for new players," explains Brack. "We're striving for a much lower barrier to entry for the game — shooting for the antithesis of what used to be de facto for MMOs, namely, plop the newbie in and watch him wander around aimlessly for a bit before getting killed by a more experienced player."

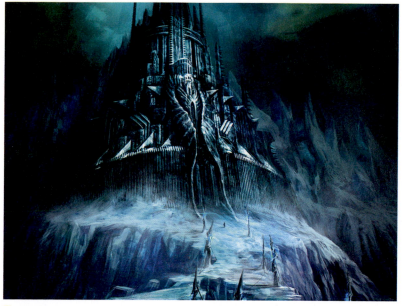

Figure 5. Concept art for the Icecrown Citadel in *Wrath of the Lich King*.

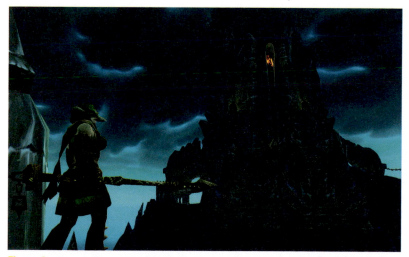

Figure 6. Players often battle the Vrykul, a race loyal to the Lich King. One is shown here in front of Balgarde Keep.

What Went Wrong
Underestimated Our Success

Everyone was excited about the game they were making, and legions of Blizzard fans anxiously awaited the launch date of *World of Warcraft*. However, Brack and his team had no idea

how quickly the *WoW* wildfire would spread. Brack recounted some of the early days, post-launch: "We had 20 servers ready at launch, and an additional 20 servers in what we called 'dark' status — these were fully complete hardware, ready to bring online, that we figured we would release over the course of the next year. Well, within the first 24 hours, we had to deploy every single one of those dark servers. Essentially, we went through our year's worth of reserves on the first day! Clearly, we had underprepared on the infrastructure front, and what we had was highly inadequate in terms of the hardware we needed. And this is just to play the game. The entire login infrastructure, which is completely different from the game, was horribly under budget as well."

Brack chuckled recalling the mad scramble to prep and deploy the hardware needed to meet the overwhelming demand for the game. "This is what we call a 'high-class problem.' We were playing catch-up, in a mad frenzy to add servers, while at the same time the game itself was also growing, launching in other regions, etc. — creating even more demand. In short, it took us almost a full year to bring the back-end hardware up to speed."

Brack recounted a memory from the days leading up to the original launch of *WoW*: "I remember a team meeting where Alan Adham, one of the co-founders of Blizzard and kind of the 'spiritual guardian' of whatever it is that makes a Blizzard game a Blizzard game — was trying to rally the troops. He told us: 'One day, this game is going to have 1 million subscribers.' We laughed at the time, but little did we know we were working on something that would eventually entertain more than 11 million monthly subscribers."

Not Understanding Branches

As mentioned earlier, *WoW* was built on an initial framework that had been developed for other games at Blizzard. Additionally, the company was working on other projects simultaneously, some of which were sharing pieces of the code base of *WoW*. Before long, not segregating out these pieces of code so they could be customized for each project — a technical concept called 'branching' — proved to be a huge challenge for the team.

"Imagine these branches as separate versions," began Brack. "Well, we only had two versions at launch: the actual live version out there, being played, and our internal testing version. With no further branching, this was hugely debilitating, because we wanted to try more stuff and make more stuff but we didn't have the different branches, or test beds, to support these efforts. We couldn't risk breaking something in test that we might be planning

Figure 7. Strand of the Ancients, one of the player-vs.-player zones where players can battle against each other and try to gain siege weapons.

to release shortly thereafter, so we were just kind of stuck. Eventually we figured out a much better system of branching much earlier off of the core code base. So, nowadays, we can be working on an expansion, a couple of patches, etc., all at the same time."

Defining the Game Audience

One benefit of having such a dedicated team is that there were loads of people interested in the game from a very early stage. At the same time, it proved a challenge to figure out exactly what the game should be with so many strong opinions floating around.

"All MMOs have a core challenge," relates Brack, "in that they need to cater to a range of people. Even within Blizzard, we had factions of people who felt one way or another. For example, the whole concept of raids was hugely controversial. On the one side, we had those who thought the concept of guilds — being able to go on raids with a group of 10, 25, or 40 players — was the coolest idea in the world. On the other side, we had players who said, essentially, 'I just want to do my quests and level up.' I think we did a pretty good job of striking a balance here, but at the end of the day no game can be all things to all people."

Figure 8. No game can be all things to all people. Certain elements of *WoW*, like the boss fight in Utgarde Pinnacle, can only be experienced by players who have put in significant hours to level up.

Making Changes Can Be Hard

Post-launch, Blizzard has worked hard to retain *WoW*'s initial fans, while also challenging themselves to continually appeal to new players and to try to continue the remarkable run of consistently increasing monthly subscribers. Brack talked about some of the specifics of the post-successful-launch issues: "With *The Burning Crusade* expansion, we implemented a less hard-core raiding philosophy, introducing 10- and 25-person raids in addition to a wealth of 40-person raids. We continued to move in this direction with *Wrath of the Lich King*, where we included 10- and 25-person versions of each and every raid zone. Now, this was kind of hard for some of our more hard-core players to swallow. They felt we were separating them from their friends. Also, of course, the impact of the raid itself is 1/25th instead of 1/40th."

Brack and his team made the decision to move raids in a less hard-core direction, catering to groups of 10 and 25, perhaps to the dismay of established 40-player guilds, which, understandably, enjoyed being rewarded appropriately for their accomplishments in larger groups. Once up and running, and especially if the game is growing in popularity, it gets harder and harder to make changes, even if everyone realizes the changes will ultimately make the game better.

Figure 9. Another scene for 10- and 25-person raids, the Coliseum is the site of the Trial of the Crusader, where players must prove their mettle in battle with ferocious beasts in order to enter battle against the Lich King.

Not Understanding the Need for Data-Wrangling Tools Early Enough

A project as massive as *WoW* generates tons of data — way beyond what might typically be expected, information such as login sessions and number of players online. The *WoW* servers can track each and every decision made by each and every player — but this would quickly drown any relevant tidbits in an over-whelming ocean of data. Brack points out that, while the team expected to be able to use data generated by players of the game, they were late in building the analytical tools and practices that could help them get anything actionable from the mountains of data the game generates continuously. Brack laments not devoting more energy toward this sooner, as he feels the game could have benefited earlier had Blizzard been better prepared with tricks and tools to interpret the information they were able to gather from the game itself.

"We now have a big effort — an entire corps of full-time employees at our company, in fact — focused on data wrangling. People need to understand that just because you have a huge pile of data, anything meaningful — any kind of answers along the lines of 'what should I do next' — does not necessarily jump out of the data. We needed to figure out what questions we wanted to ask of the data, and then build really good analytical tools to help

Figure 10. Vehicle mechanics were introduced in *Wrath of the Lich King*. In the five-man dungeon shown here, players could hitch a ride on a dragon; while on the dragon, players must manage the specific abilities of their 'vehicle.'

us tease the answers from the data. Recently we've been mining the data to help answer specific questions — some directly from users, as we're constantly listening to forum chatter and the like, and some generated internally — like 'How hard is raiding? With this specific dungeon, with 10 bosses, is this too hard? Is this why nobody's spending time there? Is this mechanic too challenging?"

Putting resources against these issues has proven beneficial — Brack only wishes they could have done so earlier in the process. "Even still," he concludes, "at the end of the day some of what you find in the data is stuff you already know."

Wrap Up

World of Warcraft is the crown jewel for what is arguably one of the most successful companies making video games today. It is an incredible end-to-end experience that keeps getting better over time, and we have a lot to learn from the team that created this mind-boggling game universe and all of its expansions. Reflecting on the entire experience, Brack told me that he feels it is still easy to underestimate the challenges of building a successful MMO. "I've worked on both MMOs and boxed products. When first taking on an MMO, I thought they were going to be two or three times more complicated than a boxed

Figure 11. Concept art for a Worgen — one of the two new playable races to be introduced in the Cataclysm expansion pack of *WoW*.

game. Actually, it's about 57 billion times more complicated. We had 400 people at Blizzard when we shipped *WoW* — now we're over 4000. The game transformed everything about the company, everything about what we need to focus on, about how we work, about what we do from day to day. The MMO, in my experience, is far, far more complicated than you might think it is."

Team Role Interview: Development Director

Please introduce yourself and your current role.

My name is Robyn Wallace, and I am currently General Manager of Blue Castle Games and Project Director on *Dead Rising 2*.

How did you get your start in the games industry? What game teams have you been a part of?

After working for many years programming and project managing real-time control system projects, I chose to transition into video games. I saw games as a good opportunity to use my skills in a creative environment, and it was a growth industry. I campaigned very hard at convincing Electronic Arts to hire me (6 months of numerous interviews and meetings). I was initially hired at EA to work on the *SSX* franchise and looked after the worlds team (which was huge) on *SSX3*. *NBA Street V3* was the second game I worked on in the industry. Starting as a spare set of hands, I was the Development Director responsible for the demo designed to show a slice of the game as the team left pre-production. I ended up as the Franchise Development Director with primary oversight of the day-to-day game development process. The team was still a bit formative as the previous iteration of the game had been done by an external developer and it had just been brought in-house.

I'm curious to hear about the role of a Development Director. Is there a game from your past that stands out as a particularly good experience?

I am actually going to discuss the making of *NBA Street V3*. My reason for choosing this project is that it stands out in my mind as a project that was really firing on all cylinders — good design, dedicated team, and a strong final product. I was the only Development Director for most of the development cycle (including final) with one Art Project Manager. There were about 60 people on the team and the project afforded me a great opportunity to be actively involved in the oversight and delivery of every single aspect of the game from development to operations and marketing.

This book is about making *great* games. I am interested to hear what a Development Director can do to ensure that the game you are working on is great. What is your part of the process, and how do you make sure that you're contributing to a great game?

With *NBA Street V3*, the scope of the project and the size of the team meant that I simply could not be hands-on with every aspect of project management of the game. The sheer volume of work led me to make some early choices about how I would oversee the team. It was the project that led me to my philosophy of project management and leadership. Rather than trying to plan and oversee every single task for every team member, I worked with them to set milestone objectives at the high level and trusted them to fill in the details, manage the dependencies, and get it done. We had check-in points along the way and most of the team was diligent in flagging issues early. My role was primarily one of coordination and removing obstacles. We used some aspects of Agile development, though at the time I didn't know much about Agile. Daily morning check-ins and lot of short ad hoc meetings were my key tools to get people together to problem solve as issues arose.

What was the strangest or most unexpected part of working on *NBA Street V3*?

When I started I had no idea how the project would turn out. By managing people less, I consistently got more. We had strong builds milestone after milestone and set the studio bar in a number of areas along the way, including delivering the first real playable demo at the end of pre-production. The team even hit alpha early (which was a good thing, as I had boldly predicted it and had shirts made in advance). It was during this time that I essentially abandoned the ubiquitous Microsoft Project as a way of scheduling work and started working with capacity and milestone planning as my primary tools.

Team Role Interview: Development Director—Cont'd

What was the most satisfying aspect of working on the game?

The team worked very hard, supporting each other with real focus. Team members managing their own dependencies and issues meant they all had to work very collaboratively. The notion of organizing people in cross-functional workgroups wasn't as common then as it is now, but that was the way we worked. The lead Animator, lead gameplay Senior Engineer, and the gameplay Designer spent hours, days even, in each others' cubes, as did the Front End artists and Senior Engineers, and we saw better/faster results from working this way.

Was there a least satisfying aspect to working on *NBA Street V3*

Satisfaction came in so many different ways on that project, which means I don't have a great answer for this question. I am not sure I have ever worked as hard as I did on that game — just the sheer volume of hours. By the end of it, my kids, who had thought making video games was the coolest thing on the planet, had pretty much decided it was for the birds (though they have continued to entertain the mystery with their friends). Some might describe it as Stockholm Syndrome, but a number of the people on that team remain my friends to this day.

As Development Director, did you feel like you were able to contribute specific ideas to the game?

It was not my role to contribute directly to the overall design of the game; however, I do believe I contributed to the quality. *NBA Street V3* was the first project where I had the opportunity to understand the product as a user experience rather than a project delivering on a timeline. This helped me to find creative ways to deliver features that might have been cut or fix bugs that we might have opted to ship in different circumstances. I am very proud of the role I played in this regard. Since then, I am a Project Manager that cares about the product and works hard to balance quality against the realities of a schedule and a budget.

What went right? Can you highlight a few areas of success during your period of involvement with making *NBA Street V3*?

If success is measured by results, *NBA Street V3* was a success. It was critically well received with a Metacritic rating of 89. It is a challenge to deliver a highly rated game without the team investing a good deal of passion in their work. A game like that doesn't deliver in 9—5 and the team worked hard without complaint and we all wanted to continue working together. Good game, product passion, and a team willing to repeat the experience is success from my perspective. For me personally, it was formative in the way I manage game development today.

What went wrong? Likewise, please describe three to five areas of difficulty, or what you perceived as missteps, and what you would do differently next time.

We certainly had some challenges along the way; however, we seemed able to roll with these challenges and be flexible in our solutions. That really helped us.

NBA Street was the first team to do an 'X-Demo' at the end of pre-production and that was an eye-opening experience. Although it is typically described as a 'vertical slice' of the game to give executives and marketing an early view of the product, it ends up being a giant iceberg with a tiny tip visible above the water. Virtually every system had to be implemented and delivered in order to complete the demo, and at times we struggled to maintain focus on our key design pillars in order to get it done. Looking back, I think we could have managed our scope even more and still afforded stakeholders an opportunity to understand the product.

(*Continued*)

Team Role Interview: Development Director—Cont'd

Not being a key franchise for Electronic Arts Canada meant that we sometimes had trouble getting, and keeping, staff on the team. I am not sure there is an easy solution for this, but it forced us to prioritize our work and that is always a good thing.

I have worked on a few projects where our pipelines were in development even as we were working to get assets into the game and *NBA Street V3* was one of them. This caused some real heartache — not just for the artists but also for the software engineers, as they always seemed to be under the gun and two steps behind. Good pipelines and data-driven tools are essential to making great games. I have a great deal of respect for tech artists and pipeline software engineers as they facilitate artists and iteration. That is where a lot of the quality comes from.

Any parting thoughts?

Do the hard stuff early. There is so much pressure to show progress that it is often tempting to deliver easy stuff at high volume and make the game look shiny. This will almost always bite you. It takes discipline to air your dirty laundry by trying (and sometimes failing) to solve the more complex problems and answer the difficult questions early. However, early is when you can still do something about it versus later when your course is set.

I know I said this already but it bears mentioning again. A team that works to appropriate objectives will be more motivated and exceed your expectations. I guarantee it.

3

DINER DASH

One of the first massive hits in the world of PC-based, downloadable casual games, *Diner Dash* arguably helped get the ball rolling with the try-and-buy business model of selling video games. Created in Director by New York City-based Gamelab and launched by publisher PlayFirst as a downloadable title in late 2004, *Diner Dash* is an action strategy game that helped define a new genre of games to come: time management.

Diner Dash has evolved into its own industry, with direct ports to a wide variety of platforms including the Nintendo DS, Xbox Live Arcade, scores of mobile phones, and as a launch title on Apple's iPad. *Diner Dash* has spearheaded an entire series of *Dash* games for PlayFirst, and has inspired a trove of restaurant-themed casual games.

In *Diner Dash* players assume the role of Flo, a frustrated stockbroker who decides to free herself from her desk job and try her hand at operating her own diner. Players must efficiently seat and serve a variety of customers that come into Flo's diner. Play progresses linearly and grows increasingly complex and frenzied as Flo succeeds in taking care of more and more needy customers. With her success, measured through increased profits, Flo grows happier and is able to upgrade her restaurant and expand operations. Several core game mechanics such as chaining bonuses, customer patience meters, and expert point thresholds that have become standard in time management casual games were popularized through their role in the original *Diner Dash*.

I caught up with Eric Zimmerman, Co-Founder and Chief Design Officer of Gamelab, to chat about what went right, and what went wrong, in the creation of this groundbreaking work. Zimmerman explained that he and Gamelab Co-Founder Peter Lee had been creating original online games for Shockwave.com, where they worked with PlayFirst founder John Welch. "We had a great time making games with John, so as soon as we heard that he was starting his own company, we contacted him and said 'We'd like to make games with you again.' I wrote up a page of concepts, he picked two of them, and we became PlayFirst's first

Making Great Games. DOI: 10.1016/B978-0-240-81285-4.10003-0

development partner. To give you an idea of how early this was, *Lunch* — our code name for the game that was to become *Diner Dash* — was in beta before PlayFirst even had an office."

Zimmerman, Lee, and *Diner Dash*'s Lead Designer Nick Fortugno were looking to put a casual twist on the 'spinning plates' mechanic of games like the arcade classic *Tapper*. "The design inspiration for *Lunch* was a '*Tapper* with stuff' approach. Of course, *Diner Dash* has a lot more going on — initiation of multiple timed processes, for example — but we were inspired by the idea of a game where players were running around a busy environment, with pesky customers coming at them, keeping their eye on everything all at once. The bartender and customers relationship just felt right for the casual audience."

Data Points

Developer: Gamelab
Publisher: PlayFirst
Release date: December 3, 2004
Release platform(s): PC Windows downloadable
Development engine(s) used: Director
Game development timeline: ~ 6 months
Development team size: ~ 7

Figure 1. *Diner Dash*, created by Gamelab, helped establish the try-and-buy model of downloadable casual games.

What Went Right
Nailed Iterative Design Approach

As with some of the other games discussed in this book, *Diner Dash* was one of the first games coming out of a fairly new studio, and this gave Zimmerman and his team an opportunity to create not only the games they wanted to make, but also the corporate culture in which the games would be developed. One aspect that was critical from the beginning, and that Zimmerman points to as a key success factor for *Diner Dash*, was the spirit of iteration within their design process.

"We established a very relentlessly iterative process," Zimmerman explains. "Our idea from the beginning was — rather

than planning our games out completely — to make just enough of a plan to get us to the next step in the process. With all our games, and especially with *Diner Dash*, we based our design decisions on our experience of the current prototype. This was instilled at Gamelab as part of the company culture. There was a tremendous amount of iteration in *Diner Dash*, and a lot of it in parts of the game where you wouldn't necessarily think it would be needed."

I asked Zimmerman to highlight an example of a specific area of the game that received an inordinate amount of iterative attention. "For instance, one area we iterated on over and over again was how we were communicating the complicated state of the game to the player. When you click on a table to pick up an order in *Diner Dash*, there are about 8 to 10 state changes going on all at once. The customers' states change, Flo's state changes, the customer heart meters change, the cursor art changes, points appear and rise up and get added to the level tally, chaining is recognized and bonuses awarded, etc. — a lot of things happen with one mouse click. We had to invent how we could efficiently communicate so many things at once to the player."

Zimmerman compared the task of communicating to the player in a 2D, 'low-fi' game like *Diner Dash* with doing so in an immersive 3D first-person shooter. "It's funny, because in a lot of the bigger 3D games, with much more complicated technology, it's really easier for the player to track what's going

Figure 2. Gamelab employed an iterative design process with *Diner Dash*; this was particularly important since a lot of player feedback had to be communicated to players in a limited 2D, 'lo-fi' realm.

on, because they are being presented with more representational visual cues. The information players need to see is embedded within the space itself. But in a game like *Diner Dash* the user interface itself has to carry much more of this weight, so we thought in terms of icons, symbols, and visual shortcuts that would communicate efficiently and intuitively. And this is just one example of how we made use of the iterative process. I think it succeeded because it allowed us to work through these design issues that really felt pretty novel at that time; there weren't a lot of good examples out there from which to draw."

Got in Early with Our Publisher

The relationship between a developer and publisher is critical to the success of any commercial video game. Zimmerman pointed to a host of benefits that he felt Gamelab reaped by getting on board with PlayFirst so early on. "We got in very early with PlayFirst," he recounts. "They were still hiring staff, finding an office, getting themselves set up as a company, so our project — *Lunch* — didn't actually have a producer assigned to it until very late in production." While it may seem counterintuitive, Zimmerman points to this as a net positive for the way the game came out in the end. "This was really very helpful for us. It allowed us to have creative freedom with the game, and that's not always the case, especially with a new developer. PlayFirst had input, and it was helpful and certainly benefited the game, but their input was pretty limited." In addition to this *de facto* hands-off approach, there were other advantages of being the publisher's first developer. "It's true that they didn't have big staff at that time," Zimmerman explains, "but on the other hand, since we were the only developer, it felt like everybody they did have in the company was working for us. In distributing the game, it really felt as if they put everything they had behind us, and this really helped the game in the long run."

Flo Worked Well

Flo is the main character of *Diner Dash*, and subsequently became the central character of the *Dash* world of sequels and spin-offs. Apart from this, even a cursory peek into the world of casual games reveals that it is chock full of spunky, young, female leads, many of whom are quite reminiscent of Flo. Clearly, she struck a nerve, and this was no accident. Zimmerman recalls the intense attention the team paid to getting Flo right.

 "The gameplay genre of *Diner Dash* was something that we feel we more or less invented, and one aspect of this is that we

really wanted to create a game that told a story and that had a strong central character. Our goal was to make a narrative, character-driven game. To that end we worked with Amy Ganter, an incredibly talented comics artist, who did the character design for Flo and also worked on much of the overall narrative. We poured a lot of our attention into Flo. One thing that was unusual at the time was this idea of doing a game about work in the first place. We needed a context for the game, and *Diner Dash* begins with Flo at her desk in a generic workplace, bored and feeling the need to break free. She's sitting in an office cubicle, and we thought that would mirror our audience — maybe they're at work, maybe they're at home, but they're sitting in front of their computer, kind of bored, not sure what to do. And I think this immediately made a connection with our players."

Zimmerman recognizes that in the larger world of video games the narrative arc and characters from *Diner Dash* may not seem extraordinary, even for their time, but in the world of casual games, they were quite a leap. "Yes, the narrative was thin, in that there wasn't a whole lot of it in the game — a comic-book-style cut scene after every few levels — but in the world of casual and online games, this was actually quite a lot of story. Essentially, we wanted to have our cake and eat it, too. We were shooting for innovative gameplay, but with *Diner Dash* we also wanted a strong main character that players could relate to and identify with, and I think we achieved that with Flo."

Figure 3. Flo, the main character of the *Diner Dash* series, received intense attention during the creation of the game. Clearly, Flo struck a nerve with players.

Made a Game We Wanted to Play

"One of the other things that I feel we really did get right with this game," began Zimmerman, "is that we made a game that we wanted to play. Despite the fact that the target audience was 40-something-year-old females, we still set out to make a game for ourselves. At Gamelab at that time we had assembled a pretty diverse team, especially for making games, with a good split among males and females on the team, etc. – but we didn't have any 40-year-olds in our office."

In many, if not all, of the successful games that appear in this book, a passion for the game among the people making the game is apparent. It is interesting to note that with a project like *Diner Dash*, designed by people quite different than the target audience, there was still a stated objective to make the game fun for those working on it. "Honestly, we felt that a lot of the games in the casual space were incredibly patronizing. It felt like they were made with themes designed to appeal to that audience but in a heavy-handed way. But I think that if you're not making a game that you yourself would enjoy on at least some level, then why bother? I think there was a certain kind of joy and passion in the making of *Diner Dash* that we feel comes through in the game, and contributed to its ultimate success."

Figure 4. With *Diner Dash*, despite their stark differences from their target audience, Gamelab made a game that they themselves wanted to play.

Got in Early with the Platform

Timing is always important, and Zimmerman feels that the ultimate success of *Diner Dash* was helped significantly by

being such an early adopter of a relatively new revenue model, namely, the downloadable, free-trial model. "We were not the first ones there — RealArcade was up and running, using the same model, and *Bejeweled* had seen a lot of success with the try-before-you-buy scheme, but we certainly got in early on this platform. Fortunately, we got there early, because the space quickly became glutted with clones and look-alike content. Timing was really good for us. *Diner Dash* was a genuine hit. For more than a year, we remained in the top-10 lists on almost all of the major downloadable portals. A couple of years later, even if you made a top-10 hit, you could only expect to remain in the top 10 for a few weeks, or maybe a couple of months at best, but you simply couldn't dominate the sales charts like *Diner Dash* did for such a long cycle. We were just very fortunate with our timing."

It's always a bet, but Zimmerman encourages game developers to innovate in all aspects of the process of bringing a game to market, including looking for new distribution and revenue models.

What Went Wrong
Made a Game We Wanted to Play

In reflecting on the creation of the original *Diner Dash*, and thinking about what he and his team might have done differently, it occurred to Zimmerman that many of the 'what went wrong' factors were actually, as he puts it, "the dark side of the coin for what went right."

For example, in thinking about the team's striving to make sure that *Diner Dash* was ultimately something they themselves wanted to play, Zimmerman wondered if they may have ramped up the difficulty of the game too quickly. "We may have erred too much on the side of making a game for ourselves. I feel that *Diner Dash* gets too hard too fast. By the time you're getting to the end of the first restaurant, the game is really hard. And by the end of the game, it's punishing. I myself can't finish *Diner Dash*. In our desire to create a game that challenged us, and that we enjoyed, we may have ultimately made it too hard. The other aspect of the game that makes it feel too hard is that we implemented just a single victory condition for each level in *Diner Dash*, with a linear unlock sequence. If you didn't finish level 8, you weren't getting to level 9. This is something we corrected in some of our later games, in which we included passing and expert score thresholds, and paid more attention to the challenge ramp overall."

Figure 5. *Diner Dash* gets pretty hard pretty fast, especially for a casual game.

Nailed Iterative Design Approach

Another 'what went right' coin with a dark side was the focus on the iterative design approach Gamelab employed in the creation of *Diner Dash*. "While we iterated a lot, and I feel that this had a net benefit for the game, there was a negative aspect to this as well. Our iteration was so important to us that, looking back, I remember feeling almost scattered, like we were emphasizing the iteration so much that we perhaps made too many twists and turns in our path to the finish line."

Another issue related to this focus on design iteration was that it precluded iteration on other aspects of the game that Zimmerman feels might have been more beneficial for the game as a whole. "We were just so focused on our own play of the game, and iterating on what came out of these internal reviews, that we missed an opportunity to do more testing and gather more feedback from our target users. If we had been more rigorous about a testing process that emphasized members of the casual game audience, I think we would have been better clued into things like the difficulty scaling and challenge ramp, and we could have better targeted the game toward casual players."

Missed Opportunity with Tutorial

Zimmerman points to the tutorial as another area of the game that would have benefited from more attention. Another issue relating to the challenge ramp of the game, Zimmerman feels that the tutorial in *Diner Dash*, while successful on some levels, fails on others.

"I think we could have done a better job with the tutorial. This is related to the overall difficulty of the game, and I think it's one of the main reasons that people petered out of *Diner Dash* after around the first restaurant. The tutorial does a good job of covering the basics, and getting players up to speed and playing the game, but it doesn't do a good job of teaching players how to play well. For example, you really have to use chaining bonuses in *Diner Dash* to do really well and to achieve the required scores on the midgame levels, and we didn't do a good job of cementing this in the minds of the player through the tutorial. It is great on basics, but it doesn't do enough to teach players how to play well enough in order to get high scores."

Character and Story

"I love Flo and the rest of the characters in *Diner Dash*," explains Zimmerman, "but I still find the whole story a little weird. I want to make games that are smart, and as savvy and clever and funny as other forms of popular culture – theater, film, music, novels – and ultimately the story in *Diner Dash* is very shallow."

With *Diner Dash* Gamelab set out to make a character and narrative-driven game, and they succeeded on some levels, but Zimmerman laments that they didn't push these boundaries even further. "This is the Flo story within *Diner Dash*: 'I'm sad; I'm going to open a restaurant; I'm going to make money; the more

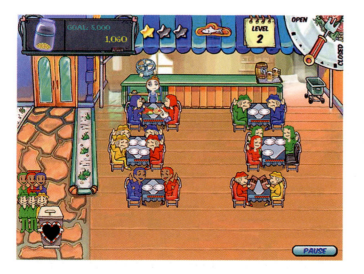

Figure 6. While *Diner Dash* tracks the story of Flo growing her business, the creators wondered if they could have done more to develop a deeper storyline for the game.

money I make, the happier I will be.' I realize that our options were somewhat limited with this kind of title, but still I just wonder sometimes if we could have done something a little bit more meaningful – made Flo a deeper character, incorporated some more human drama, created a more meaningful back story. With our later games, like *Jo Jo's Fashion Show*, for example, we were more focused on story and characters. Ultimately, the content of *Diner Dash* is a little bit shallower than I would have liked."

Should Have Self-Published?

The final issue Zimmerman highlighted was more of a business decision around the intellectual property and their choice to work with a publishing partner at all. "Hindsight is always 20-20," Zimmerman explains, "but sometimes I wonder whether we should we have tried to self-publish *Diner Dash*. Our arrangement with PlayFirst was a traditional publisher/developer deal. PlayFirst took all the risk, they funded the development of the game, and then once they got their money back, they paid us royalties on additional revenues. PlayFirst was definitely a great partner for us, and they were great to work with. But it wasn't rocket science at that time to get the games into the distribution channel. This was the beginning of online distribution, and it wasn't like getting a retail product onto the shelves of Walmart. I sometimes wonder what would have happened and if things would have turned out differently if we would have chosen to self-publish *Diner Dash*. On the other hand, I'm not sure if we would have had the money or the resources to do it all ourselves. This one is not really a 'what went wrong,' but more of a lingering question."

Wrap Up

Looking back on the entire process of bringing *Diner Dash* to market, Zimmerman recounted some of the early feedback that they received for making a restaurant-themed game. "One thing you have to remember is that the whole idea of doing games about work has become so ubiquitous that it's a cliché, but it wasn't always this way. When we were working on *Diner Dash*, and told people that we were making a game about serving food in a restaurant, people looked at us like we were crazy. I mean, there had been some precedents, but the idea was fairly fringe. Today there are too many restaurant games to count – but at the time the content was quite original."

Zimmerman also reflected on the state of game development as a whole. "I think that games are still a young cultural form, and

one in which innovation is rewarded. I would encourage game makers to always try something new, and I mean that on multiple levels. Think about content, gameplay, aesthetics, narratives, business models. These all offer tremendous space for innovation within the game industry.

"In terms of *Diner Dash*, one of the ways we helped to innovate – and I see our influence when I look at newer games like *FarmVille* and other social games – *Diner Dash* is really a game that is extremely player-centric. We take players by the hand, we teach them the core gameplay step by step, and we give lots of positive feedback. And we do that in a world that isn't a gamer world – it isn't science fiction, or fantasy, or a military simulation. In all of these ways, with *Diner Dash* we tried to create a pleasant, easy experience for the player. Some of the current crop of the most successful social games incorporate these ideas, but taken to their logical extreme. *FarmVille* in many ways is the Frankenstein monster begotten by *Diner Dash*. Some would say Facebook games go too far; that these games don't provide enough challenge and simply suck dollars from players without giving them a meaningful experience. But this is the way the cultural forms evolve, and if these games are bringing players to the table who normally wouldn't play a game, or haven't played in years, then that can only be good for our industry and our cultural form as a whole."

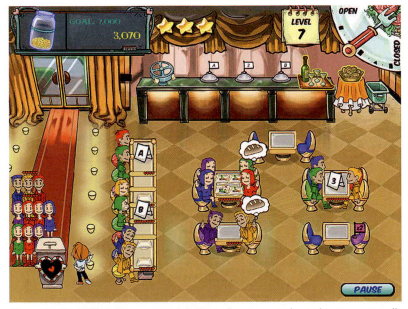

Figure 7. *Diner Dash* has spawned dozens of restaurant-themed games, as well as a host of spry, entrepeneurial leading ladies.

Team Role Interview: Producer

Please introduce yourself, your role, and the game team(s) that you have been a part of.

My name is Don Walters and I am currently the Co-Founder and President of GoBit Games. Our latest game is *Burger Shop 2*, and my role on that project was Producer and Co-Designer.

How did you get your start in the games industry?

After leaving college, where I had studied industrial illustration, I moved to San Francisco and was enjoying being a bum. My roommate at the time worked at the now-defunct educational software company named Broderbund. Since I wasn't working, she was concerned that I wouldn't have any money for rent, so she hired me as a temp to test *Where in the World Is Carmen Sandiego* for one week to earn some money.

While at Broderbund, I met a guy who was working at the also-now-defunct Kyodai Games. He asked me where I had worked previously and I told him that I had worked in the 'hardware business' due to a college job at a lumber yard. He assumed I meant the 'electronic hardware business,' as in CPUs, memory, etc., and so he offered me a full-time job at Kyodai. I was thrilled to stumble into the video games industry and couldn't believe I was actually getting paid to help make video games. I have never looked back.

As a Designer and Producer, what is your part of the process, and how do you make sure that you're contributing to a great game?

When I am wearing my Designer hat at GoBit, I need to ensure that I am helping Brian Rothstein, my Co-Designer, design a game that will be easy for our customers to figure out how to play and will keep them entertained. As a Producer, my job is to ensure that the project comes together on time and that everyone on the team is clear on what they need to do, and to provide each team member with the information, assets, and tools that they need to do their jobs.

What, to your mind, are the qualities of a good Producer? What makes someone a strong Producer of video games?

As a Producer, I believe you need know a little about a lot of different things. You're not a Programmer, or an Artist, or an Animator. You're not a marketing person, or a QA tester. But you do need to have an understanding of all the different aspects of the creation process, and the more you understand about all these different processes, the more you'll understand about how the product can be built and put together efficiently. I think being a good Producer boils down to three aspects: (1) you have to be someone who can understand the business decisions on a project, (2) you must be a strong customer advocate, and (3) you need to be able to manage a team of creative individuals.

In terms of managing people as a Producer, you need to be able to effectively lead a bunch of creative people, each one of whom has their own set of quirks (including you). I used to work at Maxis with a guy named Brian Conrad, who then managed our programmers. He was always talking about his struggle of managing the programmers as 'herding cats,' and I think this aptly describes managing creative teams as well. Generally, when you're talking about a making a video game, everyone involved is creative to a certain extent and everyone has their own ego, style, and opinion about what should be done to make the game better. It's important for the Producer to be a team leader, to be a cheerleader, and to be the keeper of the overall vision for the game. In order to do this effectively she or he needs to get to know the people on the team and to be able to understand their motivations and desires. Everyone is different, and it can sometimes be challenging to get people on the team to mesh effectively. I did not study psychology formally, but I imagine that it would be a useful skill set for a Producer. At the end of the day, you need to have good communication with your team and ensure that each team member has what they need when they need it (and sometimes a team member doesn't know what they need or when they need it and so, it becomes your job to figure this out).

Team Role Interview: Producer—Cont'd

As a customer advocate, I just mean that you need to be able to put yourself in the customer's shoes. Everyone's different, of course, but you have to try to be an 'average' customer — you've got to be the person who's going to purchase your game, in some sense. You need to look at how that player is going to interact with your game, and to get a sense of the overall feeling they'll get from it. This is true for every aspect of the game — the user interface, content, humor, art style, writing, gameplay mechanics, etc. — does it all fit together in a cohesive fashion and does it all make sense for this customer?

To do this well you must also have a good sense of the larger picture, including what's going on with other games out there that compete with yours. You need to be on top of trends in the industry — what games do people like right now? — and to have an opinion about why that is so — not in order to make clones, but to be able to use that information to get that overall picture. In a big game project, a lot of the people working on a game don't always have the overall picture because they are concentrating on singular aspects of production, but the Producer needs to have that overall picture, and to be able to communicate why that overall picture is important to everyone on the team. I think a good Producer has an innate kind of awareness of how all of the pieces need to fit together, and these vary depending on the platform you're making a game for and what current technologies or procedures are being used. Over time, you will gain more of an understanding of this awareness through experience, but it is possible to speed up this process through research.

And in terms of the business aspects, simply put, at the end of the day the Producer needs to make sure that the project will make money. This means being aware of all kinds of factors. What do we need to spend, and how many units can we realistically expect to sell? How much will specific things cost? What issues might the various groups working on the game run into? Is there a way to do any of the subtasks more efficiently? Are there any tricks we can employ to reduce asset production costs? It is often a Producer's role to create a budget and project timeline, and to do this well, he must understand the interdependencies within the process of making a game. There are going to be problems that arise, and when they do a good Producer should try to figure out inexpensive solutions.

Do you think good game Producers are born or made?

I feel like there are some people who are more inclined to be a Producer than others. I find that in general, some people like to look at trees, and some people like to look at forests. One is not better than another; they are just different. This is true in other aspects of life as well — some people like to concentrate on certain, specific things, and some people like to have more of an overall view of things. A good Producer is going to start with someone who likes an overall view of things. You need to see the overall project, and to be able to manage the overall project. If you are someone who loves living in the trees and the minutia of certain aspects of things, you're probably not going to be a good Producer.

Of course, there is also a lot of variety in terms of how game teams are structured and what exactly the role of the Producer is on any given game. Sometimes members of the creative team report directly to a Producer, but often the people working on a game team will have a boss within their function — Programmer reporting to a Lead Programmer, Artist to an Art Director, and so on. In those cases as a Producer you aren't directly managing those people. Yet you still need to manage their performance on the project. This arrangement can cause political friction sometimes, but I actually think this works better, because then the artists and programmers are getting good career growth management from their own manager, as opposed to having some Producer managing people where they don't have expertise in that field.

(Continued)

Team Role Interview: Producer—Cont'd

There is another factor that I believe is important to being a good Producer. I think that the Producer needs to work at least as hard as everybody else on the team. On some of the bigger games I've worked on, the team often had to work crazy hours in order to make deadlines. If I had people coming in on the weekend, or working late, I was coming in on the weekend or working late, too. I believe your job as a Producer is essentially that of a problem solver. Problems will arise, and at then end of the day it is your job to make sure that that problems get resolved as soon as possible. If a problem arises, and the Producer is not available, then a couple of things can easily happen: (1) the project can stall, if the team doesn't try to solve the problem themselves, or (2) the team can try to solve the problem, but maybe without seeing the forest, and then head down a wrong path. These days with smart phones, video chat on the web, all of these communication tools at our disposal you can get away with not being with the team the whole time, but you need to be available to your team, or you risk a problem arising that causes a longer delay than it should.

What was the most satisfying aspect of working on *Burger Shop 2*?

Accomplishing small tasks during the project, finally releasing the game, and getting positive feedback from customers were all satisfying aspects of working on *Burger Shop 2*. But, personally, probably the single most satisfying aspect for me was having my 6-year-old niece constantly ask me for new versions of the game during development because she was addicted to the game and was enjoying it so much.

Any parting thoughts?

If you want to make good video games, I think you need to start with an idea that you believe in. Sometimes it is better to discard an idea early if the prototype is not working out, instead of continually trying to make a round peg fit in a square hole. Once you have found a mechanic or game idea that seems to work, I believe it is important to try to understand who your customers are and to keep them in mind while you are refining the mechanics and designing the interface. But in my opinion, the number one factor to developing good games is to enable open team communication, be organized, and ensure that everyone on the team has the information, assets, and tools they need exactly when they need them.

HALF-LIFE 2

Half-Life 2, released in 2004 by Bellevue, Washington-based Valve Corporation, has proven to be one of the most critically acclaimed video games of all time. The highly anticipated sequel to the 1998 release *Half-Life*, *Half-Life 2* garnered over 40 'PC Game of the Year' awards in 2004 and has been hailed as one of the best games of the decade by multiple publications, including IGN.

A first-person shooter, initially launched for Windows-based PCs, *Half-Life 2* has received accolades across a broad spectrum of disciplines, from technical feats such as the physics engine and artificial intelligence of the game's Non-Player Characters (NPCs), to the game's novel animation techniques as well as more design-centered areas, such as narrative and story. The game also comprises multiple puzzles and other non-shooting challenges as players move about the highly realized world, which represented great leaps forward in the first-person shooter genre of games.

Figure 1. Gordon Freeman, protagonist of the *Half-Life* series of games from Valve Corporation.

Making Great Games. DOI: 10.1016/B978-0-240-81285-4.10004-2

I spoke with Robin Walker, Designer and Programmer on the *Half-Life* series, about working on such a high-profile sequel. "The original goals of *Half-Life 2* were to drive in-game narrative and rich interaction with the environment to a level that hadn't been done before," Walker began. "The primary methods of achieving those goals were through the use of high-quality character and facial animation, and a deep physics simulation that improved player's interactions with the game world." We spoke about what worked well as well as what specific challenges the team faced in working on such an anxiously awaited sequel.

Data Points

Developer: Valve Corporation
Publisher: Sierra Entertainment & Valve Corporation
Release date: November 16, 2004
Release platform(s): PC (Xbox, Xbox 360, and PS3 at later dates)
Development engine(s) used: Source
Game development timeline: ~ early 1999 start; development cycle of nearly 5 years
Development team size: Varied, but peaked at around 40 people.
Development budget: $40 million.
Awards, honors, sales thresholds, etc.: Over 40 GOTY awards for 2004; 6.5+ million units sold at retail
Secrets, FAQs, etc.: For more info on the making of *HL2*, you can chase down a copy of *Raising the Bar* (see http://en.wikipedia.org/wiki/Half-Life_2:_Raising_the_Bar)

What Went Right
Collaborative Design Process

"At Valve, we believe that much of our success in the *Half-Life* series comes from our decentralized design and production process that we call 'cabals,'" explained Walker. During the development of the original *Half-Life* release, Valve famously charted new territory, doing away with a centralized 'Game Designer' role for the project, and instead forming a cross-functional working group to focus on the design of the experience. This decision was made midstream, and required the team to essentially scrap a lot of what they had developed to basically start again. "We are lucky in that we were relatively small at that time," explains Walker, "and we were not beholden to a large publisher. *Half-Life 2*, however, posed a significantly harder problem than the original game. *Half-Life 2* is a much, much bigger game, so

Figure 2. Great weapons are a key part of great shooters, and *Half-Life 2* includes many weapons innovations that have been mimicked in subsequent games.

whereas we could get away with essentially one cabal for *Half-Life*, for the sequel we were looking at more like five cabals." Walker talks about some of the challenges this posed below, but maintains that the cabal system is one of the key elements that allowed the game to achieve so much success. "Giving groups of people the ability (and responsibility) to control their own destiny, this is something that works really well in our business, which is part functional and part creative. If we are a fast-food chain whose goal is to consistently provide the exact same product again and again, then cabals don't make much sense. But we strive, amidst ever-changing restraints and requirements, to balance the right amount of innovation, production quality, and interesting experiences in our games — and cabals have proven really effective at getting us closer to these goals."

Not only did the cabal implementation have dramatic results for Valve and the *Half-Life* series, but also their willingness to share and even evangelize their approach has had a broad effect on the games industry as a whole.

The Gravity Gun

One of the coolest and most-often mimicked features from *Half-Life 2* is the Gravity Gun, a powerful tool that allows players to in essence turn in-world objects into weapons. "*Half-Life 2*'s rich physics created an opportunity for a physics-based gameplay, but it wasn't obvious at the outset what that gameplay would be," recalls Walker. "The Gravity Gun is arguably *Half-Life 2*'s greatest

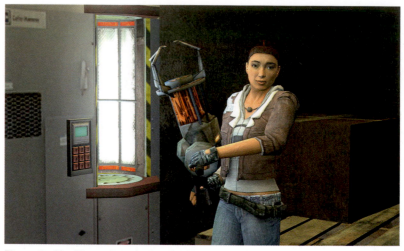

Figure 3. Alyx Vance introducing the Zero Point Energy Field Manipulator, or Gravity Gun, to Gordon for the first time.

single innovation and was achieved by various people in different cabals periodically picking it up, trying a few experiments with it, and putting it down for a while. Each set of experiments taught us more about what the Gravity Gun should be, and over time it took shape. This collaborative development with 'room to breathe' allowed everyone to lend their unique strengths to the design, yielding a weapon and tool with surprising richness and versatility."

As we see with many of the great video games looked at closely in this book, iteration played a key role in the development process at Valve. Focusing on one key component – the Gravity Gun – and experimenting extensively allowed the feature to mature and achieve an incredibly high level of quality.

Multiple Product-Wide Iterations

Iterating, both on the small scale, as discussed above, and on a large scale, is one of the hallmarks of the development process at Valve. As Walker relates, "As soon as the game was playable from start to finish, we went back to the start and did a complete pass over it. We identified the best and worst parts. Wherever we could, we improved the worst parts, and cut them out of the product if we couldn't. We also kept an eye out for low-hanging fruit, areas where a small amount of work would provide a big payoff, and did that work as well. Then, once we'd finished that pass over the entire product, we went back to the start and did it again."

Figure 4. Late-stage concept art for the Strider (with pulse cannon), a large Combine Synth introduced in *Half-Life 2*.

Taking the long view, and ensuring that each element of gameplay was pulling its weight, resulted in an overall high quality bar for the player experience. Walker continues: "These iterations leveraged a lesson we'd learned in the original development of *Half-Life*: decisions we made later in the project were always better than ones made earlier, due to our better understanding of the product. As a result of this 'weighting' of our later decisions, the average quality of the game experience was significantly improved."

Playtesting as the Core Production Driver

"The last 2 years of *Half-Life 2*'s nearly 6-year development were driven by a constant cycle of playtesting and iteration. Each week, we brought external customers in to play the part of the game we were working on, and took notes as we watched them play. These notes would then drive the work we did for the next week, after which we'd playtest again," relates Walker. "Our process of iteration is only as good as our ability to measure it, because otherwise our iterations might be making the game worse, not better. These weekly external playtests provided that essential measurement piece. Our overall focus on the minute-to-minute customer experience was a key part of *Half-Life 2*'s success."

Utilizing observation data from exhaustive playtesting, Walker and the team were able to provide focus and meaning to their iteration, resulting in a better player experience, and a better game.

Building the Beginning Last

Walker also spoke about the focus Valve puts on the onboarding process for players, and their counterintuitive approach to building out the early moments of the game experience — namely, working on these pieces last. "The start of the game is the most important piece, because it's the place where customers are most critical and most explorative. The game needs to rapidly teach them its set of rules, and convince them that it's worth investing their time into it," explains Walker.

"The end of a project is also the point at which you know the most about your game, and the tools you're building it with." As an example, Walker pointed to the moment-to-moment experience of the train station — the first full environment experienced in *Half-Life 2*. "By building the train station last, we knew exactly what training it needed to provide, what atmosphere and narrative it had to communicate, and the most efficient way to do it."

In general, intuition would dictate that the levels of a game should be built in the sequence they are experienced — after all, midstream changes might need to be reflected in later levels. However, Walker highlights a key problem with this approach — the fact that you are precluding benefiting from everything you learn over the course of the project. If you consider the development team as an organism that gets better at its task, another issue is that the parts of the game made by the team at its best are seen by the least number of players. By turning this assumption upside down, Walker and the team at Valve were able to leverage their learnings over the course of creating *Half-Life 2*, and to put their best foot forward.

Figure 5. The City 17 Train Station, the first full location visited by Gordon Freeman in *Half-Life 2*.

What Went Wrong

Trying to Build Content While Building Technology

A common pitfall with sequels is an assumption that, having built everything once for the original, the underlying platforms are established and stable, so all the team needs to do is more of the

Figure 6. A pre-release (alpha) screen shot from *Half-Life 2* featuring Antlions.

same. However, teams also work to innovate on the core engine, resulting in significant changes to those underlying systems. The *Half-Life* team was no exception. "We spent over a year building the *Source* engine that eventually powered *Half-Life 2*," recounts Walker. "During that time, we had a large number of level designers and artists trying to design and build content for the game. Without a stable technology base, much of that content was unconstrained, and as a result ended up being discarded. In retrospect, it would have made more sense to have those people building more content for expansion packs to the original *Half-Life* while the technology team built the initial platform for the sequel."

Designing While Being Unable to Test

In line with Valve's philosophy of heavy focus on iteration and testing, they struggled when experimenting with what might be considered more traditional methods of building games – for example, designing up front. "Early on in the project we tried to design large amounts of the game, because the technology wasn't there to build it. This resulted in a large design document full of gameplay ideas. Unfortunately, we ended up throwing most of it away. The hard lesson we learned was this: the deeper you go into design, the more you're building on top of early design choices. If you can't validate those choices, by building and putting them in front of customers, then any design built on top of them is at risk. Ultimately, the successful game design innovations we did (in things like the Gravity Gun) were the result of many iterations and playtests, not the result of sitting down and thinking really hard about what would be fun."

It is important to look closely at your methods and processes, and make sure they sync up with the goals for the game. If they don't, it's a good idea to adjust one or the other – changing either the goals or the methods, so that they can benefit, instead of impede, each other.

Reduced Number of Sci-Fi Monsters and Weapons

One important artifact of the iterative design and development process is that it takes time. Valve had the success of *Half-Life* and its add-ons to fuel the development of the sequel – a luxury many game teams simply don't have. Even still, *Half-Life 2* took a long time to develop, and resulted in budget overruns that meant cuts had to be made. "The increased cost of production meant that our production team was stretched thin throughout the project, and this resulted in fewer non-human adversaries and tools than we

Figure 7. Combine soldiers doing battle with a crew of Antlions in Cell Block B4.

would have liked. Where our *Half-Life 2* monsters had deeper behaviors in general than *Half-Life*'s, *Half-Life* actually had more variety in these specific areas, and it was a shame to lose some of that variety," said Walker.

Cuts are always painful, yet it is hard, if not impossible, to find a great game that did not experience this adversity during the course of development. As we'll learn elsewhere, some designers go so far as to claim that cuts are actually necessary to achieve greatness — that without making significant cuts, this high quality bar can not be achieved.

We Had Figured Out How to Make Great Games

While one might assume that it is easier to make a sequel than to create something new from whole cloth, certain challenges, specific to following up on success, plague development teams. As Walker explained: "While our corporate culture has always dictated that we never rest on our laurels, there was a bit of an understanding internally that we had figured out how to make great games. We knew we couldn't simply 'ship it again' and succeed, but at the same time we underestimated the need to rediscover new methods, and we could have been more analytical about the relationship between technologies and content the second time around. Our thinking, our methods and practices — everything had to evolve in order to continue to raise the bar and we didn't quite anticipate how hard that would be."

Figure 8. Concept art for a Stalker, an enemy engineered by Combine using humans as their raw material.

Five Cabals Are Harder than One Cabal

Walker pointed out in our discussion of 'what went right' how critical Valve feels the cabal system, and the system's progression, has been to the success of their games, but at the same time, he outlined some challenges in operating under the cabal system in making *Half-Life 2*. "Our business goal is always to balance the right amount of innovation and production values and interesting moment-to-moment experience, always working

under constraints like schedule, budget, and the like," he explains. "There are the creative aspects to all of this, but also the functional realities. Trying to keep five cabals synced up proved an enormous challenge, just in terms of communication alone. *Half-Life 2* represented dramatic increases in scope across the board — which meant many more variables, and many more problems — and we soon realized one cabal wouldn't work. Five cabals was the right amount to do the work, but communication issues among so many groups of so many people were really tough to sort out. In the end, I still feel like we did the right thing for the game, but it ended up taking longer — and ultimately costing more — than we would have liked."

Wrap Up

Robin Walker and the team at Valve gleaned much from the making of the original title, *Half-Life*, and incorporated these best practices into the creation of the sequel. The success of *Half-Life* bought the team more time to build its sequel, but Walker cautions against potential pitfalls of this additional time: "One of the specific side effects of longer schedules is that they make it harder to cut features from the game. People fall in love with specific features, and start to believe that the product can't

Figure 9. Dr. Wallace Breen, the primary antagonist of *Half-Life 2*, confronting Alyx Vance, one of Gordon Freeman's most reliable and effective companions in the *Half-Life* series.

succeed without these features. This can be poisonous, because cutting features is one of the best things you can do for your product's quality. Cutting everything but your essential features is the best way of ensuring your product will be of the highest quality." Clearly, the process worked at Valve; *Half-Life 2* endures as one of the most critically acclaimed video games of all time.

Team Role Interview: Games Writer

Please introduce yourself and your current role.

I'm Richard Dansky, the Central Clancy Writer for Red Storm/Ubisoft, and I was the main scriptwriter for *Splinter Cell: Conviction*.

How did you get your start in the games industry?

I came to the video game industry from the pen-and-paper RPG field. At the urging of a friend at Red Storm named David Weinstein, I decided to take a shot at video game design work, and luckily there was a match between my experience and credits and what Red Storm was looking for at the time. That was in 1999; since then I've done game design in lead and team member roles, plus various tasks related to game writing, narrative, and working to support 'Tom Clancy' and other game brands.

As for *Splinter Cell: Conviction*, initially I was just brought in to serve as a reference and story consultant. Then, there was a reorganization on the project and I ended up shifting into the role of primary scriptwriter, which obviously involved a lot more direct participation and time with the team.

Did you have a sense of the larger picture? Was it clear to you how your contributions would be used in *Splinter Cell: Conviction*?

I have to say, I was very lucky — the Creative Director on the project, Max Beland, wanted to make an experience where gameplay and narrative were really tightly integrated and supported each other. That meant that I was in a position to help contribute to the shape of the project pretty much from the get-go, and that I was working with folks who understood and valued the storytelling aspect as something that could help make the game experience better for players.

In one sense, as a writer it is easier knowing how your contribution is going to be used in the final product — the characters in the game say the words that you write!

I am interested to hear what you can do as a Writer to ensure that the game you are working on is great. What is your part of the process, and how do you make sure that you're contributing to a great game?

To make the narrative and writing aspects of a game great, you literally have to start at the beginning. Slapping a story and some dialogue on at the end once all the levels are built and features are set doesn't do either justice. You want your game story to get your players involved and to support and show off the features — to give the player a reason to do all the cool stuff you've set up for them to do without thinking twice about 'why am I doing this?' You want the dialogue to be seamless with the action instead of distracting from it, giving the player a positive benefit from listening. This means getting in early, being in a position to collaborate with design and level design and sound design and animation and creative direction, so that what you're doing works synergistically with what everyone else is doing.

Then, if you're lucky, you polish the living hell out of what you've written to make sure that everything works moment to moment — that no lines are too long, that the player's getting enough information, that character voice is consistent and appealing, that the jokes are actually funny — and you make sure what you're doing also supports what everyone else needs from you. The best line in the world is wasted if it's not delivered in a way that makes the player's experience better.

What was the most unexpected part of writing dialogue for *Splinter Cell: Conviction*?

Some of the last-minute script alterations for technical or other reasons got fairly strange at times. Most of the time, when you need to make a dialogue change you're hoping it's because a line's not working, or you need to shorten something, as opposed to "legal says we can't use the word kumquat any more" or "we just chopped this space/feature/character." But it's always a little weird to dive back into something you thought was done for a surgical strike while trying to alter as little else as possible — right down to syllable count — as possible.

(Continued)

Team Role Interview: Games Writer—Cont'd

What was the most satisfying aspect of working on the game?

Honestly, it was seeing it come together in the game and watching other folks react to it. There's a golden moment when someone who doesn't know you wrote a line of dialogue quotes it back to you as an example of something really cool, and hearing that — hearing folks talk about how they are enjoying the story as part of the game or really digging the characters — is an absolutely great feeling.

Did you feel like you personally were able to contribute specific ideas to *Splinter Cell: Conviction*?

Absolutely. Collaborating with the Creative Director and the Narrative Designer on the front end to develop a story that would support the game's core experience, and then working with level designers and sound engineers to contribute on a granular level was a great experience. It's great to be able to sit in a meeting and say, "Hey, the props on this level don't quite match what the space is supposed to be doing in the narrative," and have people take that critique seriously; at the same time, it's just as cool to get feedback from level designers talking about how the dialogue is affecting the gameplay and getting a chance to improve things based on that feedback.

Any best practices that you've seen that make a significant difference in the quality of writing in games?

There are a million details that can go right or go wrong, but in my opinion it all boils down to some very simple things. Get the writer involved early and collaborating with the rest of the team, so the writing can be an integrated part of the game experience. Iterate on the writing — make sure there's enough time to polish the dialogue and narrative the way you'd polish any other aspect of the game production. And above all, understand that writing can be an important asset to a game, and not just chrome that you add at the end.

The best games in the world are the ones that understand that the writing — story, character, dialogue, you name it — are a part of the game, and treat it accordingly. That means, first of all, understanding that it's for a game, that it's an integrated part of a greater whole dedicated to the player experience. That also means it's worked on through development, not just slammed together at the end once all the levels are nailed down. Finally, it means that it's something that gets as much iterative care and playtesting as other assets, to give it polish and a chance to be as good as it can be. It's not rocket science. It's hard work, planning, perseverance, and being willing to give and take criticism. And if you get all of those, in conjunction with other great game elements, you get magic.

UNCHARTED 2: AMONG THIEVES

5

Uncharted 2: Among Thieves is an undisputable masterpiece. Created by Naughty Dog, *Uncharted 2* was published by Sony Computer Entertainment for the Sony PlayStation 3 console in October, 2009. A follow-up to the highly successful early PS3 title *Uncharted: Drake's Fortune*, the sequel quickly outpaced the original, enjoying universal acclaim from critics as well as brisk sales.

Naughty Dog, Inc., established in 1986, is a well-respected studio based in Santa Monica, California, known for generating highly polished and wildly successful hit games, most notably the *Crash Bandicoot* and *Jax and Daxter* series of platformers. With *Uncharted 2: Among Thieves* they set out swinging for the fences, with a core vision to create a 'playable summer blockbuster.' *Uncharted 2* is a third-person action-adventure game in which players control the character Nathan Drake, an adventurer cut in the mold of Indiana Jones. A sarcastic, self-deprecating 'everyman,' the hero of the series drips with personality, humor, and charm. *Uncharted 2* finds Drake and his companion Chloe Frazer on the trail of antagonist Zoran Lazarevic in a cinematic adventure revolving around a search for lost treasure from Marco Polo's fleet. Moving through Turkey, Nepal, Tibet, and Indonesia, the game combines and builds upon many core elements from action-adventure games, platformers, and shooters. *Uncharted 2* represents a leap forward in the genre, pushing the envelope in terms of story integration, player mobility, engagement with the environment, and the incorporation of epic, immersive action sequences.

Uncharted 2 won a dizzying array of 'Best of 2009' awards, and went on to become the highest Metacritic-rated game of 2009. The *New York Times* called *Uncharted 2* "perhaps the best-looking game on any system," and phrases like "stunning," "explosive," "sensational," "brilliant," and "near perfect" pepper the nearly universally positive reviews of the game. Several reviewers have called out *Uncharted 2* as the "best video game of this generation" as well as "a classic, even of all time."

I had the opportunity to visit with Bruce Straley, Naughty Dog's Game Director for the *Uncharted* series, to chat about the

Making Great Games. DOI: 10.1016/B978-0-240-81285-4.10005-4

Figure 1. *Uncharted 2: Among Thieves* achieved the team's core goal of creating a 'playable summer blockbuster.'

process of making one of the most critically acclaimed video games of all time. "With *Uncharted 2*, we set out with a specific goal of making a playable summer blockbuster," Straley began. "This was almost our motto from the beginning of production: How do we take those epic action sequences from films like *Die Hard*, *Terminator 2*, or the *Indiana Jones* series, and keep the player in full control? We all just love those films and the feeling you have when leaving the theater after a great summer matinee, and we thought to ourselves: 'Wow, what if you could play that?' In addition to the action, can we have the heart and emotions of those movies as well? You know why Ripley is willing to sacrifice so much in *Aliens*, and you care. We wanted players to fall in love with our characters, to care about what happens to them and about their relationships. This is what we set out to accomplish with the sequel to *Uncharted: Drake's Fortune*."

Data Points

Developer: Naughty Dog
Publisher: Sony Computer Entertainment Europe
Release date: October 13, 2009
Release platform(s): PlayStation 3
Development engine(s) used: Havoc Physics
Game development timeline: ~ 18 months
Development TEAM Size: 105 on the core team, plus outsourcing
Awards, honors, sales thresholds, etc.: Multiple 'Game of the Year' awards for 2009, including Spike Video Game Awards, IGN, 1UP, Kotaku, Eurogamer, Academy of Interactive Arts & Sciences, Game Developers Choice Awards

What Went Right
Naughty Dog Structure

The first element that Straley highlighted in terms of what went right over the course of *Uncharted 2*'s development was the well-established Naughty Dog underlying structure and company culture. "One unique thing for our company is that we have an extremely flat structure. There is simply not a lot of hierarchy here. We are a meritocracy, and everyone is expected to step up and make the game the best they can."

Straley described his own role as Game Director as relatively easy because he has so much confidence in his team and in the structure they've created that allows ownership and responsibility to be shared among their flat organization. "I'm kind of like the rudder on a well-tuned ship," he explained. "Early on, I worked hand-in-hand with the Creative Director, whose ultimate responsibility is the story, to make sure that gameplay and story were on the same page. Through this collaboration, the game's 'story macro' is created. This is the set of overarching story beats for the entire game. What locations Drake will visit, who he'll be with, what he's trying to accomplish, and where the relationships with his allies and enemies are. Then it's my job to take that story macro and try to parallel the different story beats with appropriate gameplay mechanics, always keeping in mind the introduction, training, and ramping of each mechanic. Through all of this the 'game macro' is created, which becomes our bible for the rest of production.

"Then I really moved into a role of working closely with the production team — and more specifically the design group — to make sure that on a level-by-level basis the teams working on individual levels understood how all the pieces were to fit together. We don't have Producers at Naughty Dog. Our Designers are the Producers, in a sense. They are given a level, or a level segment, and that piece becomes their responsibility. I work closely with each Designer to create a snapshot of the moment-to-moment flow of the level, and then we brainstorm the different events that we want to have happen, or think would fit with the narrative. Once they fully understand the requirements of the level, from both a story and a gameplay perspective, they are on the hook to create a layout and start working with Artists and Programmers and get them all moving in the same direction to achieve their vision for that level or segment. They need to take into account the story beats that need to be covered in that particular level, for example, it may be essential that Chloe is portrayed as useful to help us build on her relationship with Drake at that point, or they may need to introduce a new

Figure 2. Concept art for the Nepal level of *Uncharted 2: Among Thieves*.

mechanic that we're going to rely on in the next level, but as to how these things are accomplished within the level — that is mostly up to them."

Weekly design meetings ensured that these individual groups remained in sync with each other and provided a great opportunity for designers to solicit feedback and get reactions to what they were working on. "Our Designers are encouraged to play each other's levels," explained Straley. "The weekly design meetings represented one guaranteed time each week where Designers got to see what the other Designers were working on, and to hear about their thought process. This was a great forum to show off what they'd been working on, but also to say 'hey, I'm struggling with this puzzle, any ideas?' I'm there, too, of course, saying, 'Don't forget we need to get this mechanic in there, or that story beat.' On top of that, there's a lot of 'Wouldn't it be cool if you did such and such?' brainstorming and a lot of great ideas are born from these meetings.

"On one level, Naughty Dog is made up of a bunch of perfectionists," Straley concluded, "with ownership, responsibility, and authority for what they are creating. There's a general feeling of 'If we're going to put our name on it, it has to be hot shit.' This drives us crazy at times, but it really does drive a level of polish." That polish is one of the hallmarks of a truly great game like *Uncharted 2: Among Thieves*.

Combined Traversal and Gunplay

The team at Naughty Dog had an extremely clear goal for *Uncharted 2*: create a playable summer blockbuster. They looked

closely at the original game, *Uncharted: Drake's Fortune*, to see if there were specific areas where they could evolve the game mechanics to try to better capture the epic set pieces of classic action adventure films like *Raiders of the Lost Ark*. "We felt there was a real separation in the first game between traversal and fighting," began Straley. "There was this off-again, on-again flow — now I'm moving, next I'm dumped into a self-contained combat space, like an arena, where there's going to be a fight, and then I'm moving again to get to the next combat space. One of our first goals was to break this down, to layer our shooting mechanics on top of traversal. We worked on this really, really early, in a 'block-mesh' phase with basically no art at all, and iterated over and over and over again on this core mechanic. This evolved into what we called 'traversal gunplay,' and suddenly we weren't stuck with traversing versus combat; we could have both at the same time."

Straley and his team knew that this dynamic would accent the combat aspects of the game, but this breakthrough had a host of other positive side effects as well. Taken together, he feels these greatly contributed to the overall quality of *Uncharted 2*. "This concept of 'traversal gunplay' really opened things up for us, on a number of levels. First of all, it helped our layouts immensely. We realized, kind of suddenly, why can't the player defend themselves while moving? And this opened up the idea of using an edge of a building, or climbing up to a sign to use it for cover. So the designers were freed up to create more interesting spaces for players to explore. Since the line was now blurred between traversal spaces and combat spaces, it added a sense of unpredictability for players — when am I safe? When am I not safe? It allowed us as designers to surprise the player more with new and fun ways of introducing enemies."

Because this represented so many new mechanics for players, and went against some ingrained player assumptions about this type of game, this introduced new challenges for the designers as well. Issues like how to gate between one scene and the next, or how to encourage players to exit an area to move the story forward became more significant, since there was this additional appeal of hanging out and wandering around. "We thought a lot about 'gates' — both 'soft gates,' like something you're climbing, say, to get from one scene to the next, and 'hard gates,' like a door or a puzzle or an explosion — to get players to move from point A to point B. We also had to ramp the introduction of some of these new mechanics, because players weren't used to moving and shooting at the same time, say, or climbing vertically in this type of game. We kind of had to train them a lot at the beginning of the game — 'Look, guys, you *can* climb and shoot at the same time.'"

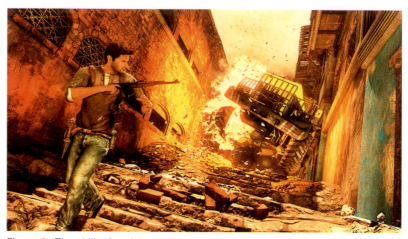

Figure 3. The ability for players to move and shoot at the same time really opened up new possibilities for the designers of *Uncharted 2: Among Thieves*.

Prototyping, Iterating, and Testing as Production Drivers

Naughty Dog is a strong proponent of early prototyping and heavy iteration. The studio's philosophy is to get something on the controller as quickly as possible, and they are adamant, to a fault, about iterating to make changes to improve the player experience of their games. "At Naughty Dog," Straley points out, "we have nothing that says design has to be wrapped up at this particular moment. This isn't always a good thing, but we totally blur the lines between design and art. Even if something is already being arted up, there is nothing that says we can't go back and tweak something, if it is ultimately going to make the game better."

How did the team ascertain whether something would make the game better? Extensive, relentless testing. Throughout the course of *Uncharted 2*'s development, the team did an unbelievable amount of testing. "First of all, we encourage everyone to get whatever they're working on to a playable state as quickly as possible. No art is fine — just how soon can I play this setup that you're working on? And there's a ton of 'Dude, can you play this for me?' pre-testing going on all of the time within the team. And with *Uncharted 2*, we did a lot of impromptu 'friends and family' testing as well. Basically, we got whoever we could to come in and sit there for 5–10 hours and play through the game. We had a recording system set up for this testing on specific machines in our offices. These computers would screen capture the entire playthrough, as well as conduct data mining during these play sessions. We implemented tracking code in the game to do more metrics gathering and analysis than we ever had

before — tracking everything from number of overall deaths, deaths by certain guns or enemies, attempt counts of specific tasks, the list goes on and on. So we could graph these events over time, and see problem areas, and then have the designers review the recorded playthroughs at those specific moments to see where players were experiencing problems. We did this with more formal focus groups as well — I think we had 15 groups come in to test *Uncharted 2*, which was more than we've done in Naughty Dog history."

More important to the succes of *Uncharted 2* than the testing was the team's attitude toward the results of all this testing. As Straley continued: "This testing was extraordinarily helpful. It made setting priorities very easy — we simply went for the most frustrating experiences for players and worked on alleviating these problems. Sometimes it was the player's fault, but more often it was our fault, and we realized, 'Hey, this is totally unfair, everyone is dying 27 times here, we need to change something.' This also boils down another Naughty Dog underlying philosophy: don't get attached to your work. Don't defend it. Someone playing the game is giving you their honest, subjective feedback, and you can not argue with it or deny it. The experience is king, and it really is all about the player — they decide what's important."

Added Multi-Player

Uncharted: Drake's Fortune was a single-player game; for the sequel Straley and the team planned to feature both competitive and cooperative multi-player across a handful of modes of play. "We saw multi-player as an obvious way to add value to the product and to help keep fans engaged with the game, and we knew it would benefit the game as a whole — the best enemy you'll ever fight is another human. One thing that surprised us, though, was how immensely adding multi-player helped the single-player experience," Straley recalled.

Experiencing the game through the multi-player filter enabled the team to revisit mechanics, some core and some peripheral, and make adjustments that improved the overall quality of the player experience. I asked Straley if there were specific aspects that were changed after the team experienced multi-player. "Absolutely. One thing was the speed at which Drake traverses. It felt fine in single-player, but it just didn't feel right in multi-player modes. We realized immediately that players needed to climb up, down, and around objects more quickly to succeed in multi-player. We knew instantly that we had to speed up our traversal animations as well as responsiveness on the controller. The way we layered traversal and gunplay was also influenced by our

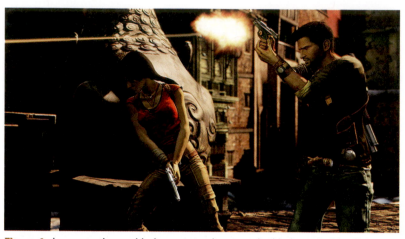

Figure 4. Incorporating multi-player not only was valuable in and of itself, but also greatly enhanced the single-player experience of *Uncharted 2: Among Thieves*.

experiences in multi-player. We ended up adding a new state within Drake's code — a 'traversal' state for our hero. This state evokes a more exploratory mindset, he's moving about more like an actual human would move when climbing or exploring. Once Drake enters combat, either by firing or being fired upon, there's a state change — his stance, his movements — everything becomes a bit more attuned to what's going on in the game. To the player, this feels like Drake is more aware of the environment, and communicates that there's a threat in the region." In a nutshell, adding multi-player had extraordinary and unexpected benefits for the single-player experience.

Focus on Actors

Many reviews point to the success of *Uncharted 2* in engaging players in the narrative arc of the game and providing an immersive experience in which players care about the characters — again, one of the core goals from the beginning of the project. Much has been made of the fact that Naughty Dog recorded voice-over and motion capture simultaneously — utilizing lava-liere microphones on actors wired up with motion capture suits — which lent an unprecedented realism to the cut scenes and in-game animations. To Straley, though, this cuts deeper than the technical process. He credits their overall approach to integrating actors into the creation of the game as a key success factor.

"When you watch a cut scene in *Uncharted 2*, it feels like the actors are playing off of each other, and it feels like there's a real relationship there, and that's because there is," Straley explains.

"The actors *are* their characters. We got the actors together for pre-shoots, where we basically worked on lines and let the specific actors help shape their own characters. Nolan North, the actor who plays Drake, brings his liveliness and his personality to the character. Nolan worked closely with Claudia Black, the actress who plays Chloe, throughout the course of development of the game. They were together in the pre-shoot, playing with dialogue, tweaking lines — and then when it came time to record actual dialogue for the game, they were in the same room, playing off of each other, shooting the scene just as if it were for a film. If there's a table in the cut scene, they are sitting there with a box in between them for the take. This 'realism' bubbles up through the entire game."

This may not seem like rocket science, but is actually fairly radical in terms of video game production, where traditionally voice-over recording is done last. Straley says, "It does seem like it was a pretty novel approach. And we are really happy with the way this aspect of *Uncharted 2* turned out: it feels real, and it feels like, as a player, I really know these characters. I know that traditionally games have taken a different approach — for instance, putting a programmer in a motion capture suit and having him act out to an actress's voice-overs, or having one actor come in to do their lines, and then their counterpart come in at a different time to do theirs. But I think it is crucial to look at character and relationships and to use actors for what they are good at: acting. We are game geeks. We're becoming better at this part of the process, but we're not excellent at it, so why not exploit the experts, and use actors to our advantage?"

Figure 5. Significant attention to integrating actors into the development process permeated *Uncharted 2* with an unprecedented, deep cinematic feel.

What Went Wrong
Production Got Ahead of Story

From the outset, Straley and his team knew that one challenge as they set out to make a playable blockbuster would be synchronizing story with gameplay. What plot points needed to be covered in each level? What gameplay mechanics did they want to feature by calling them out within the story? What would the epic set pieces need to accomplish on both fronts? In general, *Uncharted 2: Among Thieves* is a remarkable success on these terms – the game is hailed as perhaps the single best example of the integration of story into an interactive game experience. At the same time, this path exposed some pressure points, and it proved difficult to keep story and gameplay synchronized over the course of the entire project.

"In our approach," began Straley, "we don't use metrics that say every X number of minutes you need a break or a cut scene, or that this particular player experience should take Y number of seconds. This is more of a gut feeling as we're laying out the flow from level to level. Instead, we have these story beat goals for the level – either character-driven, such as relationship development goals, or plot-driven, like Drake needs to get somewhere specific to continue the story. It is imperative that these story beat goals are injected into the gameplay up front, otherwise it starts to feel like you're just playing a game – you get distant from the story. Well, one thing that happened was production got ahead of story – we produced a lot of gameplay content without story beats."

Specifically, Straley points to one sequence of the game that takes place in Tibet, where Drake is trying to retrieve Karl Schäfer, an ally who has been kidnapped and is being held in a monastery. It turns out that this was one of the first levels the team created, and it was used as a test bed and proof of concept, to help the development team understand just how they could implement combined traversal and gunplay, as well as more nuts-and-bolts issues of understanding the scope of what they were trying to build, if certain components could be outsourced, etc.

"The problem was we didn't have many story beats to work with when we started creating that level. And you think: 'This is just a test.' But we spent so many hours making the thing, you invest so much work in it and the gameplay mechanics start really hanging together and it becomes a solid chunk of fun. Suddenly we've got 45 minutes to an hour of cool gameplay, but not enough story beats to support that much time. And by then it's impossible to inject story beats; to change it would have a huge domino effect on production. Basically, we painted ourselves into a corner. We

did what we could — injecting small moments, like Drake joking around, or Elena saying, 'Oh, there he is' and pointing into the distance — kind of bread crumbing up to the plot point we did have — but there's just not enough core movement in the main story, and I worry about players going, 'Ok, how many more buildings do I have to climb here?' In the final game, while players might not necessarily be able to put their finger on the problem, I suspect this section of the game might feel a bit long, because there's so little story propping it up."

Eyes Too Big for Stomachs

It is not unusual to note that extremely successful video games started out with extremely ambitious goals. Taking on the idea of creating a 'playable summer blockbuster' provided a clear, concise goal for the entire *Uncharted 2: Among Thieves* team to rally around and work toward. At the same time, it provided ample opportunity to overcommit. "Our very first test of whether we could pull this off was to get one collapsing bridge sequence up and running in the game," recounts Straley. "The idea was to use this as a vertical slice to help us determine how much programmer and artist support we'd need and just how long everything would take. Well, it took a really, really long time and a lot of effort on the part of everyone involved. It should really have enlightened us on a lot of things, but we kind of chalked up the experience to the fact that we didn't have the right tools yet, it was our first time through the process and it would get easier, things along these lines. The next lesson came from putting together our demo for E3 in 2009. For the demo, we built a sequence inside a collapsing building, from which the player needs to escape, requiring movement controls and character physics to work in the middle of this collapsing building. Well, it took a large percentage of our entire team to focus 100% of their time for 2 to 3 months to get this sequence to a presentable point for E3. By this point, we were already pulling long hours, and we could already see that to get the game to the state of polish we all knew we were shooting for, we were in trouble. But we as gamers, not just individuals at Naughty Dog, felt that we needed to get these 'epic sequences' in. We've never seen anything like this in games before, and we wanted to play a game like the one we were making. So yeah, I'm willing to put in the hours, to sacrifice my body, heart, and soul to get this in the game. But it bit us in the end."

It's a common refrain among high-performing teams: when to say enough is enough? When is what you've set out to do too much, or, as Straley put it in the context of *Uncharted 2*, "How many collapsing buildings do we need to get the point across?"

Figure 6. Each and every epic sequence in *Uncharted 2* required fine-tuned scripting and enormous amounts of polish.

Essentially, the team stretched itself too thin. "We hit a crunch mode that was probably the longest, worst crunch in Naughty Dog history. We faced a daunting number of specialty 'one-offs' in order to do all these sequences, for example, when Drake is carrying Jeff, the wounded cameraman, we wanted Chloe scripted to appear ahead of them to motivate them forward, and there's a lot of effort required just for this task alone, to make it feel right to the player. Well, to do all these sequences — the train scenes, the convoy, collapsing buildings, the wounded cameraman — these all took a lot of TLC and fine-tuned scripting and polishing of all the details. It took a long, long time to get all of these things right. At the end of the day, when you add it all up it was simply too big of a game. It's freaking awesome! But, too big for our production schedule."

Allure of the Prototype

Clearly, the prototyping and iterating process paid extraordinary dividends in improvements to the overall player experience of *Uncharted 2*. Yet Straley spoke about a dark side to the prototyping process as well — namely, the team getting too attached to the results of their prototyping, and underestimating exactly what it would take to get these bits fleshed out and polished enough for the final game. "When in the 'block mesh' phase, everyone's working away without worrying about art or polish, and cranking together a piece of layout and gameplay in a couple of days. Take the convoy sequence — we thought it would be cool to see Drake jump from truck to truck; let's prototype it. A couple of days later the programmer had coded up a whole new mechanic. Well, the

problem is we were not considering what it was going to take to follow through with implementation and get it up to the level of polish needed to appear in the game. But it's awesome to play and people get attached to it and it becomes another one of those things we want to make happen, despite the sacrifices."

This is something that happened repeatedly during the development of the game, according to Straley. "There are many examples of this in *Uncharted 2* – another one is the sliding building in Shambhala, where a piece of a dilapidated building from an RPG hit slides down the mountainside with the player on it. We prototyped this up in a few days, and thought, 'This is going to be really cool.' When we finally got it into art, and true production, it became tenfold of what the prototype told us it would be."

This happened so frequently that the team came up with a name for this phenomenon. "We called this the 'siren allure of the prototype.' Three months into polishing and playing one of these new twists that had been a snap to prototype, we felt like we had drunk our own Kool-Aid, and knew we had become too attached to too many of these changes. Coming off of the *Uncharted 2* experience and looking at our next game, it's really, 'How many of these things can we truly do? Do we need to scale the scope back or do we need more people power?' We know these set pieces leave a huge impression on the player's experience, and we know we want them in the next game, but we need to look at the impact across several departments, and to try not to fool ourselves."

Domino Effect of Tightly Integrated Story

"We learned the hard way that getting story worked out early in the process is critical," Straley began. "When you have a solid story with a beginning, middle, and end it means that it's imperative that you have certain beats within the game's levels. If these beats are not communicated to the player, the integration falls apart."

Straley spoke earlier about production getting ahead of story; what's described here is the opposite problem, where story is out ahead of production. The difference, however, is that there is no alternative for production other than catching up. "If production is behind story and the story beats are laid out, you can't just delete some of them. The relationships depend on these beats, and they aren't going to develop well if you start cutting huge chunks of the game. If we decide to take out a level that contains a crucial story beat, there's a domino effect there. It will all start to feel like a poorly edited movie. This is one of the most difficult things, and I'm not sure what the answer is. The sooner you can

Figure 7. It was a challenge to keep story and gameplay synchronized through the course of development of *Uncharted 2.*

get the story ironed out, the sooner you can get the relationships of the characters worked out, the better you're going to be. But, as I mentioned earlier, we set a goal of tightly integrating story and gameplay mechanics, so they had to be, to some extent, created in parallel."

At the end of the day, while there isn't something specific here that Straley can point to as something to do differently the next time around, this did influence how he feels about the way things turned out in the end. "We did do a lot of cuts in order to get the game out the door. I think we have a great third act, but in terms of the time you spend in the third act as a player and the proportion of production time we spent on these areas, I can see that we really crammed things together a bit in certain areas.

"Likewise in Borneo, there are areas where we've got a bit too little gameplay, sandwiched between a few too many cutscenes. The downside to sticking so closely to the story beats means you're going to have to create some one-off code sometimes. This takes time away from your meat-and-potatoes core gameplay production time. So it's create a shorter story, create less one-off situations, or create smaller, 'less epic' core gameplay areas. I really don't have the silver bullet answer, though. It's just the nature of the beast — part and parcel of creating a tightly woven, story-driven game."

Blurred Line Between Alpha and Beta

In the 'What Went Right' section, Straley spoke to the underlying philosophy at Naughty Dog that it was never too late to make changes, if it was determined that the change would truly result in

improvements to the game. This was allowed to an extreme degree with *Uncharted 2*, with some grueling side effects. Again, this is a typical scenario among high-performing teams, and one where I'm not sure there are cut-and-dried rules to follow. Great games are the result of iteration and tons of attention and love, and sometimes that comes at the expense of the schedule, budget, or both.

"We allowed ourselves to make changes, due to playtest results, and by doing so we blurred the line between alpha, beta, and gold master," recounts Straley. "We were still changing things inside of beta. Our designers would look at our playtesting data, and think, 'We can make this better or smoother, if we just change this one thing.' Well, it's never just this one thing, and now a bunch of things need to be redone, and this pushed production so far back that it really put our audio and effects guys in a bind. They just didn't have the time that they deserved, and honestly that they themselves wanted to spend, to put beauty and polish and craftsmanship into their work. Basically, we gave them an impossible task, and there are gaps in the game like objects that don't have any audio on them at all that we, and more specifically our sound guys, aren't happy about. And this was not their fault — I think our audio is fantastic, but on a human level, they deserved to have more time for more polish. The same holds true for our particle effects guys. They were forced to reuse effects, and some objects have no particle effects whatsoever. And again, what they did accomplish is fantastic; I just know that they wanted it to be better. This one is on me — the decisions I made and allowed to be made caused these issues." The bottom line? "Make a deadline, and stick to the deadline, and that is that."

Figure 8. Concept art for Borneo, another location featured in *Uncharted 2: Among Thieves*.

Figure 9. Setting a new standard for immersive, story-driven video games, *Uncharted 2: Among Thieves* has been hailed as one of the greatest games of all time.

Wrap Up

Uncharted 2: Among Thieves set a new standard for story-based, action-adventure games. By all accounts, the team succeeded in the goal it had set before itself at the beginning of the project: create a playable summer blockbuster film. Several factors were crucial in enabling the team to achieve their goal, as outlined above, but the one that stands out is the novel approach and care given to integrating story and gameplay. I asked Straley to follow up on his earlier thoughts of what was different about the way Naughty Dog approached this aspect of making *Uncharted 2*.

"In talking with other developers, I sometimes got the sense that story is almost seen as an enemy to the gameplay team, which always seems strange to me," he related. "It's the sum of all of the parts that creates the experience for the player, and story is a key part of the picture. We really made staying attuned to story and the story needs our motto during development. What is happening right now in the game story-wise, how does it relate to gameplay, how does it instruct character development? It doesn't mean that gameplay is second to story; it just means that we respect what the story has to offer to the experience.

"I feel like *Uncharted 2* really showcases the benefits of these processes. Story is not your enemy; in fact I'd say the opposite — that working within the limitations of story can create great opportunities for gameplay. Likewise, if you have gameplay needs, try to work them into the universe your story is written in. Try to ground it in the story's reality. It's being attentive to the

combination of the two, story and gameplay, that will influence the overall experience you provide."

Clearly, *Uncharted 2* struck a nerve with gamers and critics alike; it is the whole package that hangs together as a truly great video game. "We are beyond our skulls exploding when we see each of these reviews or read comments and learn that people are appreciating our work to such an extent. The fact that anybody, anywhere, would consider *Uncharted 2* one of the best games ever — this makes your job 100% worth it."

Team Role Interview: Senior Environment Artist

Please introduce yourself and your current role in the games industry.

My name is Wade Mulhern, and I am currently a Senior Environment Artist with Microsoft at 343 Industries. Previously, I was Senior Environment Artist at Sony Computer Entertainment's Santa Monica Studio, where I worked on *God of War III*.

What was your path to becoming part of the *God of War* team at Sony Santa Monica?

My first job in the industry was as an Interface Designer/Artist for the now-defunct Austin-based games studio Digital Anvil. I had a bachelor's degree in design and I had a pretty good grasp of 3D Studio Max from a previous internship with a start-up game company. I also happened to know someone who knew the Art Director.

After two studio closures in 6 months, I was working with a recruiter and through him got a call from Sony Computer Entertainment of America (SCEA) to interview with the *God of War* team. I'm a big fan of the *God of War* series so I jumped at the chance. I flew out to Santa Monica, interviewed, and got the job.

Please describe the role of a Senior Environment Artist on a project like *God of War III*. Did you have a sense of the big picture? Was it clear to you how your contribution would be used in the final game?

Working in Maya, I modeled assets and did world building — creating the actual geometry of the spaces that the player moves around within — as well as optimization and lighting for several of the levels in *God of War III*. I didn't really have a sense of the larger picture other than knowing that my levels had to be as good as the levels that came before, in previous versions of the game. When you're working on a series as successful and well-regarded as *God of War*, that's plenty to worry about. Despite this, it was pretty clear how my work affected the final product. As an Environment Artist, your contributions usually take up 75% of the screen. It's pretty obvious if you did good or bad work.

This book is about making *great* games. How do you make sure, as an Environment Artist, that you're contributing to a great game?

It's all about team work. The fact of the matter is that I was only one of 12 Environment Artists, and one of around 120 people who worked on *God of War III*. All I can do as an individual to make sure the game is great is stay on schedule and make sure that my levels are up to the *God of War* standard (which is incredibly high). The biggest challenge on *God of War III* was the amount of work that had to be done and hitting the very high standards that had been established by the first two games. That sounds kind of boring, but it's true. Everyone on the team had a lot of work and responsibility, and if one person dropped the ball it had the potential to screw up a lot of things.

(Continued)

Team Role Interview: Senior Environment Artist—Cont'd

How does such a large team make sure that the look and quality of the levels remain consistent?

In the early stages of the project we didn't really know what the 'next-gen' *God of War* look was. Much of the early phase of development was spent figuring that out. After we started to get a strong idea of the look we were going for, we had pretty regular level reviews to make sure that everything was consistent and up to snuff. We had an Art Director and an Environment Lead keeping an eye on things to make sure that everyone was producing work that had the *God of War* look we had settled on. Toward the end when everyone had been working on the game for at least a year or so, people just kind of naturally knew how things needed to look and what needed to be done to hit the proper level of quality.

What were the most and least satisfying aspects of working on *God of War III*?

In terms of least satisfying, the labor to gameplay time ratio was at times frustrating. Frequently a level that took 4 months to make could be played through in three or four minutes. To be honest, it was so much work getting the game out the door that there weren't that many satisfying moments until after the game was done. After I was able to decompress and get a better perspective on things I was able to take a lot of satisfaction in the final product. Playing through my own levels in the comfort of my own home was a nice experience. I was able to see my levels through a gamer's eyes. Getting high ratings and selling lots of copies was certainly nice as well.

Every studio and team sets out to make great games. What, to your mind, allowed *God of War III* to rise above the fray?

There are a few key factors that contributed to the success of *God of War III*. First of all, the original *God of War* team created a great game which gave the successive games a really strong base to work from. The team at Sony Santa Monica is super talented and super dedicated to making AAA games. Finally, Sony Computer Entertainment, our parent company, was willing to give the folks at Sony Santa Monica the time and the resources we needed to make awesome games. If any one of those things had been missing, *God of War III* might have turned out very differently.

ROCK BAND

Rock Band represents the culmination of a long evolution of rhythm/music titles from Boston, Massachusetts-based developer Harmonix Music Systems. Prior to *Rock Band*, Harmonix had created a number of popular music games including *Frequency*, *Amplitude*, the *Karaoke Revolution* series, and, of course, the incredibly successful *Guitar Hero* series. Released in late 2007, shortly after Harmonix was acquired by MTV Games, *Rock Band* was an unequivocal commercial and critical success. The series has sold over 13 million copies to date, netting over $1 billion in revenues. Over 1000 songs are available for purchase through the game's online library of tracks, and the *Rock Band Network* allows bands and labels to publish and sell their own *Rock Band* tracks.

I had a chance to discuss the creation of the original *Rock Band* with Harmonix Music Systems Vice President of Product Development, Greg LoPiccolo. LoPiccolo began by describing the origins of the game: "We had been thinking of doing a band game for years, so *Rock Band* was a natural evolution for us. We had tried various approaches to creating a music performance simulation, but until *Guitar Hero* it didn't really take off. The conceptual breakthrough with *Guitar Hero* was that we realized we needed a guitar to complete the illusion. When that succeeded commercially, it became apparent that there was an opening to pursue this approach — using instruments to simulate a full band experience."

Guitar Hero was fantastic, and incredibly successful, but they wanted to do more. The team at Harmonix was chock full of musicians, and they longed to capture the essence of the communal experience of making music in a room with other people — they saw the *Rock Band* dynamic as a cultural as well as social experience. "The *Guitar Hero* experience was essentially a solo experience — but that wasn't our experience. Ours was an ensemble experience. We have tons and tons of musicians in our company, and we had all derived meaning and benefit from the communal, collaborative experience of being in bands, making music together. So, we had two big hurdles for *Rock Band*: (1)

Making Great Games. DOI: 10.1016/B978-0-240-81285-4.10006-6

Figure 1. With *Rock Band*, Harmonix set out to tap into the communal, collaborative experience of playing in a band.

build the gameplay, and build the peripherals, and then (2) build awareness of other people in the room, to fill out that experience of playing with folks."

Rock Band accomplished this beautifully, and in the process revolutionized the genre of rhythm-music games.

Data Points
Developer: Harmonix Music Systems
Publisher: MTV Games
Release date: November 20, 2007
Release platform(s): Xbox 360 and PlayStation 3
Development engine(s) used: Proprietary
Game development timeline: 2 years
Development team size: 100+
Development budget: $200 million
Awards, honors, sales thresholds, etc.: 'Best of E3 2007' awards for 'Best of Show,' 'Best Hardware/Peripheral,' and 'Best Social/Casual/Puzzle'; 1UP.com's 'Best of E3'; and GameSpot's 'Best Stage Demo' and 'Best Xbox 360 Game'; seven of IGN's 'Best of 2007' awards, including 'Best Music Game' and 'Best Local Multiplayer Game'; GameTap called *Rock Band* the 'Best Rhythm Game of All Time'

What Went Right
Prototyped the Drum Game Early

Rock Band lead designer Rob Kay wrote a postmortem for the May 2008 issue of *Game Developer Magazine*. In it, he said, "We got the drumming game up and running before doing anything

else. This afforded us time to understand the unique hardware needs, interface challenges, and learning ramp inherent in learning to play the drums. The $1200 Roland V-Drums we picked up at a local music store were easy to reconfigure, so we played around with different pad configurations and settled on four pads and a kick pedal. Our programmers wrote some code to connect this to our PC-based prototype drum game. We gave the setup its own room, and encouraged people around the company to come play it and let us know what they thought.

"This combination hardware and software prototype taught us a great deal. Crucially, it revealed an interesting drum-centric problem with our proven Harmonix 3D interface. Our usual row of note lanes (as seen in *Frequency*, *Amplitude*, and *Guitar Hero*) worked fine for the drum pads but failed spectacularly on the kick drum pedal. The spatial organization of notes on screen didn't match the spatial relationship of the pads and pedal. This made readability of note patterns exceptionally tricky. Through a combination of theorizing and experimentation we arrived at the solution seen in the shipping game — an orange line stretching across the whole track. Perhaps the greatest discovery of this drum prototype was simply how fun it was to play. It really captured the feel and power of real drumming, which gave us a huge confidence boost."

The drum game is one specific example, but prototyping played a critical role in the success of *Rock Band*, according to LoPiccolo. Speaking more generally, he highlighted the importance of rapid prototyping in fleshing out new features for the game. "For us, tech is being developed on the ground in collaboration with the concept," LoPiccolo explained. "There's really

Figure 2. Harmonix put a lot of early design focus on the drums in *Rock Band*. Extensive experimentation and iteration helped the team meet the UI challenges, specifically how to effectively represent the kick drum 'notes' in the game.

very little daylight between concept and execution. We have a big mature code base of rhythm-action components that can serve as a great starting point for new features we want to invent. This can apply to brand new features as well, utilizing fresh prototyping — a bunch of us just diving into a new initiative to get a proof of concept running."

Clearly, Harmonix benefited greatly in having a solid code base in place from which to branch out, and using this code as a starting point to prototype extensively and early in the production cycle.

Developed the Hardware and Software Together

"We began *Rock Band* as a software developer, but decided to take on the task of creating the hardware ourselves," Kay explained. "Designing the controllers from scratch, and starting up a major manufacturing effort in under a year to make them was an enormous undertaking with a considerable learning curve. The payoff, though, was more than worth it. For a game like *Rock Band*, the hardware is at least as important as the software, if not more. We were able to design and develop the hardware and software together, taking full control over the user experience."

As Kay mentioned above, they attacked the drums first. "The drum game prototyping we'd done was critical in communicating a clear brief to our industrial designer. We'd already proved that the basic form factor (four pads and a kick pedal) was successful with our stripped down electric drum kit, so the big challenge became infusing as much of that experience as we could in a video game controller that would cost a fraction of the price. The guitar controller was less blue sky, and development started after we had the basics of the drum controller down.

Hardware was a brave new world to us. Throughout the whole 1-month project cycle, we made mistakes but tried to focus on understanding the critical decisions and making the right calls. In April 2007 we begin tooling for both drums and guitar (cutting the steel molds that shape the plastic parts). The molds take about 8 weeks to complete, then you have at least another 4 weeks of pre-production and tuning. In September 2007 our first containers left the China warehouse. By January 2008, over two million *Rock Band* bundles had shipped."

Modified Cabal Implementation to Capture the Feeling of Playing in a Band

As LoPiccolo explained, capturing the essence of playing in a band was one of the central design goals of the project. Kay pointed to their success on this front: "The biggest design

challenge for *Rock Band*'s gameplay became all too obvious the moment we got our first version of a four-player game up and running. At this embryonic stage the 'cooperative' gameplay was simply four otherwise independent games running in parallel. It was not a stellar group experience. Obviously, something key was missing — player interaction! There was no reason to care how other players were doing, let alone any of the interactions musicians in a real band might recognize. This cooperative multi-player game mode was to be *Rock Band*'s reason for being, so it had to become amazing."

LoPiccolo laid out how Harmonix approached this challenge tactically: "We had a small, multidisciplinary team, and we bashed the hell out of the game. We organically built out our own process, inspired by Valve's well-publicized cabal methods. We're great admirers of Valve's process and full of respect for their team and their great games, so we basically lifted their process and modified it for our own use. Of course, it evolved into something a bit different here — I'd call it a mutant variant of Valve's cabal process — but we focused on the process here as a forum for senior people to step in on a regular basis to evaluate the progress being made in the game. Both a positive and a negative here at Harmonix is that a lot of useful design insights and inspiration flow from senior people who don't have enough time to stay focused on development. We built a channel to incorporate and capture their feedback and bring it into our development process."

Kay also referenced the cabal implementation at Harmonix: "This group identified some experiential goals for the gameplay team to go after. The experiential goals were 'togetherness' and 'distinct roles.' The gameplay team (three game coders, two UI artists, the audio lead, and myself [Rob Kay]) experimented for many months with gameplay mechanics and UI that met these goals. We were scheduled loosely with 3 days a week set aside for iteration time. Each week we'd meet with the cabal and review progress, which gave us enough freedom to react quickly and experiment, but also enough direction to stop us veering off course. We experimented with many scoring systems and gameplay mechanics to try and meet the high-level goals. The whole company played this evolving game, giving their feedback and ideas, which fed into the process on numerous occasions."

"Many experiments were failures but taught us something valuable," continues Kay. "Some worked well with four players, but fell apart with two or three. Some were diamonds in the rough, which we kept and revised and eventually honed into a cohesive whole. This was the process that birthed all of the unique *Rock Band* gameplay including individual fail outs, saving fallen bandmates, Unison Bonuses, Bass Groove, Guitar Solos,

Figure 3. Capturing the essence of playing in a band was critical to the success of *Rock Band*.

Drum Fills, and Big Rock Endings. Together these features formed the 'band' in *Rock Band.*"

Embraced 'Authenticity' as a Guiding Principle

Kay spoke about the key vision point of 'authenticity' as a driving principle during *Rock Band*'s development. "Very early on we knew our songs would encompass all forms of rock music, and that players would be choosing their own look in the character creator. We needed a way to approach the visual presentation that was generic enough to host any subgenre of rock, and yet still offer a distinctive look and feel."

"We focused on an authentic recreation of traditional rock and roll, with serious attention to detail and high production values. Character animation was motion captured from performing musicians who played in bands of a particular subgenre rather than actors (e.g., we got punk rockers to do the punk rock motion capture). Clothing was labored over, with shops representing each subgenre. Instruments were recreations of the real thing. The camera work and post-processing was tailored to present the live show through the lens of a music video. The lighting mimicked real rock show lighting as closely as possible. We even went so far as to create a custom animation system for the drummer so that every single drum hit is realistically played on the right drum or cymbal.

"The litmus test 'Is it authentic?' began as an art direction, but quickly spread project wide. 'Authenticity' became a buzzword in not only art reviews, but also design, hardware, music, and writing discussions. The music had to be authentic, so we secured

as many master tracks as possible. The guitar hardware had to be authentic, so we worked with Fender to create a replica of their iconic Stratocaster guitar. It spread through our collective conscience; everyone heard the 'authenticity' mantra and got behind it, unifying the overall presentation and vibe of the game."

'Authenticity' became the clear, concise vision consensus that allowed the entire team to rally behind and move toward a common goal.

Figure 4. Authenticity, in everything from clothing to character animations to the instruments, is one of the hallmarks of the *Rock Band* series of games.

Made Good Early Calls on Networking Tech

LoPiccolo and Kay both pointed to some solid early technical calls as key success factors in the development of *Rock Band*.

Kay spoke about the decision to use the networking and matchmaking middleware Quazal. "This decision had to be made far earlier than when our network features were fully designed. As it turned out, the flexibility afforded by Quazal far outweighed the additional complexity of integrating another middleware provider. We came out with an awesome feature set that was custom crafted for our game, including head-to-head battles, online band play, a flexible leaderboard system that can hold thousands of boards, and persistent band data storage. We were also able to create a common code base for both PlayStation 3 and Xbox 360, which helped reduce development time and kept platform differences to a minimum."

"We also decided to conduct extensive network bot testing for our online solution before release. We spent months developing a tool that simulates realistic network traffic and user behaviors. We rented time on a huge supercomputer system with a 2-gigabit

Internet connection and proceeded to attack the servers with complex scenarios simulating over 100,000 concurrent users. These tests uncovered piles of bugs and helped us make tons of client and server optimizations. The result: when we went live, everything worked! We had hardly a hitch and things continued to run smoothly, even into Christmas Day (which saw the largest number of simultaneous users online to date)."

What Went Wrong

Didn't Go to China Early Enough

"With 20/20 hindsight, we clearly should have made an effort much earlier in our cycle to understand our hardware manufacturing partners," began Kay. "It is so critical that all the people building your game have a true understanding of that game, of the people who will be playing the game, and of the initial design intent of every feature. Good hardware specs are incredibly important but they only go so far, especially in areas involving the subtleties of feel. Also, the language and time difference (China is a full 12 hours ahead of us) need to be considered when dealing with Asian manufacturing. In the early stages of our development, we sent just our industrial designer and our manufacturing agent to China to represent Harmonix. It became clear that we had to have people on the ground there. From June through September, we had a team there basically full-time and that was a critical part of our success. Had we had people there earlier, we wouldn't have needed the intensive 3-month grind that it took to get our drums and guitars on boats."

I asked LoPiccolo to explore this misstep a bit further. "This issue was very specific to our circumstances. We didn't know how to design and build hardware, and had to learn on the job. Hardware product development is highly evolved — it's like a parallel but entirely different universe than software development. Who writes the micro-code, who does industrial design, who sets the price point, do we need an entire engineering staff at a Chinese factory, who does CAD drawings? The list goes on and on, and we weren't prepared for all that was entailed in this part of the process. We definitely learned the hard way just how important it is to have a mock-up of an item as soon as possible, because as soon as you can put your hands on it you discover all kinds of things you just hadn't thought about."

Dealing with hardware, and dealing with China, introduced a healthy dose of unknowns and uncertainty. "We underestimated how logistically complicated it is to get hardware functioning in the game — how many more steps there are in the chain to make it all work together," continued LoPiccolo. "For

hardware, there's a whole parts-ordering process, with different lead times, cost of goods bouncing around, materials testing, radio interference testing, and on and on. Chips need their own testing as well, so at one point we found ourselves buying a bunch of machines from Denmark and shipping them to China. We were also dealing with different rules and obviously a different culture in China. We had to learn what everything really meant, and it took a while to get this entire process dialed in."

Figure 5. *Rock Band* players can purchase new songs for the game on a track-by-track basis. Harmonix currently has over 1000 downloadable, add-on tracks in the online library, with new songs added regularly.

Didn't Hire Aggressively Enough

"This was a key, fundamental misjudgment," began LoPiccolo. "Of course, ideally your full team is fleshed out at beginning of the project. But that wasn't the case with *Rock Band*, and we assumed that you couldn't just plug people in like widgets. So when March and April rolled around, and we knew we were understaffed, we felt that it wouldn't make sense to just add people because we had a complicated code base, which would take time for new engineers to familiarize themselves with, and so on. Well, if the stakes are high enough, you actually can integrate people in 3 days. We knew that we had to be in stores by Christmas to have a successful launch. We simply could not miss this deadline, so we brought people on quickly and yes, we had lots of people working crazy hours. Then suddenly we were doing things that we never would have done 3 months prior. So much of *Rock Band* was unprecedented — such a stretch on so many levels — that it just took us in too many directions. We spent 80% of the planned resources on the first 80% of project, and then another 80% on the last 20% of

the project! The magnitude of some of the challenges was simply not apparent to us."

Kay concurs in his postmortem piece: "From the outset it was clear this was the biggest game we'd ever made. The inherent scope of the project, essentially four games in one, was such that it couldn't be significantly scaled back. For competitive reasons, missing our launch wasn't an option either. The only way to complete the title on time was to grow the team. We put most of our staff onto the game, and expanded the organization to new levels. Our offices were bursting at the seams. With staff spread across three floors, and no room left for the new hires we needed to finish the game, we bit the bullet and moved the entire company to a larger space midway through alpha. Despite all of this, we still didn't hire aggressively enough. Many years making small, tightly focused games had ingrained an efficiency bias and 'smaller is better' mentality that was hard to shake. We were afraid of the additional management required to hire more people, and it resulted in a longer, harder crunch for all of us. We would have made our lives much easier, though, if we'd made those hires months earlier."

Figure 6. Motion capture of working musicians helped efforts to keep sharp focus on authenticity in the game.

Lack of Senior Bandwidth

Kay wrote of the strains such a large project put on the senior management team at Harmonix. "This beast of a game ate up senior bandwidth like no other we'd worked on. We assembled a huge team of leads and sub-leads. Every Monday morning we'd meet and fill a large conference room. This senior powerhouse drove the game forward, but was seriously overworked. Our own

internal postmortem revealed that in too many cases these people, who included senior management, had been doing the job of two people. Each lead was so busy working with their team to keep their goals on track, that collectively we just didn't make enough time to assess the bigger picture."

This is one of those good problems to have — the team was so successful with earlier projects that they were afforded an opportunity to stretch themselves and work on a larger project. Kay continues: "Our senior figures and team leads often provide the best design insights, and have been instrumental in crafting our earlier games. They can only do this, though, if they're playing the game regularly, and because of the huge demands on their time this was a real challenge. We plugged them into weekly play sessions, and numerous internal playtests to gain their design insights, but still big swaths of the game didn't get the relentless internal examination they deserved. I'm not convinced that many people outside of QA played some of the less mainline game modes like Bass Guitar Tug of War, or online Vocal Score Duel, for example. They just didn't have the time."

LoPiccolo agrees with Kay on this 100%. "We struggle with this consistently — we derive a lot of benefit from keeping senior folks directly engaged, instead of kicking them upstairs. But we're a 250-person company now, and it's hard to have the vision holders guide both the company and the vision of product at the same time. We've gotten much better over the last several years, with much more extensive use of the multidisciplinary strike teams we spoke of earlier, and with giving them lots of autonomy for making creative decisions and clearing the way in terms of complicated approval chains and the like — but this is still something we struggle with on a fairly consistent basis."

Struggled to Deal with Multiple Unique Controllers

"We knew going into *Rock Band* development that one of the challenges we'd have to overcome would be getting three different controller experiences working in one game," Kay said. "But we underestimated how entrenched the single-controller type mind-set is with console manufacturers and certification, and how much that would impact our own plans for shell flow and online play.

"The concepts of an 'active controller' and 'profiles attached to controllers' work great when you have one type of controller that you want a player to stick with, but work horribly when you have multiple profiles signed in to multiple controllers that have different functions (like a drum kit, guitar, and microphone). Since there's no need to swap controller types in most games to be able to play all areas of the game, there is no functionality on the system level to swap profiles between controllers, or to allow

one controller to use another profile's data. Systems like online matchmaking and invites complicate this even more — inviting is simple on a single controller, but on a multi-peripheral game it raises issues like 'What if there is already a drum player in the session?' and 'What if I want to play guitar, but my vocal controller is signed in? Can I sign out and sign in without leaving the session?'

"For months we struggled to reconcile our multiple-controller types reality with first-party certification requirements and system architecture designed for 'one controller type at a time' games. As we engaged in the technical and certification challenges with these systems, all essential to solve, it left very little time to properly test and refine usability. We ended up releasing something that functioned and passed certification, but it could certainly have been friendlier."

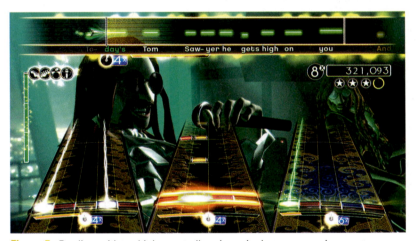

Figure 7. Dealing with multiple controllers in a single game session was a new twist, and threw a major loop into the certification process that all console games must pass with the console manufacturers.

Didn't Do Enough Tech Design

Kay spoke to another downside of a once-smaller team attacking a much larger project — assuming too much mutual understanding, and underestimating the need for documentation. "Historically, we've managed without much formal technical design documentation. This approach, or rather lack of it, probably sufficed in the past because our programmers were actually superstar designer–programmer hybrids who considered both technical and design impact as a matter of course.

"Expanding our code department for *Rock Band* meant bringing in new programmers who were very talented but weren't all designer–programmer hybrids, or if they were, didn't know

they were allowed to be. Too often we jumped headlong into implementation of a new system without taking the time to properly examine the implications or test the edge cases of the design. This bit us in a few areas, notably online matchmaking, which had to be redesigned multiple times."

Kay reflected on this shortcoming and spoke to some changes that have since been implemented at Harmonix: "No doubt about it, jumping into development of complex new systems without a technical plan up front was a flat-out mistake. We've now formalized our design process to include code review and a technical design document before implementation of a new system begins."

Figure 8. The Harmonix team's passion for music and the experience of playing in a band shine through the entire *Rock Band* experience.

Wrap Up

I asked LoPiccolo if any key learnings were currently being used at Harmonix as they work on *Rock Band 3* and other projects. "We are working on some very ambitious features for *Rock Band 3*, and they are going great with limited senior oversight. Essentially, we have fully embraced the modified cabal model, and have empowered our teams to take ownership and be empowered to make decisions."

LoPiccolo and the rest of the Harmonix team have worked hard on their corporate culture as well. "We've developed, and are continuing to develop, a culture where people trust each other, and cut each other slack. Look, it is hard to do this stuff, and it only works if people feel a sense of trust, where they feel like they can take risks and not get their feet cut out from under them." The other important piece of the puzzle, according to LoPiccolo, is

enthusiasm for the subject. "It's a cliché, perhaps, but one of the key things we keep circling back to again and again is our passion for the material. I think we'd be a pretty mediocre shooter developer. Music is what we care about and what we're passionate about here." Their passion for the material certainly shines through *Rock Band*.

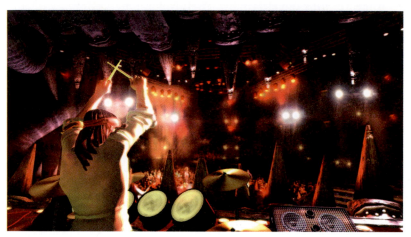

Figure 9. *Rock Band* garnered multiple awards upon its release in 2007, including IGN's "Best Music Game" and "Best Local Multiplayer Game."

Team Role Interview: Music Composer

Please introduce yourself, your role, and the game team(s) that you have been a part of.

I am Peter McConnell and I've been a Composer for games since the early 1990s. I most recently worked on *Brutal Legend* (Electronic Arts, 2009). Over the years I've scored numerous titles from LucasArts, Sony, Electronic Arts, and others including *Psychonauts* (Majesco, 2005), *Sly II: Band of Thieves* (Sony, 2004), *Sly III* (Sony, 2005), as well as the score and CD soundtrack for LucasArts' *Grim Fandango*. I worked in-house at LucasArts until 2000 when I went independent.

How did you get your start in the games industry?

Years ago Michael Land, who was running the sound department at LucasArts, needed someone who could both compose and program audio, and in those days there weren't a lot of folks who did both. He had known me and my work from college and the audio company Lexicon, where we had both worked as engineers. He passed my music demo and programming resume around at LucasArts, and it turned out to be a fit. That was a really lucky break. Over the years my focus shifted to doing just music. While at LucasArts I scored two or three games for Tim Schafer and we developed a working relationship which has continued ever since. So I was called in by Tim and his team to score *Brutal Legend*.

Did you have a sense of the larger picture with *Brutal Legend*? Was it clear to you how your contribution would be used in the final product?

Very much so. Although I was outside the company, I had superb guidance from Tim's music director, Emily Ridgway. She made each dramatic situation clear, made sure I got the assets I needed, and also provided stylistic guidance for the score.

What can the Composer do to ensure that the game you are working on is great? What is your part of the process, and how do you make sure that you're contributing to a great game?

Well, first you have to start with a great idea, a great concept. That's upstream from me, and there's not much I can do about that part. But beyond the conception there's an element that applies to everyone involved, and that is knowing how to allocate your resources. You've got to know what to really sink extra time, money, and effort into so that it will shine. And also what not to give too much attention to — that's almost as important. It's kind of like that Kenny Rogers song, "The Gambler": you've got to deal with your limitations, and every project has them. Games, great and not so great, are made in the real world, and I have seen projects fail to realize their full potential because people got mired in the details. My part of that picture is to be sure that the highest quality score gets made with the resources available. Beyond the creative aspects of composition, a big part of this is deciding what gets recorded by live musicians and when, how, and with whom that happens.

What was the most satisfying aspect of working on *Brutal Legend*?

We recorded a 36-piece orchestra for the underscore of the game at George Lucas' Skywalker Ranch. This was a great example of putting substantial time, money, and resources into an aspect of the game that really ended up making a difference in quality.

Did you feel like you were able to contribute specific ideas to the game?

Since the game was focused on music, yes, absolutely. One of the strengths of that particular team is that it plays to the strengths of individual members by inviting creative contributions at all times. Then the Project Leader has the final say so that things don't get too chaotic.

(Continued)

Team Role Interview: Music Composer—Cont'd

Could you highlight a few key areas of success during your period of involvement with *Brutal Legend*?

The process of choosing what to record live and then recording and mixing the music went very smoothly from orchestration and session prep to final mix. Orchestration — this I did myself (often Composer and Orchestrator are different people), saving the project money and getting me the exact sound I wanted. Session prep — which piece to record when — was planned in advance down to the minute, which made the session very efficient and successful. We did an unusually large amount of music in one session. Mixing — this I did with someone who is an expert at mixing the type of music I was doing, again spending a little extra money where it could really make a difference.

On the other side of that coin, any mistakes or missteps?

The biggest misstep was not preparing for live recording by booking the orchestra recording session long enough in advance, so that the sessions had to happen during the time usually reserved for polishing the content. That made things hard on everyone, particularly the internal audio team.

Any parting thoughts?

I'm only really qualified to talk in detail about the sound and music. But I can say one thing from doing this for 20 years or so that applies to most everyone involved in a game project: focus on what you do really, really well. And if you don't do something really, really well, be sure you are working with people who do.

FARMVILLE

FarmVille is nothing short of a phenomenon. Estimates have suggested that greater than 1% of the population of the entire world are playing *FarmVille*. Essentially a stripped-down, real-time farm simulation game, *FarmVille* was created by the San Francisco, California-based social games developer and publisher Zynga, and launched in June 2009 as an application on the social networking website Facebook. Microsoft's MSN Games launched *FarmVille* on its own site on February 4, 2010. As of this writing (spring 2010), more than 20% of all Facebook users play *Farm-Ville*, making it the most popular application on the service, with over 88 million monthly active users. The Facebook *FarmVille* fan page boasts over 22 million fans.

In *FarmVille*, players manage a virtual farm by planting, growing, and harvesting virtual crops and other plants and raising livestock. After creating an avatar, players receive a basic plot of land on which they can begin planting their crops. Various crops have varying costs as well as growth times, which take place in real time. If not harvested when ripe, crops will be ruined, a mechanism that entices players to regularly visit and tend their farms. Players work to amass virtual currency, which they can use to buy more land, seeds, livestock, and a host of decorative elements for their farms. Players also earn bragging rights through the accumulation of ribbons earned for various achievements in the game.

I had an opportunity to sit down with Mark Skaggs, Vice President of Product Development for Zynga and Creative Director on *FarmVille*, to chat about what worked well and what learnings he and his team gleaned from the process of creating Facebook's most popular application. "Our original idea was to make a real time strategy (RTS) game for Facebook," recalls Skaggs. "But after spending about a month exploring the idea, we realized that the Flash development platform couldn't support all of the things we wanted to do. We knew we had to simplify our goals, and then it occurred to us that we could simply focus on the first part of a traditional RTS game — the resource accumulation and management aspects. That's how we arrived at the idea of doing a farm game. When we saw some other farm games out there that people were playing pretty regularly, we knew there

Figure 1. *FarmVille* allows players to tend and grow crops on their own plot of land — eventually raising livestock and harvesting trees in addition to their basic crops.

were at least some players enjoying this kind of thing. So, we set out to make the best farm game that we could make."

Data Points

Developer: Zynga
Publisher: Zynga
Release date: June 19, 2009
Release platform(s): Facebook
Development engine(s) used: Flash, *YoVille* Avatar Creator, Zynga internal statistics server, internal monetization page, etc.
Game development timeline: ~ 6 months to initial launch; ongoing with updates and refinements
Development team size: 10 (on core team)
Development budget: $40 million
Awards, honors, sales thresholds, etc.: *FarmVille* has garnered multiple significant awards, including 2010 Game Developer's Conference Best New Social/Online Game Award; Academy of Interactive Arts and Sciences Social Game of the Year Award; DICE summit's Social Networking Game of the Year Award
Through *FarmVille*, and special virtual crop sales designated for this purpose, Zynga was one of the largest contributors to earthquake relief in Haiti, contributing more than $2 million to this particular cause.

What Went Right
Small, Experienced Team

Skaggs points to the small, highly skilled, and highly focused team that Zynga put together as a key success factor in

creating *FarmVille*. "We basically acquired a team to work on *FarmVille* with us. In doing so, we got not only a great team of talented individuals and all their experience, but also the technology base to work from." Zynga acquired a company called MyMiniLife, who had been working on a decorate-your-house type simulation for another social network. "At the time, there simply weren't that many people with social games experience. With their code base and their talent, we were able to really hit the ground running and be super-efficient with a relatively small team."

Keeping their team small allowed Zynga to take advantage of something almost opposite to an economy of scale — it felt like scaling down enabled the team to tighten feedback loops and keep the entire process hyper-efficient. "*FarmVille* was actually a lot smaller than some of the typical products many of our team had worked on, so we could take advantage of that smaller size with our shared knowledge of the game development process. One small team, with one simple goal: make the best farm game we could. Because everyone had games experience, we could speak in a kind of shorthand with each other and get stuff done quickly."

Keeping the core development team small allowed them to alleviate, or avoid altogether, some of the issues that we have learned about plaguing larger teams. This stands to reason, as many of the core issues boil down to breakdowns in communication, and with a smaller team, effective communication is naturally much easier.

As Little Reinvention as Possible

Another successful practice that increased efficiency for the *FarmVille* team was the mantra to not reinvent any wheels as they built out the game. "We had multiple teams working on multiple titles at our company, and we simply grabbed pieces of code from other teams in the interest of shipping the game quickly," began Skaggs. "For example, our avatar creator was borrowed from *YoVille*. We've got pieces from the *Mafia Wars* team, the *Poker* team. Behind the scenes, a lot of the server code — transaction infrastructure, those kinds of technologies — we were able to leverage from other teams as well."

By taking advantage of working code bases that handled both player-facing and 'behind-the-scenes' aspects of the social application, the *FarmVille* team was able to save a lot of time, and a lot of headaches, in bringing their game to market. "Basically, if something worked that did what we wanted or needed to do, we used it. Doing this allowed us to build and ship the game as quickly as we did."

Figure 2. The *FarmVille* team leaned into and used other Zynga technologies, such as the Avatar generation engine from *YoVille*, in an effort to streamline their production process.

Great Art

"*FarmVille* turned out to be just a gorgeous game," Skaggs told me. "I think this is one of the things that went really well for us. We had a fantastic Art Director, Craig Woida, who came out of the traditional game business. Also, we had established a pretty clear vision for the art style of the game — fast and breezy — and having such a strong, clear visual style in mind for the game from the beginning made the entire process easier. The convergence of us knowing exactly what we were looking for style-wise, and finding Craig, an artist who could create that style, as well as lead a team to create that style, was a big win for the game and the way it ultimately came out."

Figure 3. *FarmVille* offers a unified, compelling visual style, described as "fast and breezy." This style was established early in the game's development cycle.

Putting the right team together is always the goal, and luck is an important component whenever you wind up with a team that really comes together and gels. Skaggs agrees that luck was a factor, but also feels that their focus on bringing on the right people made a big difference in the assembly of the *FarmVille* team. "We were fortunate across the board, and made some really smart hires in some key positions."

Tapped into Entire Company

"The core team for *FarmVille* was only 10 people," explains Skaggs. "But people from all over the company helped us and contributed to the game becoming such a great title. The whole company was behind getting it done well." Aside from sharing technology, Skaggs and the team made a point to reach out and include perspectives from across the entire organization. They had folks from across the entire company play builds, soliciting ideas and feedback from everywhere they could. "We got some great ideas from unlikely sources, and having so many different people pounding on what we were doing allowed us to keep improving the quality of the experience."

This success factor assumes, of course, that testing was given a high priority during the game's development cycle and that the team utilized testing feedback to help course correct and fine-tune the player experience. For informal testing, by looking outside of the core team and tapping into the entire company, the *FarmVille* team was able to greatly expand their 'test bed,' and the overall quality of their game benefitted from this approach.

Launched on the Amazon Cloud

Another decision that proved critical to *FarmVille*'s success, especially early on, was to serve the application utilizing Amazon's Cloud, instead of Zynga deciding to buy and staff their own servers. "All Zynga products have launched on the Amazon Cloud," relates Skaggs. "Basically we're renting instead of buying boxes ourselves. What this allows us to do, though, is to scale and ramp up to meet demand almost painlessly."

Skaggs told me the story of *FarmVille*'s initial launch to illustrate this point. "Our plan was to do a 'soft launch' on Friday, June 16, 2009. We just thought, OK, let's turn it on. Just for families and friends — in fact we called it 'family and friends weekend.' We, the team, had made an internal bet to see if we could get 2500 players by the end of the first 24 hours. Well, in actuality we wound up with 25,000. On the next day, we had over 100,000 players. Day 3, we saw 500,000 players and on day 4 we crossed the 1,000,000 player threshold — all this with no

announcement, no cross-promotion in our other games, no advertising, no nothing.

"It took us a while to grasp just how successful the game was, even after this incredible launch. I guess we had all seen Internet phenomena that experienced explosive growth and then petered out just as quickly." Eventually, the game's success pushed the boundaries even of Amazon's Cloud. "Fortunately, Bing Gordon, a games industry luminary who happens to be one of our investors, was able to contact Amazon CEO Jeff Bezos and pull some strings for us," remembers Skaggs, "so they were able to pull in additional resources and keep us afloat."

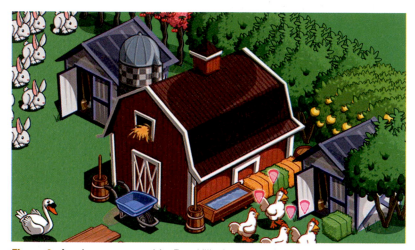

Figure 4. As players succeed in *FarmVille* they can take advantage of new opportunities in the game, including the ability to collaborate with Facebook friends to raise a barn on their plot of land.

What Went Wrong
Not Staffed Well for Success

"This is one of those great problems to have," Skaggs said with a chuckle. "But when the player numbers started exploding — and kept exploding — we had to scramble across Zynga to try to keep up with the game. We had to hire a bunch of people quickly, many within the core team, but also in customer service, server techs, you name it. We had to really staff up in order to keep up with the demands of the game and also feature flow."

Unlike more traditional game launches, social games are the gifts that keep on giving. New players continue to flock to the game, but current players also expect to expand their experience and discover new things as they continue to play. It can be a mad dash to try to keep up. "We had to initiate so many people so

quickly into the Zynga culture. We also needed external help — for example, we eventually got a technical team in India looking after our servers so the American team could get some sleep at night. Looking back, it is clear we weren't ready for our own level of success, but then again, how do you predict that kind of thing?"

Ongoing Leveling Curve Issues

The leveling curve in *FarmVille* did not work out as well as Skaggs and his team would have liked. "With an RPG or RTS game, moving up from level to level is such a key part of the player experience, and getting that balance right is so important. At the same time, it's a different balance in the social games space — it's not exactly head-to-head competition, and also a very different type of player profile. As you level up in *FarmVille*, you unlock new crops and buildings, and these are important to motivating players to continue, and some of our levels were just taking too long to complete. Instead of taking a day or two maximum, some levels were taking folks five days to complete. Fortunately we are able to course correct — we do so all the time — but there is always a cost to your current players, and I think we could have done a better job tuning the game and tailoring our level curve to our target audience."

This is another issue, it seems to me, that relates directly to testing. As we are starting to see in case study after case study, high-performing teams test extensively in an effort to tune the interactive experience of their game to the target audience's expectations and abilities. Despite this focus, though, until the game is released more widely it remains really difficult to nail this down. Only more extensive testing can help alleviate this issue; I am still waiting to hear from the team that felt they did too much testing during the course of development of their game.

Soft Launch Became the Real Launch

Skaggs discussed above the remarkable numbers of players who flocked to *FarmVille* from the absolute beginning. What was planned as a soft launch, for friends and families only, saw more than 1,000,000 players within four days. "We simply couldn't undo over 1 million players playing every day," says Skaggs. "And there were things we needed to have in the game that we were planning to include in the 'real' launch that we hadn't yet implemented. For example, we had to furiously add lines of code to track how people were playing. We had to wire up the metrics tracking pieces after the fact, and metrics are really important to us as a company and to how we do business. Nowadays, no more games launch at Zynga without metrics tracking code — this is an important lesson we learned from the *FarmVille* launch."

Figure 5. The *FarmVille* team knew they had a hit on their hands when player numbers crossed the 1,000,000 mark on day 4, after a 'soft' launch without advertising or cross-promotion.

Triggering Facebook Failsafes

"Again, I don't know how you predict a problem like this," explains Skaggs, "but early into that first summer we started bumping into some Facebook limits that hampered our progress. Like some of their failsafe code that attempts to automate the process of dealing with issues within your application. The actual numbers don't matter, but let's say Facebook has established a system to make sure that all applications are functioning correctly, and they verify this by tracking communication 'errors' like timeouts and the like. Well, they establish thresholds that seem reasonable for 50,000 people using an application, and then *FarmVille* comes along and we've got 10,000,000 people using the application. Suddenly a normal ratio of timeouts and other errors, which are simply a part of life online, trigger alarms in the Facebook system and the game is shut down."

This is the kind of problem all game developers would love to have – their game is too popular and overloads the system or platform. "Facebook was excellent to work with, and eventually we got it all figured out, fortunately," concludes Skaggs, "but it was no fun at the time."

Should Have Made Changes Faster

"I mentioned some of the issues with our leveling curve earlier," began Skaggs. "And there were other things as well – technical glitches, or infrastructure changes – basically, changes we knew we needed to make, but that we delayed over concerns about the installed base." Having millions, and then tens of millions, of

people, using your product adds a lot of weight to decisions to change anything. What if I make it worse? What if I delete something that is attracting many of these fans?

At the same time, according to Skaggs, it is a mistake not to go ahead and make the changes you realize that you need to make. "We definitely should have just gone ahead and made the changes. If you wait, you're not really servicing the new players, or the current players. If something should be changed, go ahead and change it."

Figure 6. Making changes to a world with tens of millions of players can be daunting, but once you realize that there are changes to make, you have to go ahead and bite the bullet, advises Mark Skaggs, *FarmVille*'s Creative Director.

Wrap Up

I asked Skaggs if he had any parting thoughts, looking back on the process of creating Facebook's most popular application. "I would say the biggest takeaway is to make sure your application has all the metrics and analytics tracking code in place before release, in order to keep track of what's going on with it. Coming off the *FarmVille* experience, we now have a Zynga metrics team as well as an entire stats group — these are centralized resources that service all the teams. We are an extremely metrics-driven company. But this is one thing that is kind of cool about this space, and Zynga specifically. Instead of wondering what's going on out there, or even if a button should be red or blue, we can track and analyze the statistics, and do a whole lot of A/B testing along those lines as well. So, be well metric-ed and know what's going on before you go out the door."

Skaggs has blogged about an underlying design philosophy he and his team employ at Zynga, which he calls 'Fast, Light and Right.' He explains: "Speed is very important in this space. Don't

think of design that you'll do in 6 months; figure out what players want, and do it quickly. If what you're working on is not getting your game ready for launch, or post-launch support, than you're just wasting your time."

Figure 7. 'Fast, Light and Right' — the design doctrine employed at Zynga that has helped make *FarmVille* the most popular application on Facebook.

Team Role Interview: Programming Lead

Please introduce yourself and your current role.

Hello, I am Stefan Sinclair, Director of Technology at Certain Affinity.

How did you get your start in the games industry?

My path into the games industry really started about 20 years ago, when as a freshman in the Mechanical Engineering department at the University of Nebraska, a friend convinced me to teach myself how to program in C, rather than continuing with FORTRAN along with everyone else in ME. Eventually, I began developing 2D *Street Fighter* clones in my spare time, with my younger brother providing the art and animation (he is also currently working in the games industry, as it happens).

I loved playing networked *Marathon*, and had always been a huge fan of Bungie games. In 1999, an opening for a network programmer at Bungie became available and I got hired, abandoning a career in consumer product development in the telecommunications industry to try game development full-time. During my time at Bungie, I had the opportunity to develop the online game servers for *Myth*, add OpenGL rendering support to Oni, and contribute to a variety of systems on the *Halo* games, including *Halo: CE*, *Halo 2*, and *Halo 3*. *Halo 3* is probably still the game I am most proud of from the course of my career.

What was your role on *Halo 3*? Did you have a sense of the larger picture? Was it clear to you how your contribution would be used in the final game?

My role on *Halo 3* was Software Development Engineer working on the multi-player, Live, interface, and various related systems. To be a bit more specific, this meant that I designed and programmed many of the technical systems behind the various multi-player game modes, systems related to Xbox Live integration, the shell menu UI system, and other various bits here and there as needed. In many ways I had a much clearer sense of the larger picture and what my contribution to the final product would be than might otherwise be the case, as I had similar roles and responsibilities on *Halo 2*.

The multi-player game from *Halo 2* had been a huge success, so we wanted to keep all of the things that had made it great (matchmaking and party systems, highly configurable game modes, extensive website support, and of course the awesome maps and incredible gameplay) and then build upon it. With *Halo 3*, we took some gambles at getting a number of new and ambitious multi-player-related features into the final game — new game modes, saved film playback and screenshots, the *Forge* editor mode, networked campaign game and campaign meta-game scoring — many of which had been conceived and implemented in *Halo 2* and even *Halo: CE* but never quite made it into a finished game. We were all very excited and proud to see all of these features finally make it into a shipping game and at such a high level of polish.

This book is about making *great* games. I am interested to hear what you can do as a Programming Lead to ensure that the game you are working on is great. What is your part of the process, and how do you make sure that you're contributing to a great game?

For someone who is in any contributing role on a game development project, really any creative endeavor involving a multidisciplinary team, there are a few things that rise to the top of my list of what will make the end result truly great:

- **Talent**. Not just having talented team members, but also putting them in roles where their talents are able to be best utilized, is critical.
- **Passion and positive attitude**. You need to have people who absolutely love what they are doing if the end result is going to be truly special.

(Continued)

Team Role Interview: Programming Lead—Cont'd

- **Hunger for personal development**. Game development is a highly technical field with rapidly changing technology across all disciplines. You need developers who are continuously developing themselves in order to make really great games.
- **Hard working**. In today's competitive world, all other things being equal, it's the team who is willing to work harder than anyone else who will have the edge in the long run.

Narrowing this question to talk specifically about someone in a lead role on a creative development project, I would add to the above list:

- **Experience**. It helps to have a considerable amount of experience as well as talent in your specific area. Not only will this allow you to better make sound decisions, but team members (especially those who perhaps have not worked with you before) will have more faith in you.
- **Excellent communication skills**. In a lead role on an AAA game development project, you are going to be juggling multiple issues among not just your department but also with other departments and possibly external partners. Without excellent communication skills, this just isn't possible.
- **Lead by example**. In order to make a great game, you need great leads that are willing to do just as much as they ask of their team, if not more, and demonstrate that by example.

What was the strangest or most unexpected part of working on *Halo 3*?

The most unexpected part of working on *Halo 3* for me was seeing how far Bungie's production department grew over the course of that project, and how much better that made everyone's life. As many tales published about the development of *Halo 2* will attest to, trying to take on too much in too little time without adequate production support, planning, and oversight can result in soul-crushing crunches and painful last-minute cuts of huge chunks of your game. The scarred survivors of *Halo 2* learned many valuable lessons, and the ability with which the studio recognized and acted to correct the factors that led to those situations by building up a top-notch production management team paid off incredibly well. It's not simply the fact that our production processes improved on *Halo 3*, but how drastic the improvements were and how much more productive and successful it allowed the team to become, which was most exciting and unexpected for me to see.

What was the most satisfying aspect of working on *Halo 3*?

As part of the multi-player engineering team at Bungie, not to mention a long-time online gamer, it was incredibly exciting and personally satisfying to see how successful *Halo* multi-player had become. We knew that *Halo 3* multi-player was going to be even bigger — you could tell very early on in development that the game was going to be really special. The knowledge that every line of code I wrote, every bit I was able to shave off of a network packet, was going to impact millions of people around the world and the Internet in general was a pretty good feeling. Realizations such as this pushed everyone on our team, and similarly everyone working on the game, to do our absolute best possible work. This was probably the most satisfying aspect of my work on the game.

What about the least satisfying aspect?

Everything that I contributed to the development on *Halo 3* was satisfying in one way or another. However, if I had to pick, I would say I am least satisfied about the Easter Egg that I added to *Halo 3*, because no one has found it yet! In fact, you can still find it in *Halo: ODST* and as of this writing it is even found in the *Halo: Reach* multi-player beta. As far as I know, no one has found it yet. And no, I'm not telling what it is.

Did you feel like you were able to contribute specific ideas to *Halo 3*?

Absolutely. I have been very fortunate in my career in that the studios that I have worked for, Bungie and Certain Affinity, both truly embrace and foster a culture where everyone is not only able but encouraged to contribute their ideas

Team Role Interview: Programming Lead—Cont'd

to the game. This type of open, collaborative environment is a key factor toward growing a successful game studio. Again, this is one of the things that will help to produce a great game as opposed to just a good game.

Have you seen any common, avoidable pitfalls among Programming Leads?

The primary one I have seen is allowing communication to lapse, either between the lead and their direct team or between the lead and other department leads. Programmers in general are not known for their exceptional communication skills; most of us are happier being heads-down solving hairy problems. Nevertheless, allowing the lines of communication to wither and die out is detrimental to the health of a team and the success of a project.

Another common problem I have witnessed is people ignoring problems in early prototype or pre-production phases of game development, only to have them cause even bigger headaches down the road, when they can no longer be ignored. I have found that it is always better to address problems early on and in a decisive matter.

One last thing I have seen in the past that has not worked out so well is attempting to institute major, department-wide shifts in production methods or processes without adequate explanation of the intended results and perceived benefits. People like to understand the reasoning behind big changes.

Any advice for those hoping to break into the games industry as a Programmer?

I would say that if you have the passion and motivation, you will get there — it's simply a matter of persistence. Start small — modeling/texturing/animating your own objects, characters, or environments; programming your own games and demos; contributing to game mods or open source/community-driven projects — and do it because you love it and would be doing it anyway. Always be pushing to improve yourself and your skill set. You will get your break into the games industry if you keep at it and continuously improve yourself, and eventually just may find yourself at a top-notch studio making truly great games!

BEJEWELED TWIST

Released in late 2008, *Bejeweled Twist* is a standout entry in the now-classic puzzle game series created by PopCap Games, headquartered in Seattle, Washington. The original *Bejeweled* was first published as a browser-based game entitled *Diamond Mine* in 2001. Renamed *Bejeweled* shortly after its release, the game quickly became the flagship franchise among PopCap's offerings and has gone on to be one of the best-selling and most recognizable video game brands of all time. Over 50 million units have been purchased across the franchise. The game's core three-in-a-row mechanic has allowed *Bejeweled*, its sequels, and the inevitable legion of knock-offs to essentially define an entire genre of casual games.

As part of such a successful and important line for PopCap Games, *Bejeweled Twist* was developed under a great deal of scrutiny. I had a chance to catch up with Jason Kapalka, PopCap Co-Founder, *Bejeweled*'s original Designer, and the Designer of *Bejeweled Twist*. "*Bejeweled Twist* was the first fully original expansion to *Bejeweled* since 2004's *Bejeweled 2*," Kapalka began, "so it came with several years' worth of expectations and assumptions, and towards the later stages of development it became our most elaborate and involved launch to date. It didn't start that way, however."

The team at PopCap had different ideas for the game initially. "For the better part of its first year of development, the game was known simply as 'Zongo.' It wasn't initially intended to be a *Bejeweled* game at all, but evolved from some experimental gameplay ideas we were trying out involving the 'two by two' rotation mechanic. We plugged in *Bejeweled* gems as placeholder graphics as we fooled around with different gameplay tests. The game was fun, and eventually we sat back and wondered: 'Hmm. Do we *have* to take out the gems?'"

Bejeweled Twist has gone on to be a not only a successful addition to the PopCap line of games, but perhaps more importantly the launch pad for *Bejeweled Blitz*, which has enjoyed

Making Great Games. DOI: 10.1016/B978-0-240-81285-4.10008-X

a spectacular reception as its own PC-based game and as a hugely popular Facebook and iPhone application.

Figure 1. An early screen capture of 'Zongo,' a game in development at PopCap that would someday be released as *Bejeweled Twist*.

Data Points

Developer: PopCap Games
Publisher: PopCap Games
Release date: October 27, 2008
Release platform(s): PC (Windows)
Development engine(s) used: PopCap Framework
Game development timeline: 3 years
Development team size: 2–7
Development budget: ~$1 million–$1.5 million
Secrets, FAQs, etc.: Type SNACKERS while playing to replace the Coal gems with the head of Kapalka's cat Snackers. Snackers also makes a special appearance during certain rare between-level cutscenes in her own private UFO with some secret codes on it.

What Went Right
Extending the *Bejeweled* Brand

For Kapalka and his team, the decision to update the core mechanic of their flagship franchise did not come easily. At the end of the day, though, it's hard to imagine the game as anything but a member of the *Bejeweled* family. "For a game that was originally not meant as a *Bejeweled* title at all, the final result ended up feeling like a logical extension of the original," explains Kapalka. "Although the two by two rotation mechanic did bring up its own set of problems [see our discussion in the What Went Wrong section], the similarity of the 8 × 8 grids, the three-in-a-row matching mechanic, and the seven gem types were all close enough that *Bejeweled Twist* never felt like a different game that had simply had the *Bejeweled* title slapped onto it for commercial reasons. It proved that there was room within the very-well-trodden range of match-three games for some more unusual variants."

Figure 2. At the end of the day, it is hard to imagine *Bejeweled Twist* as anything other than a member of the *Bejeweled* family of games.

Building a Bigger Development Team

PopCap has earned its reputation as a boutique developer by consistently releasing extremely polished games of exceptionally high quality. PopCap is known for taking adequate time with its titles and ensuring that exacting quality standards are met. During the process of building *Bejeweled Twist*, PopCap ramped up the team size, while managing to maintain their legendary focus on quality. Says Kapalka: "The development time for

Bejeweled Twist, at 3 years, was pretty lengthy for a casual game, even by PopCap standards, which tend to be a lot longer than most casual developers. For the first half of this effort, we had only a single programmer, Kurt Pfeifer, working on the title, which was our usual technique: have a small team take longer to make a product, because it allows a lot more experimentation, than a large team that is burning up money at a fast rate and cannot iterate ideas without wasting a lot of resources."

PopCap made the right call of staffing up in order to continue to meet the demands of the larger project, while at the same time staying organized and focused in the way they applied additional resources to the project. "Still, we recognized at a certain point for *Bejeweled Twist* that our normal method would result in a very long development indeed, as the coding was becoming the main bottleneck, rather than art demands. So midway through development we added three more programmers to the project to work simultaneously on different aspects of the game code: Chris Hargrove on the new graphics engine, Josh Langley on 3D animations, and Brian Fiete, our Chief Technology Officer, on miscellaneous new elements, leaving Kurt to focus on the core gameplay. This could have become an ugly process, with lots of confusion, but by keeping each programmer focused on very distinct and separate aspects of the game, redundancy and confusion were kept to a minimum. As a result, the latter half of the development proceeded fairly painlessly for a project of this scope, with few unexpected disasters, and we hit our projected launch date without too much last-minute crunching."

New Tools and Technology

Another success factor Kapalka speaks about is the creation of new tools that not only have benefited *Bejeweled Twist*, but have continued to be leaned into to the advantage of several other PopCap titles. "We took the opportunity of having multiple developers on the *Bejeweled Twist* team to go ahead and create a number of tools and engine changes that we'd been wanting for a long time," explains Kapalka. "These included support for multiple high resolutions, up to 1920 × 1200 pixels, and limited true 3D support, for some optional 3D scenes and effects that could still scale down for lower-end machines, as well as a number of new resource management and source control systems.

"While the creation of all this new technology definitely added to the development time, they will also form the basis for many other PopCap titles in the future. Tying the technology development to a game has some disadvantages, but there's no substitute for having actual goals and problems to solve rather

than just trying to implement technology solutions in a vacuum. For instance, the ResourceGen tool we created for *Bejeweled Twist* allows artists to directly import multilayered Photoshop files directly into the game, rather than requiring them to break the .PSD file down into layers and offsets. This allows for much faster creation and modification, especially of user interface graphics."

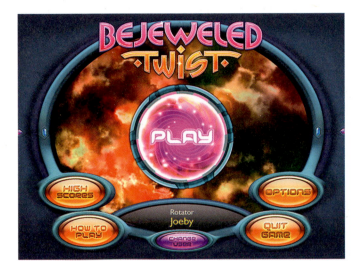

Figure 3. For *Bejeweled Twist* PopCap developed techniques that enabled them to push the limits of overall production values for a casual title.

Pushing the Envelope on Production Values

One challenge specific to casual games developers is the wide variety of computers used by the genre's target market. While consoles offer developers a fixed target platform that their games must work on, teams creating games for PCs have a much wider variety of platforms that their games must run smoothly on. With casual games, this is somewhat exacerbated because the target market are frequently using older lower-end machines as well.

With *Bejeweled Twist*, PopCap was able to successfully focus on this issue, and develop tools and techniques to ensure that the game looked and played great on a wider range of machines. Kapalka: "We introduced a number of high-tech (for casual games) features such as pixel shaders and 3D objects in order to raise the bar for *Bejeweled Twist*'s special effects, along with a variety of more traditional techniques for audio and visual feedback during play. We had to be careful not to go overboard and create a game that wouldn't play acceptably on the lower-end machines that still comprise much of the casual audience

base, but we also wanted to 'future-proof' the game, and forth-coming games, because of our experience with *Bejeweled 2*, which still remains a solid seller 4 years after its release."

"In this respect we felt *Bejeweled Twist* was quite successful," Kapalka concludes. "The effects and graphics are extremely pretty on high-end machines, while the game still runs cleanly on low-end devices like netbooks. The techniques used here will likely also show up in other PopCap games now that they've been successfully pioneered during the *Bejeweled Twist* development cycle."

Simplicity Trumps Complexity

In aiming for simplicity, Kapalka and his team at PopCap ended up, almost parenthetically, laying the groundwork for what was to become one of the most popular Facebook applications. As he explains: "We ended up trying a large number of different mechanics and meta-mechanics during the development of *Bejeweled Twist*. Luckily, the extended development time allowed us to see that a big part of *Bejeweled*'s appeal is its simplicity, and we modified, simplified, or outright chucked a lot of the more complicated mechanics, for a final mix that felt like a good balance between classic gameplay and innovations."

What came out of the other end of this process were several refined, elegant new game modes. "Some new game modes were developed that are likely to have life in future *Bejeweled* products,

Figure 4. Focusing on simplicity in *Bejeweled Twist* helped lead to the creation of 'Blitz' mode, which has been spun off into both its own PC game, as well as one of the most popular applications on Facebook.

like the 5-minute Blitz mode, which has already been spun off into a Facebook game (*Bejeweled Blitz*). The Challenge mode of *Twist*, featuring a number of more cerebral rules variants, was also judged a big success, and may feature in upcoming *Bejeweled* titles."

What Went Wrong
Feature Creep

Kapalka also speaks of the downside of enjoying such an extended development cycle. "Having the luxury to take 3 years on a casual game is nice in many ways, but the 'it's done when it's done' approach has some considerable risks and drawbacks. On *Bejeweled Twist*, the experimental/prototyping stage went on for a very long time and led down a number of dead-end paths featuring increasingly complex RPG-style mechanics and an escalating number of special game pieces. Eventually we winnowed these down to a more manageable set of features, but it took quite a few false starts and revisions in the first half of the project."

Apart from challenges to the game itself, this had ancillary ramifications for the company as a whole. "It also made it quite difficult to start on the mobile or console ports of *Bejeweled Twist*, because the design kept shifting until quite late in the project. In the future, our goal is to not to eliminate the freeform

Figure 5. 'Feature creep,' the bane of game creators everywhere, played a role in the expanding number of modes offered in *Bejeweled Twist*.

experimental stage of a project, but to speed it up and carefully limit it, to prevent lengthy and costly design overruns." This challenge is certainly not unique to PopCap, as many companies work hard to establish effective production timelines and then struggle to keep to them.

Technical Difficulties

Another common challenge of creating a sequel or line of products involves figuring out what to reuse and what to make from scratch for the next iteration. The *Bejeweled Twist* team struggled to strike the right balance here, with varying degrees of success. As Kapalka elaborates: "We probably should have rewritten the code base once the final design had been more or less locked down. Instead, we ended up with code that had started as a *Bejeweled 2* variant and then had numerous changes hacked in and then out again. As a result the final project was considerably more rickety and bug-prone than we would have liked, which was compounded when the third-party group that was going to do compatibility testing for us bailed at the last minute, forcing us to do it internally."

Key learnings here? Kapalka highlights an internal goal of dedicating technical resources earlier that grew out of this process. "Many of the technical issues might have been avoided if we had committed some of the extra developer resources earlier. In the future, we're no longer scared of doing multi-developer projects, and are more likely to split up programming duties closer to the beginning of a project."

Too Hard-Core for Some Casual Players

Another core difficulty in making great games is creating and tuning the challenge ramp — finding the sweet spot where the game stays continually challenging and interesting but does not grow too hard too fast and frustrate players. This is a particular concern with casual games, which need to appeal to a wider range of player abilities in general. With *Bejeweled Twist*, PopCap struggled with this and wound up with something Kapalka worries might still be a bit too hard for the core casual audience.

"While most people found the twisting mechanics compelling and fascinating once they played for a bit, quite a few of the more casual players found the twisting a bit confusing at first. With time, most players got over their initial confusion and became fans of the new rotation mechanic, but in a casual game, you don't always have that time; players are not necessarily going to give you the hour or so they might devote to a hard-core console title before giving up."

Another conclusion drawn from the creation of this game — and one that perhaps will influence decisions on later projects at PopCap — is that casual players won't read extended explanations of how to play a game, no matter what. "We did what we could to simplify the mechanic, and tried a host of different tutorial techniques, but in the end *Bejeweled Twist* remains somewhat more difficult to pick up than basic *Bejeweled*, though some will argue more rewarding once you do. One lesson learned is that no amount of tutorials will make a difficult mechanic any easier to learn. If one or two lines of explanation won't do it, 2+ pages

Figure 6. 'Twist Shop' was one of the more complex features that was built for *Bejeweled Twist*, but did not make it into the final product. This feature allowed players to buy and level up a whole host of power-ups for the game, but was deemed too hard-core for the casual audience.

won't either… people will simply refuse to read extended explanations, and if you force it on them, they won't comprehend or remember it anyway."

Length of Development

"Three years is a long time to work on a casual game, and the extended development time took its toll in various ways," begins Kapalka. "It was hard to maintain morale and excitement over such a lengthy cycle. In addition, with the market changing and evolving as rapidly as it does, we ran the risk of it changing radically for the worse by the time we were done with the game. Some of these fears were realized — a number of other games featuring 'twisting' mechanics did make it to market before us — while others were not: *Bejeweled* was not forgotten, and remained a strong brand that allowed us to sell successfully into various retail markets."

Like with many factors, what seems like it should be a clear benefit — extra time — proved to have a downside as well. "In retrospect, having a clearer timeline and release date in mind would have helped us to allocate resources as needed to make it happen within that period. Having the luxury to do 'pure R&D' for so long seems like it should be great, but sometimes you need clearer limits and goals."

Figure 7. The Trophy Room was another of many features that got added to, and then dropped from, *Bejeweled Twist*.

Hype and Expectations

Again, these are a familiar challenge to teams working on sequels to hit products. Kapalka feels that the added pressure may have taken something away from the game when all is said and done. "One of the biggest factors contributing to some of the above problems was the high expectations associated with a new product. Although we tried to always be clear that *Bejeweled Twist* was not a direct sequel to *Bejeweled 2*, but a spinoff or variant, the expectations for it to be a super AAA+ hit remained very strong. The assorted marketing and PR strategies oriented around promoting *Bejeweled Twist* as the next big thing may or may not have worked on their own merits, but the pressure the team felt as a result was definitely problematic. PR efforts to play up the development time — actually inflating it from 3 to 4 years — increased the expectations and pressure even further. With expectations sky-high, it was difficult to lock down anything until it was '100% perfect,' a condition that was hard to achieve. If the product had remained 'Zongo,' it is likely a lot of the redesigns and overthinking that plagued it would not have been as bad due to lessened pressure."

Figure 8. *Bejeweled Twist* has enjoyed a successful reception in the marketplace, and one of its many play modes — Blitz mode — has become a wildly successful game as well as Facebook application on its own.

Wrap Up

All things considered, *Bejeweled Twist* has been another remarkable success for PopCap — not least of all because of its role in helping spawn *Bejeweled Blitz*. Reflecting on the process of creating the game, Kapalka emphasizes some of the challenges he and his team faced, and some of the key takeaways PopCap will bring to future development efforts. "*Bejeweled Twist* ended up as a good game, and it has performed well so far, with the belief that it will have a long shelf life, like the other *Bejeweled* titles. However, the development cycle was much longer and more painful than necessary, and in the future we will likely take more safeguards against such extended development efforts. Several useful tools and systems were developed during the process that will see more exposure in future titles, so some of the development efforts are being 'amortized' across upcoming projects as well.

"In terms of the *Bejeweled* franchise, *Bejeweled Twist* does extend it in an interesting direction, but it's clear that the 'core' gameplay of the original *Bejeweled* remains simpler and more accessible, while *Twist*'s strategic gameplay appeals to a more sophisticated player. Trying to cater to both the hard-core and casual gamer at the same time, however, is a difficult task, and it remains probable that 'classic' *Bejeweled* will continue to have its place."

Team Role Interview: Presentation Art Director

Please introduce yourself, your role, and the game team(s) that you have been part of.

I'm Clint Jorgenson, most recently Presentation Art Director on *Skate 3*.

How did you get your start in the games industry?

Skate 3 is my fifth game, and I have been with Electronic Arts my entire career. I got my first job on the *Def Jam: Fight for New York* project. I was extremely lucky. It was a great game and a seriously talented group, and I happened to have the right skills at the right time to be able to join the team. A couple of years later, with more experience under my belt, I moved over to the original *Skate,* which was in pre-production at the time, and I have been with the team ever since.

Describe your role on *Skate 3*. What does "presentation" mean on your team?

Presentation is a word used in a lot of different ways in the industry. In my case, it is all the non-game-world elements that glue together the game experience. User interface is the largest part of it, and that's where most of my experience lies. I am also responsible for cinematic effects, motion graphics for videos, visual indicators, and transitions, and I am an advocate for polish and clear communication in the game in general.

This book is about making *great* games. What is your part of the process, and how do you make sure that you're contributing to a great game?

There is something special about games that speak with one voice and are highly polished; I'm a strong believer in the importance of that. So I bring that approach to everything I work on. I have the unique position to make sure a lot of separate parts being worked on by different people come together in a unified way. Inconsistency and lack of polish keep reminding the gamer that they are using a piece of software, and that breaks immersion.

What was the strangest or most unexpected part of working on the game?

It is always interesting how certain visual elements that you think are going to work out so great can fall flat when they have to conform to a usable interface. For example, on *Skate 3* we were heavily influenced by Modernist graphic design and print from the 1950s and 1960s. Some visual elements that looked killer in a single reference piece ended up feeling forced and unneeded, so we cut them out. On the other hand, elements born spontaneously from an unexpected UI purpose can completely take over and become a strong part of the visual look. An example of this came from our Heads-Up Display, or HUD. We used the philosophy that our HUD needed to be as lightweight and clear as possible, so we always started with text, only adding art as needed. As a result, some of the framing solutions found their way back into the UI and improved the entire package. Our *Skate 3* style guide, kind of like a style bible we use to make sure certain style guidelines are followed across the game, looked really different at the end of pre-production compared to our final results. It has the same feel, but we made a lot of improvements to the details that weren't planned.

Did you feel like you were able to contribute specific ideas to *Skate 3*?

Yes, definitely. Our team has a culture where everyone's ideas are given respect and have a chance of realization. The idea of the singular genius and an army of workers grinding out his vision based on the perfect design document is a myth; everyone has to feel ownership and be involved.

Was there anything specific to *Skate 3* presentation efforts that you felt went particularly well?

We have an approach to pre-production that brings everyone into the process of deciding on the presentation concept. Knowing from the past what poison uncertainty can be, this is invaluable. Hitting that stride of knowing what you are setting out to accomplish is a huge moment. For me, at the very beginning, staring at a blank slate can be terrifying!

(Continued)

Team Role Interview: Presentation Art Director—Cont'd

What about the flip side? Anything specific that didn't work so well?

Speaking of the entire past here, not just *Skate 3*, some of the biggest mistakes I have seen are spending too much time noodling over a concept before proving it is technically feasible, and then having no time to react when things go wrong. It's better to get engineers, designers, artists — everyone, in a word — invested and involved, with clear goals, and to work on the concept together in incremental steps.

Clinging to a failing idea is another problem I think everyone who has tried to do something complex and ambitious can relate to. It's important to not get attached to ideas before you know whether they'll pan out. And, speaking specifically about user interface, I think visual metaphors or clever feature naming can be a problem if they start to inform your design decisions. Common examples in games are cell phones, pagers, file folders, tomes, elaborate 3D menus… these things can look great and add flavor, but the moment they start to erode usability, or slow the player down, they are doing more harm than good. The UI has to be clear and responsive first — mood and flavor come second.

Any parting thoughts about your experience and perspective on how the world's best video games get made?

The best games I have worked on have had one simple thing in common: people working hard to make a game that they themselves want to play.

9

MADDEN NFL 10

Originally published in 1989 as *John Madden Football* for the Apple II, *Madden* is a key, exclusive licensed property for Redwood Shores, California-based Electronic Arts (with their license currently in place through 2012), a venerable force in the video games industry and one of the best-selling computer game franchises of all time. Updated year after year, the game has a rabid stable of hard-core fans and manages to bring new fans into the fold each year. With so many repeat customers, the *Madden* team faces a significant annual challenge to improve. The *Madden* franchise, perhaps better than any other, has done an outstanding job of consistently attracting new players, while at the same time retaining the core fan base who buy each new version of the game year after year upon its release.

Madden has taken on a life of its own beyond its presence on every major video game platform. The game has spawned tournaments, including *Madden Bowl*, staged annually during Super Bowl week in the host city, which pits NFL pros against each other. The *Madden Bowl* has been nationally televised; the game has also spawned an ESPN reality television series, *Madden Nation*.

All of this focused attention shines a white-hot spot light on the quality of the game and, therefore, as one might imagine, puts incredible pressure on the development team. How does a team approach the task of delivering a quality product year after year under such intense scrutiny? Within the industry, teams talk about the '80/20' rule for successful sequels — the concept that new annual versions of existing, successful games should be composed of 80% familiar content and features and 20% brand new. However you slice it, it is extremely challenging to find the right balance, especially with a game as well-regarded as *Madden*.

I spoke with Ian Cummings, Creative Director and Lead Designer of *Madden NFL 10,* and asked him to give us a peek behind the curtain at the *Madden* development process at EA Tiburon. Cummings began: "We strive to build a realistic sports simulation experience, while at the same time innovating to make the game feel totally fresh and new. A big design challenge is balancing all of this while not alienating our loyal fans who have purchased and played the 20 previous versions." The game

9

Making Great Games. DOI: 10.1016/B978-0-240-81285-4.10009-1

experience must be different enough to encourage those who own previous versions to purchase the new release (and to entice new players to the franchise), yet keeping it familiar enough that the game meets the expectations of those who played previous versions. *Madden NFL 10* was highly successful on these terms; I asked Cummings to talk about what went right as well as what went wrong in the creation of the latest success in this long-standing series.

Figure 1. *Madden NFL 10* — continuing the tradition of annually releasing one of the best-selling video game series in history.

Data Points

Developer: Electronic Arts/Tiburon
Publisher: Electronic Arts
Release date: August 14, 2009
Release platform(s): PS3, Xbox 360
Development engine(s) used: Proprietary
Game development timeline: 1 year (previous release was August 12, 2008)
Development team size: 90–100 people
Awards and honors:

- Highest-rated *Madden* (Metacritic, GameRankings) on current platforms
- G4 — Best Technical Achievement, Software (Winner)
- 1UP.com — Best of E3, Sports Game (Winner)
- GameFocus— Best of E3, Sports Game (Winner)
- IGN — Best Overall Sports Game (Runner-up)
- IGN — Best Xbox 360 Sports Game of E3 (Runner-up)
- IGN — Best PS3 Sports Game of E3 (Runner-up)
- IGN — Best Sports Game for Wii (Runner-up)
- GameSpot — Best Sports Game of E3 (Finalist)
- GameSpy — Best Sports Game of E3 (Runner-up)

What Went Right

Experienced Engineering and Art Team

Cummings says one of the key success factors of the *Madden NFL 10* development process was the core people who he had on the team. "Putting out an AAA video game is no easy feat," he recounts. "Doing it every single year with no wiggle room on a ship date is even more challenging. It's critical to have a core team of experienced engineers, with years and years of working together on the *Madden* code base." Without these expert engineers and experienced art team providing the foundation for each new version, the development team would not be able to focus on developing a game that builds on the success of the past versions with significant new features and gameplay, while staying true to the original concepts and vision of the game.

Unified Vision

Crafting a vision at the beginning of the development cycle, and keeping true to this vision throughout the development process, was another important factor Cummings spoke about as something that worked particularly well with *Madden NFL 10*. According to Cummings, it is often quite difficult to keep a game like *Madden* on track, due to the sheer size — it is easy to continue to embellish and evolve the game, sending the team off on tangents that may distract from the new elements of the gameplay critical to the product's success. With only 12 months to design, build, and ship the game, these diversions can be deadly. Cummings's advice? "Have an unwavering vision right from the start — in our case, it was 'Everything You See on Sunday' with presentation

Figure 2. "Everything You See on Sunday" provided a unifying vision to the development team working on *Madden NFL 10*.

and 'Fight for Every Yard' in gameplay — both were instrumental in keeping us all on track and working towards one goal." If a new idea, even a great idea, did not fit into the core vision for *Madden NFL 10*, it was shelved for future consideration, allowing the team to stay tightly focused in order to continue to head toward their shared goal.

New Design Team

While Cummings says the experienced team members were critical to the success of the game's development cycle and to shipping the project on time, it was also exciting and helpful to have some fresh hands working on *Madden NFL 10*. The design team was instrumental in providing some of the new ideas for the game. "The entire design team was new that year, although many had worked on other games at Electronic Arts/Tiburon," he says. "Prior to *Madden NFL 10*, the core design team had not changed for the four previous years of *Madden*, so it was a fresh start for us, which allowed for some new ideas to grow and foster and a whole new vision to take shape."

The fresh ideas of these new designers had to be weighed against those of other members of the development team who had been through the cycle many times, and were understandably weary about straying too far from the secret sauce that had made the *Madden* franchise so successful year in and year out. According to Cummings, it is important to include and respect the perspectives of those who have been through the cycle many times, but keep them balanced against fresh ideas of new team members. Striking the right balance between these competing interests is critical to elevating the overall quality of a sequel.

Community Interaction

Over the past several years, the *Madden* community had begun expressing some dissatisfaction with the game. The *Madden* development team jumped head-first into their community of fans, in a real effort to understand what the core issues were, and to try to repair the relationship that had been damaged over so many years. Cummings reports that they interacted with players on message boards, followed Twitter accounts, and basically reached out to fans any way they could in order to ensure that they were (1) listening to their fans, and (2) making changes based on their feedback.

One example of a change that came about from specific fan feedback is the way *Madden NFL 10* handles pass rushing. As Cummings reports, "We were having some problems during development with tuning our pass rushing. Any video that we released would get picked apart because to the realism junkies

there was not enough pressure on the quarterback (and that had been a big perceived problem from *Madden 09* as well). So after finally getting the time to dig into it a bit, I found what seemed to be the culprit: a piece of technology we were experimenting with, called the 'weapon curve,' that was wreaking havoc on the way the game handles pass rushing. This is something I discussed explicitly with our community on message boards, like operationsports. com. I'd also post videos showing how our tweaks affected the game, gather more feedback from the fans, and use this feedback to make our final tuning changes in the game. These were pretty cool exchanges, and they definitely increased the quality and realism of the game."

Here we see yet another example of a form of testing driving production, setting priorities for which parts of the game need to be changed. Finding ways to create dialogue with players, and to leverage their expertise, will stand you in good stead in terms of improving what you are offering to your players.

Buy-in from Above

Cummings is thankful to have the necessary support from the entire production and executive team at Electronic Arts. "EA SPORTS is a huge organization, so getting buy-in early on the design and vision for the product from the executive level is key to ensuring a solid launch and a good game," he relates. "We presented ideas early, sharing our research and thought process, and all the folks in that executive level, from Peter Moore to John Riccitiello, were excited about what we were committed to deliver for *Madden NFL 10*. They gave us support all along the way when it was needed."

Figure 3. Getting executive buy-in early for the new visual and presentation style was key to ensuring a solid, on-time launch and a great game.

What Went Wrong
Too Broad a Scope

In an effort to keep a recurring franchise fresh, one danger is trying to do too much. "A key lesson from *Madden NFL 10* is that we bit off more than we could chew," relates Cummings. "This led to a less-than-ideal amount of time left to polish what we had. Being that this was a new design team, we really wanted to leave our mark and come out with a bang, but we overpromised in many areas and even had to remove things very late because they didn't have the polish level that we wanted." This is a factor we hear over and over again. Great games are made by ambitious people, who frequently fall victim to indulging their hearty appetites for new features, levels, mechanics, etc., despite the risks to the project schedule, and, very often, their own well-being, as they are the ones who will suffer most from the inevitable crunch mode.

Not Enough Focus on Audio

"A common problem across many game teams is that they test the game without any audio for months," explains Cummings, "and it was no different here." Cummings recommends assigning key areas of the game – audio, as a specific example – to specific team members so they receive the early attention they deserve. "Once everyone on the team started spending much more time listening to the game, it was too late in the cycle to make many of the changes, polish, and bug fixes that were needed to really shore up our commentary and crowd audio."

Especially with large-scale game development projects, there is simply too much for any single person to keep track of. Assigning specific areas to specific team members is a good way to delegate some of this responsibility and can be effective, as long as the 'delegates' understand and adhere to the core vision for the game.

Disconnected Systems

With any game as large as *Madden NFL 10*, teams must coordinate across multiple systems – front end, core gameplay, online components, etc. – that all must hang together as a complete, unified package. This proved challenging for *Madden NFL 10*, as Cummings explains: "We spent a good deal of our cycle building a lot of new technologies that would allow us to create better overall broadcast presentation – including cutscenes, banners, instant replays, cameras, and audio. Unfortunately, we didn't quite have enough technology to hook everything together seamlessly, and

there were different content creators owning each of the above areas. So although we made some great strides in presentation, we weren't able to make it 100% polished to the level that we wanted – with inconsistencies with the amount of replays or the correct camera targets on cutscenes or what have you. If we had put one person in charge of one tool-set that was able to control this, then everything would have 'jelled' together better in the long run."

Figure 4. New technologies allowed for great strides in improving individual elements of the game, but disconnected systems made tying it all together a challenge.

Late Scheduling Changes

Of course, being part of a large corporation means that some decisions are handed down, outside of the complete control of the team itself. In the case of *Madden NFL 10*, a late scheduling change introduced a hiccup in the production process, resulting in the need for extra people, and hours, to get all of the features in place on time.

"The biggest feature initiative for *Madden NFL 10* was in building an 'online franchise,' a feature where players across the globe could play seasons year over year against each other," says Cummings. "This feature was a major undertaking, and due to the fact that it was going to be built in a server-driven fashion, we originally planned on having it release as a downloadable content feature right at launch. Unfortunately, some major issues cropped up on how we would be able to accomplish this in our architecture, so we had to make the decision later to pull the feature in by 3 or 4 weeks, which ended up requiring a major push to get extra headcount and work more hours."

Alpha/Beta Crunch Time

The release of a franchise like *Madden* is tied to the schedule of the National Football League, and that schedule doesn't slip. This means that for Cummings and his team, their ship date is written in stone. "All of the above issues basically add up to the problem of having too big of a crunch at the end of the cycle to get the game out the door," he explains. "This is always something we try to alleviate but on such tight schedules — basically we have 12 months total to design, build, test, and release the game — too often we have to put in some bad overtime to get all of the major bugs out of the way."

Figure 5. The development team intended to make playing *Madden NFL 10* feel like watching an NFL broadcast.

Wrap Up

By any yardstick — awards, sales, critical reaction — *Madden NFL 10* has been a huge success for Electronic Arts. A combination of a new design team and a clear, unified vision allowed the modest-sized team to execute on their vision and build and ship the game in 12 months — a relatively short amount of time for an AAA game's development cycle.

It is interesting to note that even such a high-profile game — perhaps the highest-profile video game there is — suffers from some of the same development pitfalls we've come to recognize in the creation of other games across the spectrum. As Cummings told me, "Though many might think that by now the development of *Madden* would be a well-oiled machine, there are still plenty of areas to improve. We have shifted to a much more 'agile' development process where we try to fix more issues upfront instead of pushing them off to the alpha phase, and we feel this will still give us the predictability of shipping on time with better quality and

more features." We can look forward to many more years of amazing gameplay wrapped in an incredibly polished package from this highly talented team at Electronic Arts/Tiburon.

Figure 6. A success by any measure, *Madden NFL 10* continues the winning tradition for EA SPORTS.

Team Role Interview: Voice Actor

Please introduce yourself, your role, and the game team(s) that you have been part of.

My name is Stephen Kearin and I am the Co-Creator of *Simlish*, the language spoken by *The Sims*. I voiced all the principal male characters in the first game *The Sims*, as well as one of the principal male voices in *The Sims 2.0*.

How did you get your start in the games industry? How did you come to be a member of *The Sims* team?

I was living in San Francisco in the late 1990s, and I was very established in the improvisation community at that time. I started training in 1986, and over the years I worked with *Bay Area Theatresports, Pulp Playhouse, Improv Theatre, True Fiction Magazine* and was a founding member of *3 For All.* One element of my work that I had developed over the years was providing sound effects for improv scenes, and I even taught a regular class on the subject at *Theatresports*.

I was contacted by Claire Curtin, a producer at Maxis, Will Wright's company that produced *SimCity* and several other Sim games. She was familiar with my work and wondered if I might be interested in helping to develop a new language for their new game, *The Sims*.

When I arrived, I met Claire and Will and a handful of others in the control room at Maxis. As I remember, it was a tense atmosphere, as they were attempting to essentially 'graft' languages together to create a totally new-sounding dialect. I think by the time I got into the recording booth, the latest attempt was blending Swahili with Cherokee, and it wasn't going well. Things continued to bump along and I asked if I could just improvise some gibberish to some of the existing animations, knowing in general what they wanted the characters to 'say' and at that point, the response was basically, 'Sure, what the hell… nothing else seems to be working.' Strangely, things started to come together as we worked the scenes over and over. For me, it was always a matter of emotional content first, that is, knowing what needed to be said, but letting the emotional state of the Sim pull the language through, if that makes sense.

Describe your specific role on *The Sims*.

Will and Claire would direct me throughout in the formation of the sound, or the intensity of the feeling, so it was truly a co-creation. For me, I was using everything I knew as an improviser; as well as everything I knew about just creating sounds on the fly in working out the language of *The Sims*… it was intense.

To me, the heart of *Simlish* is a sound, rather than actual words. For years, fans of the game have attempted to create a dictionary for the language, but because so few actual words are repeated, it has proved difficult. I always had to be reminded of actual *Simlish* words they wanted included in a scene.

In any event, the team wanted to add a female voice to the mix, so that we could play off one another in 'conversation' as well as push each other as improvisers. I worked shoulder to shoulder with Gerri Lawlor for 10 years in *The Sims* recording booth, and I always felt like I was running to keep up. She is a force of nature and has an amazing command of her voice. The real sound of *Simlish* came out of Claire pushing us so hard in those early sessions. I have never worked that hard in a recording booth, before or since. Literally hundreds of takes in a session was the norm.

I think when it comes to *Simlish*, Gerri and I were very much like test pilots. Claire (and later the great Bill Cameron) would urge us to push the plane to failure, so that we learned a great deal from crashing and paying attention to what *wasn't* working. They would come back the next day after listening to playback and be able to focus us in on a particular sound or emotional color they wanted. The sounds varied greatly depending on the scenario and the overall tone of the game or expansion pack. In the morning we might be trying to seduce each other and by day's end we were telling bad jokes… all in gibberish. All hunched over our music stands and staring into the monitors. The timing of

Team Role Interview: Voice Actor—Cont'd

Simlish, of having to loop exactly to existing animations, is an art unto itself. At times, that can be one of the most challenging elements of recording on *The Sims*... just knowing when to talk and when to shut up. That's when having a partner is really valuable, because I was always learning from Gerri on where to drop in and where to drop out, when to push the emotion and when to pull back. I once had a professor in college say: "Artists don't look at art like other people do... they look for what they can steal." He saw it as normal and just how art is made. I stole from Gerri as much as I could, but I tried to make a habit of announcing it. "I'm stealing that," I would say... and soon enough, she would be saying the same thing.

Did you have a sense of the larger picture?

I understood the basic premise behind the game itself, but I don't know that anyone could have known or predicted that *The Sims* would become *such* a phenomenal success. They once estimated that our voices were being heard 24 hours a day, 7 days a week, 365 days a year all over the planet. I don't think it's possible to really get a true sense of a picture that large.

Was it clear to you how your contribution would be used in *The Sims*?

Yes and no. When we recorded to the animations (even though many of them were rudimentary) and then watched playback, we would understand how the character would look and sound, of course, but what was missing was context and narrative, which changed everything. I certainly recognize my voice and can recall the actual sessions where we were screaming or kissing or whatever, but what makes it more than the sum of its parts is story... the story really makes it feel like a language.

What can a Voice Actor do to ensure that the game you are working on is great?

For me, the idea of courting greatness during the creative process is akin to the kiss of death... at least in my experience.

I think what you set out to do is your very best, every day, and continue to strive for this over as much time as possible, which I guess is a fancy way of saying "work hard." I once had a writing teacher say, "At one point, quantity becomes quality."

As far as greatness, I wouldn't even go near the idea, and certainly not during the process of creating. That's like saying you want to be famous. It is putting the cart way before the horse in the worst way, and can seriously dilute the process. Work hard to consistently create your very best product and the greatness will take care of itself.

What was the strangest or most unexpected part of working on the game?

By far the strangest part of this whole odyssey of *The Sims* has just been the sheer overwhelming popularity of it all, as if it filled some sort of vacuum that was just waiting there. I remember meeting a mother and daughter at some show I was hosting and somehow word got around that I had something to do with *Simlish*. The mother came up to me and asked me if I would speak *Simlish* to her daughter, and so I rattled off something, and the girl immediately teared up and gave me a hug, while her mother just shrugged and smiled. That had nothing to do with *Simlish* and everything to do with *The Sims*, and what it meant to her; and whatever it meant was profound. I don't know if empowering is too trite a description, but *The Sims* seems to have a deep effect on people. You rarely hear anyone talking about *The Sims* halfheartedly. They either have never heard of the game or are intimate with it... nothing in between.

What was the least satisfying aspect of the work you did on this game?

By far the least satisfying aspect of the work on *The Sims* is no residuals. ;)

(Continued)

Team Role Interview: Voice Actor—Cont'd

To be honest, there have been instances where we recorded up to 700 individual takes each in a single day. You are beyond yourself at that point, and it can be painful and feels almost surreal. That being said, if one were to describe our work as hard, it is important to remember a famous British actor's response when a producer apologized after an especially grueling voice session. He put his hand on her arm and whispered hoarsely: "Coal mining is hard, dear."

Any parting thoughts?

There was a running joke at Maxis that Gerri and I were going to be sent to Budapest to appear on a float in an annual parade that was devoted to, among other things, *The Sims*. The idea was that Gerri and I would be encased in a see-through recording booth on the front of the float and perform *Simlish* live to animations that would be playing large enough for parade goers to see. It has yet to come to pass, but I still dream of that float. In my dream, it is winter and we are warm and cozy as we parade through the streets of Budapest, sipping hot chocolate between takes of *Simlish* in our see-through cube.

WORLD OF GOO

2D Boy, "a brave new indie game studio based in San Francisco," are the creators of the WiiWare standout title *World of Goo*, which they describe in the following fashion: "*World of Goo* is a physics-based puzzle/construction game where you drag and drop living, squirming, talking globs of goo to build structures, bridges, cannonballs, zeppelins, and giant tongues. The millions of Goo Balls that live in the beautiful *World of Goo* are curious to explore — but they don't know that they are in a game, or that they are extremely delicious."

A leveled puzzle game at its core, *World of Goo*, released in the fall of 2008, presents a unique, inventive twist on the video game construction set mechanic. In each level players must create, place, and use a limitless variety of structures appropriately in order to get a certain number of Goo Balls out through the exit pipe that appears in each level. This all takes place within the backdrop of an evolving five-chapter story that recounts the struggles of the Goo Balls to avoid extinction at the hands of the evil World of Goo Corporation.

World of Goo is incredibly polished, from the style, to the story, to the music, to the level design, controls, and core physics. The game has sold extremely well on all of the platforms for which it has been released and has met with widespread critical acclaim — as of this writing, the Wii version holds an aggregate Metacritic rating of 94. 1UP called *World of Goo* "one of just a handful of truly excellent original games for the Wii," and *Resolution Magazine* dubbed it an "instant classic." IGN called the game "absolutely fantastic." The game has garnered dozens of awards as well, including Best Independent Game from Spike TV and both the Design Innovation and Technical Excellence Awards at the 2008 Independent Games Festival. It is hard to fathom that such an influential and acclaimed game was created by two guys.

I had a chance to connect with Kyle Gabler and Ron Carmel, the 'two guys,' entire core team of 2D Boy, and the creators of *World of Goo*, to discuss what went well, and what went not so well during the development of this truly astounding game. "*World of Goo* was made by two guys," Gabler and Carmel explained. "We both worked at Electronic Arts, but felt a little

Making Great Games. DOI: 10.1016/B978-0-240-81285-4.10010-8

Figure 1. *World of Goo*, conceived and created by a team of two, has amassed accolades, awards, and brisk sales.

restless, so we left our jobs and decided to make a game, working out of coffee shops around San Francisco." Their results are extraordinary.

What Went Right
Started Small

Carmel and Gabler took advantage of the results of an earlier project, a game called *Tower of Goo* that Gabler created as part of the Experimental Gameplay Project. "In *Tower of Goo*," explains Gabler, "there is a little green hill with 100 Goo Balls, and your goal is to build as high as possible. The original *Tower of Goo* prototype was released online for free as a part of a school project. It became popular on some message boards where players posted screenshots of how high their towers had grown. Others posted screenshots of things they built with the game, like cats, and buildings, and abstract art, but mostly giant penises. The large amount of feedback from the original prototype helped us feel confident that the game we were making had some fun ideas behind it."

Incorporating the feedback of these 'hundreds of thousands of strangers' who had played and enjoyed *Tower of Goo* gave 2D Boy not only a lot of great information about what parts of the experience were compelling, but also the confidence to move forward with their unconventional concept for *World of Goo*.

Data Points

Developer: 2D Boy
Publisher: 2D Boy
Release date: October, 2008
Release platform(s): Wii, PC, Mac, Linux
Development engine(s)
Used: Our Own
Game development timeline: 2006; ~ 2 years
Development team size: 2
Development budget: Food and rent
Marketing budget: $0

Figure 2. *Tower of Goo*, the original prototype created by Kyle Gabler, provided the inspiration for *World of Goo*, as well as a kind of distributed test bed that allowed the creators to gather feedback from 'hundreds of thousands of strangers.'

No Contractors Allowed

Having previously worked together at Electronic Arts, Gabler and Carmel were looking for something different, and therefore committed to keeping 2D Boy small and to embracing an indie aesthetic and approach to their projects. They made the decision to make a game themselves — without leaning into any external resources whatsoever. "We decided to embrace the fact that we were a team of only two guys," Carmel explains. "So all art, programming, music, sound effects, marketing — everything — was done in-house." Gabler adds: "Contractors are nice in theory, but it's hard to dump emotions into their brains and get them to make something cohesive with the rest of the project. Since absolutely everything was done by one of us, I think it helped everything mash together more seamlessly."

Deciding to not allow contractors provided a useful constraint for the game's design as well. Without the option to throw more bodies at the project, 2D Boy was forced to keep the design focused and, while it took longer than they expected or they would have liked, the indie aesthetic shines through the end result. *World of Goo* hangs together with an internal consistency and certain intimacy common among many great games.

Figure 3. 2D Boy strictly enforced an internal rule during the development of *World of Goo*: no contractors allowed.

Tapped into Fans

The success of the early prototype *Tower of Goo*, as related above, meant that 2D Boy was starting out with a solid group of fans already in place. And because fans of independent games, eagerly trawling the Internet for novel game play experiences, are spread out across the globe, this meant that 2D Boy's supporters were also located in many different countries. Gabler and Carmel, in another element of their process that illustrates their indie spirit, made a key decision to tap into this ready and willing fan base to help localize *World of Goo* for multiple European markets.

"This is one of the things we're proudest of," Carmel and Gabler explained. "Some motivated fans took the time to build a translation wiki, and translate the game into dozens of languages. We were able to use their translations for our European releases." Operating outside of the structure of a large corporation, with resources constrained by necessity, enabled 2D Boy to be creative in order to tackle what otherwise might have been an expensive, lengthy process of bringing their game to market in multiple territories.

Ruthless with Levels

High-performing teams are extremely self-critical, and 2D Boy was no different in this regard. Whether by looking back on the entire process of game development, or, from a more macro perspective, examining the results of day-to-day work on game projects, strong teams take the time and energy to closely

examine their output and to put it up against internal quality standards.

It can be difficult to cut work that has been 'completed,' but in striving to achieve an incredibly high overall quality bar, Gabler and Carmel were ruthless with the levels they created for *World of Goo*. At the end of the day, they wound up shipping less than one-third of the levels that they had created for the game. If a level was deemed not up to snuff, it was gone. "We ended up throwing away over two-thirds of our levels. In the final game, we kept only the levels where there was a really good reason for keeping them around. The general rule was, if a level didn't have something that made the player say 'wow,' it had to go away."

This relentless approach and ability not only to be self-critical, but also to be willing to face the music and delete their hard work, resulted in a set of levels of incredibly high and consistent quality in *World of Goo*.

Figure 4. If a *World of Goo* level didn't elicit a 'wow,' it was cut.

IGF as Deadline

"The Independent Games Festival gave us a deadline to work towards," began Carmel. As the development cycle dragged on, and weeks turned into months, honoring internal milestones proved increasingly challenging. Not engaging contractors, as well as not working with a publisher, lent Gabler and Carmel an incredible amount of freedom to pursue their creative vision with *World of Goo*. At the same time, one side effect was that

there really was no back pressure on the schedule. Working out of coffee shops meant no rent and very little overhead for the pair of developers. Eventually, they realized that in order to wind up with a shippable, sellable product, they were going to have to impose and meet some deadlines. The Independent Games Festival provided this external schedule pressure they were looking for.

Submitting the game had additional benefits as well. The overwhelmingly positive reaction to their work provided additional motivation to continue their efforts and ship the game. As Gabler recounts, "Winning some awards at the IGF gave us the confidence and credibility to keep moving forward."

Figure 5. Preparing *World of Goo* for submission to the Independent Games Festival gave 2D Boy a welcome, although challenging, deadline.

What Went Wrong
Grossly Underestimated Effort Involved

A fairly straightforward misstep, and one that is common for any new entity, large or small, that is getting their first game project out the door, is a gross underestimation of the actual size of the undertaking. Creative endeavors take time, and often more time than one ever imagined. For Carmel and Gabler, their estimates were way off — not to unheard-of levels, but fairly extreme nonetheless. As they put it, quite simply: "We thought *World of Goo* would take a few weeks to make. Almost 2 years later, we decided that that was an underestimate."

Figure 6. 2D Boy figured *World of Goo* would be done in a few weeks. Two years later, they realized they were a bit off with this estimate.

Challenges Scheduling Creativity

Somewhat related to the above is the struggle to nail down a schedule for a creative undertaking. The creative process, in any medium, is a mystery, and it often feels like trying to get a square peg into a round hole when mapping out a schedule for a creative endeavor like designing a new game from scratch, or even an interactive level for a game.

Levels are the core experience of *World of Goo*, and generating levels became the main production bottleneck. As discussed above, Gabler and Carmel were ruthless in their drive for an overall quality target for each and every level, and this added additional pressure in their attempt to drive toward beta and shipping the game. "I don't think we ever found a good way to schedule creative work," admits Gabler. "Making a level could take anywhere from a few hours to a few days, depending on how 'inspired' we were at the moment. This was also the case with writing the music and creating all of the pieces of art in the game. Does anyone have a good way to schedule creative stuff? If so, please let us know!"

Should Have Made a Demo

Demo versions serve an important function for a video game — they allow players to experience, without making a significant commitment, your game first-hand. In the case of a game like *World of Goo*, namely, a game with such a fresh, novel approach to many aspects of the experience — style, story, core game play

mechanics, etc. — a demo can be especially crucial in allowing players to get a sense of the new experience.

Looking back, Carmel and Gabler regret not moving more quickly with a demo version, and planning to release a demo at the same time as the game. "We failed to realize that customers weren't sure what to expect from a weird game about building stuff with goo balls, and that they would be reluctant to buy a risky game where they had no idea what to expect," concedes Carmel. "We finally released a demo a few days after launch, and quickly saw sales increase."

Figure 7. Releasing a demo at the same time as the game would have helped initial sales of *World of Goo*.

Used Shared Hosting

World of Goo has enjoyed an incredibly active user community. Player-generated wikis include extensive level-by-level walk-throughs, detailed descriptions of every element in the game, fan-created add-ins to enhance the core gameplay experience, as well as 'high scores' leaderboards where players can log in and post their accomplishments and compete with other players world-wide. One of the most popular leaderboards tracks the highest towers built by players in a bonus activity within the game called the *World of Goo Corporation*.

All of this online activity represents an opportunity for 2D Boy to interact with their engaged and passionate fans; however, all of this activity, for the most part, is happening on non-2D Boy sites. Gabler and Carmel have come to regret their decision to utilize shared

hosting services for their website as well as score-reporting functions of the game itself, recognizing the missed opportunity here. "We used shared hosting for our website and score reporting," says Carmel. "Shared hosting providers are unreliable. The bottom line is that our sites have been flaky, which has cost us sales."

Tried to Multitask

Clearly, leaving Electronic Arts to launch 2D Boy was a risky move. Early on, Carmel and Gabler took on consulting projects on the side in order to help make ends meet. Initially, the concept was to work on both endeavors — consulting gigs as well as their game — but at the end of the day it proved too diverting, and they made the difficult decision to forgo the consulting income, and the peace of mind that came with it, in order to focus entirely on *World of Goo*. Ultimately, they realized this was the only way that they could, as a two-person outfit, get the game done. As Gabler recounts: "Luckily, we discovered that consulting was distracting us from what we really wanted to be doing, which was making *World of Goo*, and so we decided to focus entirely on our game, even at the risk of going completely broke."

Figure 8. Gabler and Carmel risked 'going completely broke' in order to focus entirely on *World of Goo*.

Wrap Up

2D Boy's first title, *World of Goo* has been wildly successful as WiiWare as well as on the Windows, MacOS, and Linux platforms. An iPhone version is also in the works. *World of Goo* reaped a wide range of awards and collected the highest praise from a wide array of industry reviewers. Amazingly, this highly

polished and best-selling game represents the efforts of only two individuals who decided to forgo other opportunities in order to pursue their dream of making a great video game.

In a series of essays exploring the process of creating *World of Goo*, Rob Carmel wrote: "Probably the most important thing I have learned from Kyle so far is that game design is more about crafting an experience than perfecting a game mechanic." *World of Goo* offers a wonderfully engaging gameplay mechanic. But it goes way beyond the mechanic, elevated through the story, the art, the level design, the music — the whole package. *World of Goo* achieved what all great games achieve — it is more than simply a great game; it's a great experience.

Figure 10.9. *World of Goo* rises above.

Team Role Interview: Art Director

Please introduce yourself, your role, and the game team(s) that you have been a part of.

I am Rich Curren. I am currently Creative Director at Nexon America; previously I worked at Electronic Arts Canada, where I was one of two Art Directors on *SSX On Tour*.

How did you get your start in the games industry? How did you come to be a member of the *SSX* team at EA?

I was working as a design director for a studio in Vermont called Jager Di Paola Kemp Design. We were hired by Electronic Arts to do some branding work on one of their games, and as part of that project, I got to travel to EA and meet the team. Little did I know that these people were the core of the *SSX* team. A few years later, my wife and I were considering a move to Vancouver, so I called the Creative Director I had worked with on the previous branding project to inquire if there might be any opportunities for me at EA in Vancouver. I was just fact-finding, but 2 weeks later I heard from some of the people at EA and they seemed interested in talking to me more seriously. My wife and I ended up traveling out to Vancouver for a family visit shortly thereafter, and I went in to the studio on that trip and met some more people.

Since I had no 3D experience or games background, there wasn't a clear fit for me, and I wasn't sure I wanted to get into games myself. I suggested that I come out for a month-long test period, and they thought that was a good idea. After a month, during which I worked on three different projects, they made me an offer, and I moved up to join the *SSX* team.

As Art Director, what is your part of the process? Did you have a sense of the larger picture, and of how your contributions would be used in the final product?

Definitely. Jager Di Paola Kemp did everything for Burton snowboards for the prior 15—20 years. We were integrally tied into the snowboarding scene, so when I joined EA, I was suddenly one of the team's content knowledge experts. My role involved being in charge of the overall sensibility and personality of the game, and more specifically the look and feel of the front-end, HUD, and in-game movies. I was also heavily involved in things like naming in-game events, creating in-game pickup items, and also setting the music and audio direction for the game — we moved away from the brand's techno/rave style to something that was more reflective of snowboard and youth culture at the time: the second coming of rock.

When we suggested having Judas Priest, The Scorpions, Motorhead, and yes, even Def Leppard in the game, we got a lot of blank stares. But after some initial testing the music got the highest rating of anything in the game, so we gained enough credibility with the Producers and were able to run with the musical direction. More importantly, I got to fulfill a lifelong dream of using an Iron Maiden song in our intro movie. The change in musical direction, along with the hand-drawn graphic aesthetic, ended up being the driving stylistic force for the game.

What can the Art Director do to ensure that the game you are working on is great? What is your part of the process?

My role was to make sure that the game was relevant to the current day in terms of look and feel, and that the style and personality support the gameplay and be consistent with the actual culture of snowboarding. I'm not sure that I would characterize *SSX On Tour* as a 'great' game, but I think it was the best game we could make under the circumstances, and it was reviewed positively by fans as well as the press.

For me with *SSX On Tour* it really came down to answering one question: How do we best re-envision the *spirit* of snowboarding? It was never going to be a sim, since a huge part of what made the franchise great and accessible was the over-the-top gameplay and fantastic tracks. We had to find a new voice that supported these ideals, and since this was the fourth version of the game, I felt like the rave and techno music and the super clean aesthetic that came with it had passed. Accepting this allowed us to take a fresh look at the overall graphic

Team Role Interview: Art Director—Cont'd

sensibility, and we were free to embrace the scrawlings of a 15-year-old listening to Motorhead as our visual mantra. Oddly enough, the presentation elements (front end, intro movie, etc.) wound up being one of the first things most reviewers talked about.

What was the strangest or most unexpected part of working on *SSX On Tour*?

One of the more unexpected aspects was the entire experience of getting the sketchbook, hand-drawn style front end into the game. The first time we showed the front end to people — the first time it appeared in a playable demo — people were like, "Yeah, that's kind of funny and cool, but when are you going to put the real front end in the game?" The hand-drawn style was fresh, it didn't take itself too seriously, and it looked pretty different from everything else out there. Later on, the same people that had questioned the style wanted it infused into the back end of the game — the snow markings, pickups, the HUD — anywhere it could conceivably go. It was pretty striking — the turnaround from that initial reluctance to embracing the style, to "Give us more of those doodles, and more Iron Maiden."

What was the most satisfying aspect of working on *SSX On Tour*?

I'd have to say having the chance to use the song 'Run to the Hills' in our intro movie. One day we were having a music meeting, and the Executive Producer popped his head into the office, and he was like, "Iron Maiden? Kids don't listen to that stuff, they listen to Avril Lavigne." But a few weeks later, after we got a lot of positive feedback from testing, there were no more calls for Avril Lavigne. The fact that we got away with featuring a unicorn hammering out Iron Maiden on a double-necked guitar in our intro movie is a personal career high point for me.

What about the flipside — the least satisfying aspect of working on *SSX On Tour*?

SSX On Tour was the first game I ever shipped, so it was all pretty novel to me and kind of exciting to see it all happen. Most of what I wanted to happen happened. There was a little coalition of people on the team who had worked on previous versions of the game who didn't like all the changes we were making. In particular, one guy was fairly religious and had some personal issues about our use of hand-drawn skulls in the game — he felt it was somehow an evil thing to do — even though they were pretty comical. We actually ended up having to have a meeting about exactly how many skulls were in the game, and coming out of that meeting, we had to back off on the skulls. Looking back, it's all kind of humorous, but at the time I wanted my skulls!

What went right? Can you highlight a few areas of success during your period of involvement with making *SSX On Tour*?

The biggest thing was that it felt like people trusted my opinion on what snowboarding was and wasn't, and really let us try things, and then embraced them if they worked.

You know, it was kind of a special project, because really not a lot went wrong. I think we were in this sweet spot within EA — the franchise had enough of a track record of success that we didn't have to worry about it getting canned, but also it wasn't so big that it was under the microscope. It was small enough on the EA radar that it wasn't over-scrutinized. If it had been a huge-budget game, I think more eyes would have been on it, and the creativity likely would have been watered down.

One other element that might seem a bit weird is that it felt like at the end of the day *SSX On Tour* is a game that I would be proud to show any real snowboarder. I feel like I got to inject a lot of the sensibility of snowboarding, as well as the humor, music, and overall 'we-don't-take-ourselves-too-seriously' culture of the sport into the experience. When I got a chance to work on the *SSX* brand, I knew I was going to inject it with more 'reality' — not to make a dry simulation of something real, but more of an honest representation of snowboard culture — and I was really happy to be able to successfully get that in there.

Team Role Interview: Art Director—Cont'd

What went wrong? Likewise, please describe three to five areas of difficulty, or what you perceived as missteps, and what you would do differently next time.

In terms of the game itself, I think the inclusion of skiing didn't help us too much — in fact, it actually feels like it detracted somewhat from the snowboarding. We had to split animations, assets creation, everything, in order to accommodate the skiing, so we couldn't do as much with the snowboarding, which was really core to the brand and the game. I understand that we were trying to make it more popular, ultimately trying to add sales by including skiing, but in the end I think it took away from the core snowboarding experience.

We also made a big effort to get real brands in the game — skis and snowboards, as well as clothing and gear — and most of the companies were fine to work with, but on the whole, I'm not sure it was worth it. I would rather that we had contracted a bunch of artists to create new stuff for us for the game — I think that would have been more interesting.

A couple of other things had more to do with our 11-month production cycle, from pre-visualization to getting it out the door. We just didn't have enough time to innovate on the gameplay as much as I would have liked because the cycle was so fast. Ditto for the written copy in the game — I think the tone of voice could have been better — and I think the variation in the front end could have been greater. But again, a lot of things had to happen in a short amount of time.

Any parting thoughts?

This might sound nerdy, but you really do have to challenge conventions. I think there are certain conventions that just become accepted as part of video games, and if you identify and challenge them, you can often come up with something just as relevant but a whole lot more interesting and engaging. You can find opportunities for this in pretty much everything — style, story, aesthetic, subject matter. For instance, why does just about every MMO have to have goblins, knights, mages, and a fantasy theme? When we looked at the *SSX* franchise, everything was shiny and slick and felt too 'produced.' We went in an opposite direction — everything was just four colors — black and white with pink and yellow highlights. We used drawings that looked like they were produced by a 15-year-old kid — and not even 'good' drawings at that. We committed to this concept and it worked. So, we challenged some things and I think it paid off for us.

I feel that gamers are open to new styles — in fact, they crave it — and all too often lately, it seems games fall back to a variant of photo-realistic as the 'visual style,' but if you can't pick it out of a lineup it's not really a style at all, it's just photo-realistic. Perhaps development studios don't give gamers enough credit, or they aren't trying hard enough to do something different, but I think when you do take the chance and commit to it, you get rewarded. I think there's a lot of room out there on the visual style side to do something new and excite gamers at the same time.

PART

2

ANALYSIS

COMMONALITIES: WHAT GOES RIGHT

We have gotten a peek behind the scenes at a variety of games across a variety of genres, platforms, and gameplay styles. We have looked at enormous projects — games created with multi-million dollar budgets — as well as at some truly great games developed by small teams. We have learned about making sequels to smash hits, as well as launching brand-new intellectual property. We have heard from the creators of platform-exclusive titles as well as titles released simultaneously on multiple platforms. *LittleBigPlanet* represents a new brand on a relatively new platform, the Sony PlayStation 3. *Madden NFL 10* continues a long-standing tradition, first launched in 1989. We've looked at *FarmVille*, the most popular social game in the world, as well as *World of Warcraft*, the most popular Massively Multiplayer Online Role-Playing Game in the world. We've heard about the creation of *Uncharted 2: Among Thieves*, the highest Metacritic-rated game of 2009 on the PlayStation 3.

We have also visited with several industry professionals, folks currently working on high-profile games, who have shared their thoughts on their specific roles on the teams working to create great video games.

This book represents only a miniscule sample, a tiny collection of representative examples from the scores of great games that have been created over the past several years, and an infinitesimally small set of the voices from among the thousands of Programmers, Artists, Designers, Writers, Producers, Composers, and other games professionals collaborating to make video games. Each and every game team, and each and every game project, is unique, with its own set of advantages and challenges, its own group of creative individuals and all that they bring to the table. Trying to directly mimic a successful team's efforts would be pointless, due to the unique circumstances that surround the creation of each and every game, not to mention the shifting sands of the ever-fickle and fast-moving marketplace.

At the same time, it is illustrative to look for commonalities across the processes of making these great games, to dig deeper

Making Great Games. DOI: 10.1016/B978-0-240-81285-4.10011-X

in order to tease out potential common key success factors that crop up in the examination of what went right in looking back at the creation of these particular best-selling and critically acclaimed projects. The goal here is for all of us to try to make better games. So what can we glean from our explorations? What commonalities emerge across platforms, varying team sizes and budgets, and disparate project and studio goals? In this chapter, we'll explore some of the best practices that rise to the surface in terms of 'what went right' in the creation of some of the world's greatest video games, in the hopes that some of these practices can in turn be applied to the future of games creation.

Iteration Is Paramount

A certain amount of iteration nearly always accompanies any creative process – and the more complicated the process, the more important iteration seems to be. I have heard of song-writers describing a flash of inspiration, or even dreaming perfect lyrics and melodies that they simply wrote down once they woke up. In terms of making games, while lightning strikes of inspiration are part of the process, the overall undertaking is so complicated that it is impossible to imagine the equivalent of waking up with the thing, or even part of the thing, there for you, ready to go.

The teams that made the games highlighted in this book have all built iteration into their development process, and many point to their emphasis on this iterative process as a key success factor in their practice of making games. Iteration, at its core, encapsulates the prototyping process. You put something together, try it out, and tweak and tune until you achieve desirable results. Moment-to-moment gameplay is an interactive experience, and you can never be quite certain about how those pesky players are going to respond to the information that you are presenting to them. It is only through testing and observation, either real-time, direct observation or data collection and analysis, and preferably both, that game creators can gauge how their designs are actually being experienced and understood. Iteration is a key part of that creative process.

The development of *World of Warcraft*, the world's most popular MMORPG, incorporated a vast amount of iteration. J. Allen Brack, *WoW*'s Production Director, highlighted a key area of the game that benefited from their focused, iterative efforts – the raiding system. Raids are a key component of *WoW*, as they offer guilds the opportunity to gain rewards and level up, a key motivator for players. As *WoW* has evolved over the release of dozens of updates and patches as well as multiple expansion

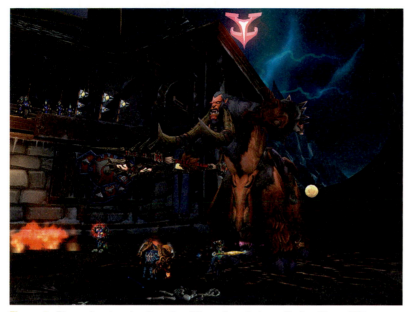

Figure 1. Through extensive iteration Blizzard settled on offering 10- and 25-person versions of all raids in *World of Warcraft: Wrath of the Lich King.*

packs, the team has iterated on the raiding system, eventually deciding to include 10- and 25-person versions of every raid in the game.

PopCap's Co-Founder Jason Kapalka, discussing *Bejeweled Twist*, also highlights the benefits to that project that resulted from extensive prototyping and iteration. "We ended up trying a large number of different mechanics and meta-mechanics during the development of *Bejeweled Twist*… and we modified, simplified, or outright chucked a lot of the more complicated mechanics." Time for iteration gave the team at PopCap the confidence and ability to ditch whatever wasn't quite working in favor of the elegant, simplified game modes that resulted from these extended, focused experiments.

Eric Zimmerman, Co-Founder and Chief Design Officer of Gamelab, tells a similar story in recounting what went right in the creation of the original *Diner Dash*, a casual game classic. *Diner Dash* was Gamelab's first game, and Zimmerman speaks of forming the company with an explicit goal of making iteration central to their design efforts. "We established a very relentlessly iterative process," as Zimmerman put it. "Our idea from the beginning was to make just enough of a plan to get us to the next step in the process. With all our games, and especially with *Diner Dash*, we based our design decisions on our experience of the current prototype." This relentlessness helped *Diner Dash* to

achieve its iconic status, and to play its role in popularizing so many gameplay mechanics that have become standard casual game fare.

Rapid prototyping and exhaustive iteration are hallmarks of the development process at Naughty Dog as well, creators of *Uncharted 2: Among Thieves*. As Game Director Bruce Straley explained, they strive to get ideas 'onto the controller' as quickly as possible, and continue to iterate on the player experience even into the beta phase of development, despite the significant pressures and challenges this adds to the team. They simply view these sacrifices as worth it in their effort to attain an incredibly high quality bar for their games.

Rock Band, LittleBigPlanet, Madden NFL 10, World of Goo, Half-Life 2 — without exception iteration played a key role in each of these wildly successful game projects. Several of the team role interviewees as well speak about the critical position of iteration, and of having enough time in the schedule to iterate if you set out to make a great game. I would offer that, more than any other single factor, a hearty emphasis on iteration is a common thread that binds the creation of each and every great game discussed in this book.

Cabals Taking Over?

'Cabals,' used to refer to the concept of smaller, cross-disciplinary work groups popularized by Valve Corporation, have clearly found their place among some of the world's highest performing teams making video games today. Several of the industry leaders I spoke with mentioned being inspired by Valve specifically, and referenced a December 1999 Gamasutra piece by Valve's Ken Birdwell on the cabal structure that Valve employed in the creation of the original *Half-Life*. The successful implementation of this structure, or more specifically multiple individual iterations of modified versions of this structure, represents a real paradigm shift in the way games are being made.

Unequivocally, it seems that the days of the modeling department being handed a design specification by the design department are numbered. Smaller groups — 'molecules' at Media Molecule, the creators of *LittleBigPlanet*, 'bands' at *Rock Band* maker Harmonix — are responsible for specific areas within larger game projects, setting their own goals and being held responsible in a 'soup-to-nuts' fashion for complete features, levels, etc. In fact, I suggest that games creation is moving toward a creative system more aligned with a film-making paradigm, where interdisciplinary teams sit together for 'dailies,' in which they review progress from the past day on their piece of the puzzle, look

collectively and critically at where things stand, and generate a list of what needs to be fixed or addressed for the next day.

This process engenders ownership across multiple levels of contributors, allows for quick iteration, and keeps a sharp focus on quality. It also seems to result in better integration along functional lines and a more critical approach to the quality of the end product, due to the process of reviewing features as a group.

Greg LoPiccolo, Vice President of Product Development at Harmonix, spoke of his team's central design goal of trying to recreate the experience of playing in a band in their creation of the original *Rock Band*. One of the teams directly inspired by Valve, they tweaked the approach to meet their needs, resulting in "a mutant variant of Valve's cabal process" that LoPiccolo pointed to as a means they utilized to incorporate valuable design insights from busy senior members who otherwise might not have been able to plug in to the development process.

Media Molecule represents another team directly inspired by Birdwell's Gamasutra piece. The incredibly distinct, fresh, and commercially successful *LittleBigPlanet* grew out of the company's 'game jam' design process, their own interpretation of the cabal structure, tweaked to meet their own specific needs and goals for the project. Siobhan Reddy, *LBP*'s Executive Producer, speaks of the central role their molecules play not only in the creation of the games, but also in the creation of their company culture. It is hard to imagine a game as fresh and dynamic as *LBP* growing out of any other process.

Figure 2. It is hard to imagine *LittleBigPlanet* being created outside of Media Molecule's 'moleculized, game jam' design style, which was directly inspired by Valve's 'cabal' design process.

And, of course, there is Valve themselves, and their own evolution of the cabal process that was used in the creation of *Half-Life 2*. Valve famously did away with the centralized 'Game Designer' role during the creation of the original *Half-Life*, and they took this process even further in making the highly anticipated, much larger, and ultimately much more successful sequel, *Half-Life 2*. Robin Walker, Designer and Programmer on the *Half-Life* series, expressed his opinion that the creation of video games is particularly well-suited to the cabal structure, due to the nature of the games creation business, which he describes as "part functional, part creative," and one that strives "to balance the right amount of innovation, production quality, and interesting experiences in our games."

Again, the similarity to creating film strikes me here — another endeavor that at its core is half creative, half business. There is, however, a key difference around the interactive component of games — the fact that the experience is not entirely controlled by the creators, but is also partly up to the player. This exacerbates the need for a 'dailies' type of process, where what is being created can be touched and experienced by the creators, looking together as a group, in order to move forward with the changes, tweaks, and course corrections that result in a great video game.

In terms of smaller teams, it also appears that successful smaller teams are essentially functioning as one cabal, operating as a cross-disciplinary unit, with all members looking at the entire output, rather than simply focusing on their smaller piece of the puzzle.

A modified cabal structure may not be right for every type of game, but it certainly bears consideration, as evidenced by the successful implementation of this structure across such a wide variety of extremely successful video games.

Beg, Borrow, and Steal

Traditionally, many game teams, even incredibly successful ones, have suffered from what is referred to as 'NIH' syndrome: Not Invented Here. Even teams approaching work on sequels have shown the tendency to re-work, re-write, re-do everything from scratch. There seems to be an emerging trend to shy away from this practice and to recognize that gaining a leg up on development, even if it means giving up a bit on specific areas of what the game can do or how it can perform particular functions, can be a worthwhile trade-off.

This is growing more and more true, as (1) games continue to become larger, requiring larger teams and higher stakes, and (2) more and more capable and dynamic technologies become available to game creators. From core functions such as rendering

to complete game engines, more and more options are available for licensing or through open source models. There are many good choices, and a wide variety of successful and instructive examples of great games — award-winning and best-selling games — built using game engines such as Source or Unreal are out there serving as references.

Why would you not seriously consider using something that exists already? If your game relies on a new mechanic, like *LittleBigPlanet*, then there simply may not be an engine out there that accommodates your design. But if your game is a novel twist on a first-person shooter, it may worth considering the trade-offs of licensing an underlying technology and conforming your design to what the engine can accomplish.

FarmVille, as of this writing being played by more players than the players of all three major consoles combined, saw great advantages in leveraging existing technologies to get to market faster. Mark Skaggs, *FarmVille*'s Creative Director, spoke of his team's mantra of "not reinventing any wheels" during the game's production. Skaggs credits the team's approach of taking advantage of working code bases, both player-facing and underneath the hood, mostly leveraged from other Zynga games and teams, with saving a lot of headaches and allowing the team to "ship the game as quickly as we did."

Figure 3. *FarmVille*, Facebook's most popular application, benefited from the creative team's leveraging of technology from *YoVille*, *Mafia Wars*, *Zynga Poker*, and other Zynga games.

Rock Band grew out of a long history of music/rhythm games, and Harmonix was able to take advantage of their mature code base, which they used as a springboard to test and tune new mechanics. *Madden NFL 10* tapped into their extensive fan

community to refine specific features; this rapid design iteration, despite a 12-month development cycle, was enabled by having a well-established code base in place to lean into and borrow from. With *World of Warcraft*, Blizzard drew on years of technology development utilized in previous, stand-alone games.

The point here is this: don't compromise, but look for shortcuts that will allow you to get where you want to go faster.

Focus on Talent

Perhaps this seems painfully obvious, but almost every single contributor to this book with whom I spoke about making great games emphasized the importance of their team. Making great games, for the most part, is a team sport. Each and every member of the team is a critical resource, and this becomes more important as projects grow in scope and require more and more people to get the job done. You simply must hire the right people. If experimenting with cabals, or a cabal-inspired structure, these smaller groups will need to have the autonomy to develop and iterate on their own design ideas, and this often means they must be trusted to experiment without direct supervision from above, making having the right people in place doubly important.

In discussing the successful cycle of building *Madden NFL 10*, Creative Director and Lead Designer Ian Cummings spoke of the benefits of combining engineers with years and years of experience with the *Madden* code base with a crew of designers who were new to the franchise. Media Molecule's Reddy, in discussing their game jam approach to designing *LittleBigPlanet*, compared this process to putting a band together, emphasizing the importance of having the right people in the band in order for it to work. She spoke of her company's early struggles to develop an effective method for interviewing and hiring new members into the team, and of finally getting this process right as a key contributing success factor for the game.

Several key contributors to these great games, notably Greg LoPiccolo at Harmonix, also spoke of the trust factor as being instrumental to the success of their development efforts. Again, this is especially true with smaller, cross-disciplinary teams working independently on features, levels, or other 'chunks' of larger games.

These are simple truths, perhaps self-evident, but I think the lesson to be learned here is one of patience. Finding good people is hard. Oftentimes, game teams are desperate to add bodies to their project in an effort to make deadlines. However, if you are perhaps filling a seat with someone who can do a particular job, but who might not (1) be excellent at their role and/or

(2) engender a feeling of trust among the other members of the team, it may make more sense to hold off and wait for that right person. Great games are made by great people, and it is important to recognize that, on balance, the long-term benefits will more than offset any short-term hassles or consequences of waiting to be sure that you've got the right person for the role.

Use Your Whole Company

An often overlooked resource, especially at larger companies, is the company itself. In a large studio, where multiple teams are working on multiple titles, teams tend to become 'siloed,' each focused on their own individual games, scrambling to meet their own deadlines and understandably wrapped up in their own projects. There is often internal competition as well, in terms of both the fight for resources and 'friendly' competition to attempt to out-perform other games in the marketplace or in Metacritic ratings.

Many of the game teams featured in this book managed to find a way to tap into the wider talent pool within their own companies, and used this talent to their advantage. One other particular challenge as companies evolve is that key creative people tend to move 'up the ladder,' often winding up in management or other overseer roles, thereby becoming less involved in the hands-on creative process. This was outlined by LoPiccolo at Harmonix, where he includes himself in the group of creative people who have found themselves "kicked upstairs" and somewhat removed from the creative process. While making *Rock Band*, the team made a concerted effort to loop these folks back into the process through their utilization of smaller, independently operating teams responsible for specific features within the game. These small, lithe teams were able to tap into the senior management on a regular basis and fold their feedback into the development process.

Skaggs, the *FarmVille* Creative Director, highlighted the teams' efforts to utilize the wider, entire company as critical to the game's ultimate success. "The core team for *FarmVille* was only 10 people," as Skaggs explained in our interview. "But people from all over the company helped us and... we got some great ideas from unlikely sources, and having so many different people pounding on what we were doing allowed us to keep improving the quality of the experience."

WoW was Blizzard's first foray into the world of MMOs, and the game's Production Director Brack spoke to their process of tapping into the entire company to help iron out the kinks specific to this new MMO world — monthly subscription fees, how many quests made sense, etc. — that they were embarking

Figure 4. The *Rock Band* team made a concerted effort to tap into the collective wisdom of the entire company, especially the senior management who had been "kicked upstairs."

on. What on the one hand could be seen as a disadvantage — namely, the company's lack of core competence with the type of game they were making — was turned into a net positive by testing and paying close attention to the results.

At the smaller studios highlighted in this book — Gamelab, Media Molecule, 2D Boy — the entire company was effectively working on the game together. There is something tangible within a game that has had the attention of the entire company, even if the entire company is the team making the game. Attempting to capture that magic of an 'all hands on deck' approach to game development is a wise move, and one that can lend a certain intimacy to projects, even those created at the world's largest development studios. Demonstrating your game-in-progress at lunch, at company gatherings — any chance you get — can pay huge dividends in terms of the overall quality of the project at the end of the day. It's amazing to consider how much has been bartered for with pizza over the history of video game development.

The bottom line? Be creative and entrepreneurial about enlisting help. Look close at hand and far afield for resources to tap into, and use those resources to solicit feedback. Utilize your entire team, and your entire company, if possible, to help you make the best game you possibly can.

Playtesting as Production Driver

Most teams take advantage of formal as well as informal play-testing in the development of their games. At the same time, we

see a pattern among some of the wildly successful game projects in this book of these teams really leaning into the playtesting process — both formalized testing and informal testing — as a production driver that allows them to make more informed, ultimately better decisions.

This is somewhat closely tied to the iterative process; as described above, iteration means producing something, testing it, paying attention to the results of that testing, and turning the crank once again on the piece that was tested. However, there is a marked difference between simply iterating and focusing on the playtesting itself as the key driver of production. In many cases, testing is considered after the fact, and the folding in of any feedback or ideas that come out of the testing process is very much a reactive procedure. 'We saw this in test; we need to fix it' is typical. This type of course correction, which I think is more traditional in the games industry, is very different than the forward-looking playtesting that several teams talked about as critical to the success of their games. With these projects, the teams set out to use testing in a proactive way — they went into the entire process of development with a shared, explicit focus on the playtesting process as part of the design and development process.

This was baked into the development process at Naughty Dog during the production of *Uncharted 2: Among Thieves*. Their extensive formal and informal playtesting, on hardware set up in their offices specifically for testing and data gathering, drove their decisions on what to work on to make the game better. As Straley explains, "We simply went for the most frustrating experiences for players and worked on alleviating these problems." He spoke of their philosophy of not allowing themselves to deny player feedback, and of really respecting and honoring the test players' experiences and letting these test results dictate what is important to address.

For *Rock Band*, Lead Designer Rob Kay spoke about their extensive, early testing of the drum prototype, one of the key new features introduced in the game. With *Half-Life 2*, Walker spoke of 2 years of a "constant cycle of playtesting," and called this process instrumental to the overall success of the game. At Valve, they organized formal, weekly playtest sessions with fresh, outside testers and took detailed, data-driven notes on what they observed. These notes and findings formed the basis for the week's work, which in turn would be tested the following week. Blizzard's Brack also highlighted the "unbelievable amount of testing" they conducted with *WoW* and its expansion packs.

If you're working on a new mechanic, or at least a new twist on a tried-and-true mechanic, there is simply no substitute for

Figure 5. The *Half-Life 2* team spent the last 2 years of the game's 5½ year development cycle in a 'constant cycle of playtesting,' continually refining and improving the moment-to-moment gameplay experience.

careful, methodical observation and analysis of 'real' players playing your game. I have yet to hear of a team complain that they conducted too much testing during the course of developing a successful video game.

Miscellaneous

There are a few additional success factors, highlighted by the teams discussed in this book, that, while not repeated by other teams, and thus perhaps not universally applicable to all games, bear mentioning here, as I think they offer particularly useful guidance.

There were two factors highlighted by Naughty Dog's Bruce Straley as critical to the success of *Uncharted 2: Among Thieves* that struck me as particularly noteworthy. First were the benefits to the single-player experience provided by the addition of multi-player modes to the game. Adding multi-player gave the team an entirely new set of filters through which they could evaluate the moment-to-moment experience of the game. The second was the team's approach to using actors. Naughty Dog paid enormous attention to the process as they endeavored to create a 'playable summer blockbuster.' What they did was not rocket science, especially when viewed in hindsight, but it was novel in the world

of games. They treated this aspect of creating *Uncharted 2* as if they were making a movie, workshopping the actors together in their roles, allowing them to develop their own characters as well as their relationships as characters, and the results are astounding. The game grabs you as a player; the characters are more 'real,' you care about their story and what happens to them. Perhaps their location not far from Los Angeles and the world of moviemaking gave them an unfair advantage, but if you're working on a story-driven game, there is a lot to be learned from the process at Naughty Dog.

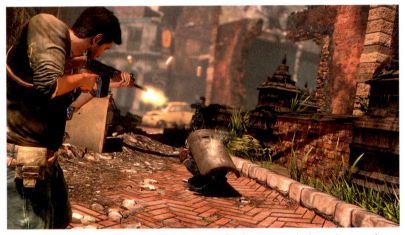

Figure 6. *Uncharted 2: Among Thieves* benefited enormously from the team's focus on integrating actors into the development process.

In his discussion of *Half-Life 2*, Robin Walker talked about the benefit of building the beginning last. He pointed out that the beginning is the most important piece of the game — this is the part that every player who launches the game experiences. In imagining a video game in development out in the world, I sometimes envision a downward sloping curve, with players on the Y axis and time in game along the X axis. As you move out along the X axis over time, players drop out of your game. Some will give it one minute, less will give it one hour, significantly less will finish the game entirely. So, that first minute is experienced by the largest percentage of people playing your game and so therefore is the most important. By building this first minute last, once most of the other unknowns are sorted out, the *Half-Life 2* team was able to benefit from the process of making the game itself and to emphasize what is arguably the most important part of the overall experience — the beginning.

Authenticity was another factor highlighted in the recollections of the development of both *Madden NFL 10* and *Rock Band*. Both teams used the yardstick of authenticity as a guiding design principle and felt that staying focused on this clearly defined goal allowed their teams to grok the overarching vision and helped make decisions easier along the way. Should we do A or B? Well, which is more authentic? This factor, of course, applies to games that attempt to simulate something real more than to indulge fantasy experiences, but the point is that having a simple, easily understood guiding principle makes a huge difference once you're in production on your game.

Finally, I appreciated PopCap's Kapalka's discussion of simplicity trumping complexity in the evolution of *Bejeweled Twist*. Simplicity can be mistranslated at times as a perceived lack of challenge or engagement on the part of the player. However, I view simplicity as a hard-wrought result that emerges after rounds and rounds of iteration. In UI design as well as in gameplay, being simple enables the player to become more immersed in the experience itself – playing the game instead of playing the interface is another way to describe this. When I consider an element of *Bejeweled Twist* to be simple, I understand this to mean an element that has evolved through rounds and rounds of testing and tuning to the point where it has been stripped of anything superfluous. The game is simple in the same way that checkers is simple – elegantly simple.

Figure 7. The elegant simplicity of *Bejeweled Twist* is the result of intense focus and relentless iteration.

Wrap Up

Each of the case studies presented in Part 1 of this book provides insights from the team's perspective on some key factors that led to their successes. In this chapter, we have taken a step back to look at these postmortems as a group, and to tease out certain key learnings that were called out by multiple people working on such different kinds of games. These gleanings can serve as a useful set of tools and tricks of the trade of making great video games. Next, we'll take a look at some common missteps experienced by these teams.

12

COMMONALITIES: WHAT GOES WRONG

Each of the games we examined in Part 1 of this book was an enormous triumph, both critically and commercially. This collection of 10 featured games, while a tiny subset, represents some of the 'greatest hits' out of the thousands of video games produced on various platforms over the past several years. By any measure, these projects were incredibly successful. Yet all projects face a wide variety of challenges, and, with the benefit of hindsight, there are always elements of the creation and development process that the creators feel could have been handled differently or gone more smoothly.

The postmortem is a common practice among successful games teams, both large and small. *Game Developer Magazine*, the industry standard, features an in-depth postmortem of a high-profile game project in nearly every issue. In some development studios the practice of conducting a postmortem is formalized and facilitated by someone outside of the team itself. At other studios the process is more informal, but all good teams, usually after some much-needed, recuperative time off, look back on their creative process in an effort to highlight best practices, as well as to call out identifiable missteps in order to try to avoid them the next time around.

The creators of the games in this volume are all incredibly proud of their games, as they should be. It is always easier, and more pleasant, to talk about the 'what went rights' than the 'what went wrongs,' especially when discussing such incredibly successful projects. Nevertheless, learning from their mistakes, and working to not repeat mistakes, is one of the hallmarks of high-performing teams.

Taking stock of the collection of postmortem case studies presented in Part 1, what common pitfalls emerge? What mistakes, or perceived mistakes, have tripped up multiple teams striving to create hit games? What skeletons lurk in the closet — where did these projects, large and small, go off the rails? What can we look at and learn from as we think about making our own

Making Great Games. DOI: 10.1016/B978-0-240-81285-4.10012-1

games? Most importantly, are there common faults that you can try to be aware of in an effort to alleviate potential struggles in your own current and future game projects?

Test, Test, Test

As mentioned in the 'Commonalities: What Goes Right' chapter, I have yet to hear a developer lament the fact that she or he did too much testing during the course of their game's development. Creating interactive experiences is hard. You simply never know how your target player is going to react to the game until you see it happen. Watching a 'real person,' an actual player, sit down and try to figure out how to play your game is an illustrative experience, and one that can be daunting as well as frustrating. Why don't they see that button staring them right in the face? We just told them exactly what they need to do, aren't they paying attention? It's so obvious; I can't believe they can't pass this level! Is he stupid or what? As 2D Boy's Rob Carmel put it in a piece he wrote on the development of *World of Goo*: "Why are these play testers so bad at my game? Do they simply suck?"

The rubber meets the road when the player picks up the mouse or controller and dives in to experience what you have worked so hard to create. Games are ambitious projects, and during the course of the development cycle all kinds of challenges emerge − technical hurdles, staffing issues, feature creep, incomplete design − that can all cause delays. The end result is usually schedule compression and a 'crunch' period to try to get everything you have planned for into the game and up to an appropriate level of quality. Often, testing cycles are skipped or underemphasized. This is understandable, as testing is really a non-tangible aspect to making a game. If I create another level, I have another level to show for my work. If I complete a series of user tests, I have a bunch of notes and maybe a cache of data, but there is no tangible difference to the game after I have completed these tests. Nevertheless, several of the game creators pointed out the perils of not doing enough testing, and their wish to go back and have done more.

Diner Dash was built within a development model and culture that prized iteration. Their explicit plan was to build the experience out to a certain level, test, and then use the test results to drive design toward the next milestone. Even still, Eric Zimmerman, Gamelab's Co-Founder and Chief Design Officer, spoke about missed opportunities for more testing, especially with people from the game's target audience. As he relates: "If we had been more rigorous about a testing process that emphasized members of the casual game audience, I think we would have been better clued into things like the difficulty scaling and

Figure 1. More testing with casual gameplayers could have helped the creators of *Diner Dash* better tune the game's challenge ramp.

challenge ramp, and we could have better targeted the game toward casual players."

Creative Director Mark Skaggs also worried about ongoing issues with the leveling curve in *FarmVille.* "I think we could have done a better job tuning the game and tailoring our level curve to our target players," he explains. The only way to truly influence this aspect of the game — to get a real read on leveling — is to test. How long is it going to take players to get through the first level? What about from level 4 to level 5? Watching the person who made the level play the level, or someone else from the team, just doesn't work. You need to observe players, actual players.

Observation has challenges of its own, most significantly that players don't always, or ever, behave under observation the way they normally would at home or wherever they ultimately play your game. Oftentimes there's a natural bias to try to please, especially if players know that the game makers are watching them play.

There are well-established means to conducting testing in order to alleviate some of these potential issues. I like instrumented builds with a closed beta test, meaning the game code itself is implemented with tracking as well as data collection components. Ideally, players are given an opportunity to play your game in the exact same environment that they will eventually play the game — in their home, for instance — and the game simply tracks and reports what they are doing. How long did they spend in the tutorial? How many play sessions did it take before they reached level 3, or ship 2? Is there a certain level that's taking

players a lot longer than others? Is everyone dying in the exact same spot? Do people tend to quit at the same point in the game? Data wrangling and analysis can go a long way in helping you tune your game and experience. Ideally, you tune any problem areas and then re-test (with a new group of testers, of course).

Is it ever too early to test? *Half-Life 2* suffered, according to its Designer Robin Walker, from a lack of testing early on, even though testing played a central role in the final third of the game's development cycle. Walker feels that early design efforts were ultimately unsuccessful because they were conducted outside of any testing. We'll consider issues around the tutorial in a moment, but *LittleBigPlanet* also could have avoided a massive end-of-project crunch, and ultimately cut features, through earlier and more effective testing.

In conclusion, thorough testing should be built into your schedule and prioritized throughout the course of development. Not to put too fine a point on this, but there is simply no such thing as too much testing.

Bite the Bullet

Change is hard. This is true in many facets of life. When talking about the process of making video games, making changes often brings a host of negative side effects, including practical matters such as schedule delays, wasted work, introduction of new technical challenges, and the like, as well as more intangible nuisances like a struggle to realign the team on a new direction, diminished enthusiasm for or confidence in the design, and frustration among people working on the project because they may feel they are working on shifting sands. In general, people don't like change, and this is especially the case if they have become attached to a particular piece of the game or design direction, one that they have invested a lot of time and energy into.

For these reasons it is completely comprehensible why change is often put off until later. However, this is a costly mistake in the long run — essentially you are putting off, and perhaps diminishing, long-term gains in exchange for avoiding short-term discomfort. Once you know that there are changes that are going to be needed with your game, you need to make the hard decisions and get these changes underway. Communication here is critical. Everyone wants to make a great game. If the people on your team understand the reasoning behind the change, and feel confident that making the change will actually result in a better experience for the player, this makes things a lot easier to swallow. Support proposed changes with evidence from testing, direct and clear feedback, and the like — otherwise, there is a danger that people might feel they are being misdirected, and

there is not a whole lot that is more de-motivating than the feeling that you are working on something that will be changed again, or probably won't make it into the game anyway. Experimentation is important, but make sure design decisions aren't managed under a 'let's just try this' philosophy.

Put another way, don't make change for change's sake, but if change must be made, just do it.

Several interviewees highlighted their hesitation to make necessary changes as a key 'what went wrong' factor in looking back over their processes of making their games. Again, the two massively multi-player games considered here — *FarmVille* and *World of Warcraft* — shared something along these lines. Both games were up and running and attracting players wildly out of proportion to the expectations of the developers. With so many players in game, it became doubly hard to make changes, as the creators then felt they were, in a way, abandoning their current players in preference to future players.

With *Wrath of the Lich King*, Blizzard decided to ramp down the raiding system in the game, which had catered to 40-person as well as 10- and 25-person guilds, favoring the smaller, less hard-core direction. "Now, this was kind of hard for some of our more hard-core players to swallow. They felt we were separating them from their friends. Also, of course, the impact is "1/25th instead of 1/40th," as Brack put it, referring to the amount of spoils won through the smaller, 25-person raiding squads. Making this decision — this change — was difficult, as it meant potentially alienating some of the existing players and fans. In the long run, however, the change resulted in a wider appeal of one of the core features of the game — the raiding system — which, in turn, meant growing player numbers across the board following this change.

FarmVille, as we have discussed, faced an onslaught of players after their 'soft, beta' release. In Skaggs' retelling, the soft launch became the real launch, as "we simply couldn't undo over one million players playing every day." There were pieces of the game — including metrics capturing that would allow Zynga to track player actions and continually refine and tune the game — that had to be added post-launch. Additionally, in the game experience itself, there were elements that Skaggs and his team were unhappy with, one example being the challenge ramp early in the game. The team figured out what they wanted to do differently, but hesitated to implement these changes over concerns for alienating current players, as well as an understandable fear that they might fix something that wasn't really broken. After all, they had attracted millions, and then tens of millions, of players into the game — so what if what they felt was wrong wasn't really wrong? Yes, there's extensive testing and metrics tracking that we discussed above to help assuage doubts.

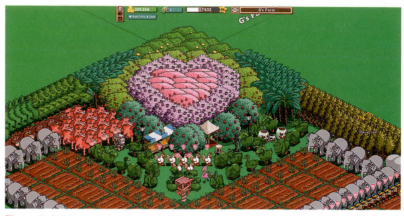

Figure 2. With tens of millions of players in the game, making changes to *FarmVille* came with high stakes.

At the end of the day, though, sometimes it boils down to trusting your gut. "We definitely should have just gone ahead and made the changes," Skaggs reflects. "If you wait, you're not really servicing the existing players, or the new players. If something should be changed, go ahead and change it."

Don't Ignore the Tutorial

Several of the projects explored in Part 1 introduce new mechanics of play to the world of video games. Boldly going where none had traveled before allowed the teams creating *Uncharted 2, Diner Dash, Rock Band, LittleBigPlanet, Bejeweled Twist,* and *World of Goo* to rise above the noise in the marketplace and achieve recognition not only critically but also commercially. Yet players who approach these new mechanics and experiences often need a helping hand in figuring out exactly what they are supposed to do.

2D Boy iterated over and over with experiments with their tutorial system, ultimately deciding to focus instead on the core gameplay experience so that a tutorial would not be as needed. Yet this solution only emerged through focused attention on and experimentation with the tutorial — in fact, this was the only way it could emerge.

Combining traversal and gunplay into the core gameplay mechanic of *Uncharted 2* meant that players had to be instructed in new ways of playing a familiar type of game. Players had to be convinced that they could get on top of buildings and that they were able to use their weapon while climbing up the rope to get there.

With *LittleBigPlanet*, Media Molecule was forced to make the painful decision to cut an entire area of their game once they

Figure 3. If doing it again, Media Molecule would plan to spend a lot more time and energy, and focus much earlier, on the tutorial in *LittleBigPlanet*.

realized how much time was going to be required for their tutorial. They simply needed more hand-holding to bring players up to speed with the Popit mechanic as well as simply teaching them how to play their game with so many new features. Being reactive instead of proactive toward the tutorial in *LittleBigPlanet* was a costly misstep.

The team at Gamelab also worried that *Diner Dash* gets too hard too fast. They, too, would have counseled themselves to spend more time on their tutorial, and this is something they have done successfully in subsequent projects.

Think long and hard about onboarding players into your game. Don't let your tutorial be an afterthought. The tutorial often provides players with their first impression of your game and sets the tone for what is to come later. Additionally, if you are introducing a new twist or mechanic within gameplay, it is up to the tutorial to teach players how to succeed.

Another ancillary benefit of early focus on the tutorial is that it will also help to expose any gaps or false assumptions about the gameplay itself. There's nothing like trying to explain something to someone else as a means to check your own understanding. Wiring up the tutorial can force the team to tackle some difficult questions head-on, as well as ensure that the game you are creating matches up with the vision and overarching goals for the project.

Every Project Is Different

This came up specifically with the games featured in Part 1 that are sequels to established franchises. The teams working on

Figure 4. Yes, *Half-Life 2* was a sequel, but the game was built on so many new systems that it was even more complex to build than the original.

Half-Life 2, Madden NFL 10, and to some extent *Bejeweled Twist* all assumed that, since they were 'simply' doing a new edition of an established game, the process would be, if not easier, at least more clearly defined. This proved to be a false promise, as each creative leader emphasized that each and every game development project is unique, and to assume that a project is not unique can lead to serious issues down the line.

While most striking when considering sequels, this can really be applied to game development projects across the board. The lesson here is that while there are clearly considerable benefits gained from experience, each project needs to be approached with fresh eyes. Inevitably, ideas evolve, and in order to meet new ideas, new approaches are called for. Another facet to consider with this issue, and one that can dog development teams, is that the competitive landscape is always marching forward. By the time you release Great Game v2, the other games out there with which your game competes have improved, to the point that you would be foolish to release simply more of the same — in fact, Great Game v1 would perhaps struggle to compete with the now-current crop of competitors.

Each great game moves the needle forward in at least one respect, and usually several. Teams can not rest on their laurels and rely on established methods and practices — the entire organism must evolve to keep up with the trends and new developments in the industry. Of course, there must be limits, or else there can be a debilitating side to this as well. If you attempt

to keep pace with every cool new game that comes out late in your cycle, you can wind up in a never-ending loop of catch-up. There are no hard and fast answers here, but I think a good general guideline is that once your game has entered the production phase, you should be locked down in terms of core technology and visual targets, and should not be swayed away from these by other, newer games entering the market.

Beware the Prototype

As we learned in the previous chapter, prototyping is a critical component to making great games. There is no substitute for implementation, for being able to touch and feel the actual gameplay, and the means to quickly get a component up and running is to prototype. Prototyping is an invaluable tool, yet there is a dark side to the extensive use of prototyping as well. While it may be straightforward to get components up and running and onto the controller, translating this effort into what will be required to bring that particular component in line with everything else in the game, from an overall quality standpoint, can be deceptive.

Bruce Straley spoke to this phenomenon in relating the process of bringing *Uncharted 2* to market. Naughty Dog are staunch proponents of the prototyping process, encouraging team members at all levels to build out the gameplay components they envision to the point that they can be experienced by other members of the team. The issue becomes, however, that folks get attached to the newly prototyped mechanic and committed to making it happen in the game. Layering the intensive art, programming, level design, and tuning effort required to bring each and every one of these components up to snuff in terms of overall quality, though, left the team overcommitted, resulting in an exceptionally trying crunch phase required to finish the game. The team even had a name for the phenomenon by the end of their production cycle: 'the siren allure of the prototype.'

Media Molecule, in developing *LittleBigPlanet*, worked under a style that empowered small working groups, or 'molecules,' with end-to-end responsibility for specific segments of their game. Utilizing a 'game jam' design style, prototyping played a crucial role in enabling a relatively small team to create such unique, compelling, and distinctly novel gameplay. At the same time, a similar tension was experienced by the *LittleBigPlanet* team, whereby they grew enamored with the output of what boiled down to rapid prototyping efforts and committed to ship these features in the final product. This generated a long list of production tasks and left the team stretched too thin and working in a significant crunch mode.

It is imperative to prototype. It is equally important to be realistic when considering exactly how much effort will be required to get the results of prototyping up to a level of quality that will match up with the rest of the game.

Plan for Success

Can a game be too successful? Several of the games discussed in Part 1 of this book experienced what Mark Skaggs, Creative Director for *FarmVille*, called "a really good problem to have" — they grew so popular so quickly that they far exceeded their creators' expectations. This is a problem many of us would love to experience, but when the games rely on an underlying technology or service, such as Facebook, a problem such as this can also mean an interruption in the delivery of the game and a poor customer experience, ultimately resulting in diminished revenues.

Some of the numbers related to this issue are staggering. With both *World of Warcraft* and *FarmVille*, player numbers accelerated so quickly that they stressed the underlying technologies supporting the games to the breaking point in a matter of days.

Skaggs talked about *FarmVille's* exponential adoption numbers as both a 'what went right' and a 'what went wrong' as he reflected on the game's development. Fortunately, the game launched on the Amazon Cloud, which essentially meant that rather than building out and maintaining their own back-end servers, Zynga was renting space on Amazon's servers, and so could easily add additional boxes on the back end to support their exponential growth. Even with this relief outlet in place, however, their player numbers were growing so fast — they welcomed the millionth *FarmVille* player on day 4 of their 'soft' release (one without any promotion whatsoever, relying completely on viral, 'word of mouth' efforts) — that they started bumping into Facebook limits and triggering failsafes that interrupted the service of the game, meaning that players could not log in to their accounts. With one million players in the game, Zynga also could not go back and do a 'real' launch — the 'soft,' beta launch became the real launch, leaving them exposed without some key code elements in place, such as an ability to carefully track player actions within *FarmVille*, which had always been part of their launch plan. Additionally, the team was forced to scramble to ramp up staff to help deal with their success, on many levels, from engineers to customer support representatives.

J. Allen Brack tells a similar tale about the initial launch of *World of Warcraft*. Blizzard made the decision to handle their own servers — *WoW* is built on top of proprietary technology and does not run on a service like Facebook — and to play it safe, the

team had built out what they felt would be enough servers to handle all traffic for the game for the first year. Blizzard deployed half of these servers for the launch, with the second half reserved in 'dark' status, ready to be rolled out as needed over the course of the game's first year. As the game took off like wild fire, they were forced to deploy their entire bank of servers within the first 24 hours. "This is what we call a 'high-class problem,'" as Brack put it. "We were playing catch-up, in a mad frenzy to add servers, while at the same time the game itself was also growing, launching in other regions, etc. — creating even more demand." Brack recalled how it took over a year of this catch-up to adequately meet the infrastructure demand for the game.

Figure 5. *World of Warcraft* grew so fast that the team at Blizzard was forced to deploy what they had planned to be a full year's worth of servers in the first 24 hours after launch.

What lesson can we take from these experiences? If you truly are trying something new, and operating in a universe where virality can result in explosive growth, be prepared for unprecedented success. Take advantage of opportunities that lower risk and provide scalability, such as choosing the Amazon Cloud instead of rolling your own servers. Not all problems are bad problems, and too many players is an issue that I can't imagine anyone not wanting to experience, but it can be a problem nonetheless.

Wrap Up

Looking at the commonalities of 'what goes wrong' across this small sample of games, we see that a lot of the challenges can be

met head-on with consistent and open communication — both internal communication within the team and communication with the eventual players of your game, through either testing or other forms of feedback gathering. You must be willing to ask the difficult questions, to expose the dirty laundry early, and to be honest about the results in order to learn from the data and information you gather, and then to make the sometimes difficult changes called for by this information.

A distinguishing dynamic of high-performing creative teams is their openness and willingness for self-examination. Post-mortems are a staple of the industry publication *Game Developer*, and are often excerpted in the free-to-access sister website, gamasutra.com. Read them! Learn from the mistakes of others — it's a heck of a lot cheaper than making your own.

THE NATURE OF HIGH-PERFORMING TEAMS

In our survey of 10 of the world's greatest video games released over the past several years, we have looked at a wide variety of types of games, as well as of the teams that made them. *World of Goo* was made by two guys; *Rock Band* was made by a team of over 100. Development budgets represented in this small set of games we have considered range from 'food and rent' to upwards of hundreds of millions of dollars. We have looked across this spectrum of games for commonalities in what the creative teams felt went right, as well as wrong, and teased out specific areas of focus that seem to crop up for multiple teams, in terms of both best practices to emulate and common pitfalls to try to avoid.

In this chapter we'll take another step back to examine, from both the postmortem interviews and the team role interviews, the nature of what I refer to as high-performing teams — video game development teams that consistently produce great games. Of course, in actuality there are multiple factors that determine whether a game will rise to the level of being great, and many of these factors are outside the control of the team making the game. For example, perhaps the game is tied to a movie launch, and the movie sucks, leaving the game without the exposure it deserves to breach the waves of the marketplace. Perhaps the publisher that has funded development is bought by a larger company that is not interested in your game, or, even worse, the publisher goes out of business and your great game never sees the light of day. However, it is the goal of the development team to make the best game they can make given whatever external circumstances they face, including the vagaries of the publisher and/or marketplace, and it is illustrative to look at the information we have gathered here to see what we can learn about the nature of high-performing teams.

As with most everything in life, there are no hard and fast rules here. What works for one team may not work for another. In fact, what works for one team may not work for the same team on a subsequent project. Circumstantial factors, environmental factors, economic factors, and life-getting-in-the-way factors all

Making Great Games. DOI: 10.1016/B978-0-240-81285-4.10013-3

play a role in the outcome of a creative project, especially one as complex and interdependent as a large-scale video game production.

I look at it this way — there are no guarantees for what you need to do in order to assemble a high-performing team. There are no inflexible rules; there is not a checklist you can follow to ensure that the team you are putting together will be high performing. At the end of the day, the stars must align and a certain magic must take over that elevates your team to that high-performing level. At the same time, there are factors that, if missing, will preclude a team from achieving its potential — a set of baseline factors that must be in place for this to be possible. So what are the elements that need to be in place in order for you to set your team up for success?

The Goal

A team is simply a collection of individuals. This group of individuals does not automatically become a team. There are, however, some baseline characteristics that, if missing, preclude a group from truly becoming a team. One of these fundamental elements is a clear, shared goal. If the goal of your project is not clear, it is going to make it very difficult for the individuals you have assembled to coalesce into a team at all, much less a high-performing team. The clearer the goals for the project — however ambitious they may be — the easier it is for the group to grok, and then share, those goals. Without clearly understood, shared goals, the team will not be set up for success.

The range of acceptable goals for a video game project is practically limitless. A goal may be to simply finish a game. It may be to achieve a Metacritic score of 90 or above. Another goal might be to displace *FarmVille* as the number one application on Facebook. Goals can be extremely specific — make a game that teaches the Texas standard third grade mathematics curriculum — or more open-ended — create a game that captures the feeling of being in a haunted house — but they must be clear in order to be understood by everyone in the group.

Having goals is critical, and so is having the ability to measure whether or not the goals have been met. The more nebulous the goal, the more work that needs to be done to clarify exactly what the criteria for success are. Put another way, how will we know whether or not our goal has been achieved? With the examples above, some goals have measurable 'yardsticks' that can be used as success factors. Others must be included with the goals themselves. How will we know for sure whether players of our game learned the standard math curriculum? Well, perhaps before and after assessment testing could provide adequate data

to support the claim. What about recreating the feeling of being in a haunted house? With this type of goal, further definition is in order. What does that mean — that the player reports being afraid? Including some kind of measurement tool enables goals to be tracked, and also helps you refine the goals, making them more easily communicated and understood.

2D Boy had a very clear goal that really had nothing to do with the content or theme of their game, *World of Goo*: they wanted to complete and ship a game with a team of only two people. This constraint influenced every decision they faced, providing a kind of yardstick for whether whatever they considered doing with their game made sense. Should our world be true 3D? No, we can't do that as a two-person team. Should the style be photo-realistic? Should the game include level-editing tools to allow players to create and share their own levels? Can we modify an existing, open source physics engine and bend it to our purposes? Whether the answers to these questions are yes or no, the point is that with clear, shared goals, they are easily answerable in the same way by everyone in the group, and therefore are more likely to contribute to that group's jelling around the conquest of these goals, and therefore feeling like a team.

This is true of large teams as well — in fact, the larger the team, the more important it is to have clearly defined and clearly communicated goals. The creative team behind *Rock Band* was aiming to recreate the feeling of being in a rock-and-roll band. The team making *Uncharted 2: Among Thieves* set out to create a 'playable summer blockbuster.' *Madden NFL 10* was built behind a stated goal of 'everything you see on Sunday' — this provided a clear target for the experience of the game and helped drive the developers forward toward the same target. Media Molecule set out to create a game that highlighted and featured user-generated content; *LittleBigPlanet* grew out of, and excelled beyond, that shared goal.

Many of the interviewees, looking back and reflecting on what contributed to their shipping great games, spoke of clear goals that set their teams up as key factors for their success. Having clear, clearly stated, and measurable goals is a hallmark of a high-performing team.

The People

At the risk of stating the obvious, a team is simply the people it is composed of. Which people you have on your team determines what kind of team you're going to have. Chemistry is a difficult thing to quantify, but at the same time it is incredibly important. Many of the leaders, both those of the games featured in-depth and those featured in the team role interviews,

when reflecting on the best teams that they have been a part of that have turned out great games, talk about their connections with their teammates, often explaining that the people on their teams felt more like friends than co-workers, or even that they were like family.

Chris Trottier, Lead Game Designer on *Spore*, put it this way: "Making great games is not about having a big killer idea of your own, or even great solutions of your own. It's about collaborating well with a group of very talented people. Basically, fill the team members with religion, and then let *them* be the stars." She spoke of the importance of knowing her team members and their individual strengths and weaknesses. Don Walters spoke of the importance for a Producer to understand his or her team members' motivations and desires in order to be successful.

Many also spoke about the importance of assembling the right people onto the team. With their 'game jam' design style, Media Molecule's Siobhan Reddy spoke of the importance of "having the right people in the band." Being able to trust team members is paramount, especially as teams are moving toward more decentralized structures to build games, where smaller cross-disciplinary groups are responsible for setting their own goals and agendas.

'Chemistry' is a word that comes up over and over again. This is yet another intangible – it's not like you can go out and buy or hire chemistry. Sometimes it is only through trial and error that correct chemistry is established, but you'll know it when you have it, and you'll know it when you don't. Along the same lines is another concept that comes up over and over again with high-performing teams: passion. Great games are created by teams that are passionate about the games they are making.

So how can you plan for or accomplish this? For starters, forgo filling a seat until you feel that you have found the right person. Trust your gut. Making a great game is not about dotting i's and crossing t's – although you certainly can't make a great game without doing so – but is more about all of these intangibles we've discussed: the magic that happens when the group elevates above the level of the combined individual contributions and churns out something special. Be sure to focus intensely on the recruiting and hiring process, and build ample time in your schedule to assemble the right team.

Recognize, too, that relationships grow over time. High-performing teams sometimes magically come together on a first project, but more often they emerge over time and over multiple projects working together. The main takeaway here? Don't mess with success. If you are part of, or in charge of, a high-performing team, I encourage you to do your best to keep your team on its path. There is often a tendency to focus too highly on individuals,

with sometimes disastrous consequences. For example, you may think Team A has two good animators — let's call them Suzy and Hiro — and Team B has two mediocre animators, Frick and Frack, so you might just swap Suzy from Team A with Frack from Team B to even things out. The problem here is that a team is not simply the sum of its parts — it's the hard-to-define interdependencies and how all the pieces fit together that contribute to the successful team. So what you have done, potentially, is deconstructed the high-performing Team A, and not necessarily increased the performance of Team B.

As much as practical, keep a high-performing team together, even if it makes things more difficult in the short term.

The Environment

We'll talk about this more in Chapter 15, 'Hiring and Managing for Success,' but it is also important to consider larger environmental factors. By this, I am referring to two main areas. The first is the practical matter of your physical environment. What kind of physical space are you making your game in? Making games is a creative process. It is important that team members are in a comfortable environment that fosters and encourages their individual creativity.

Media Molecule's Reddy spoke of the importance of their physical space, in terms of how they used their wall space as a focal point for communication of the art team's progress, as well as the large, communal dining area where her team shared meals. Another well-known example is San Francisco-based Three Rings Design, Inc., makers of the casual MMORPG *Yohoho Puzzle Pirates!* The company engaged a design-build studio, Because We Can, to fabricate their offices, giving the designers the following mission statement: "Make our office an over the top, amazing and fun place to be so we can attract and keep top talent." Better space equals better games? Sometimes it sure seems that way. People are different. Something that is critical to one team member — gourmet coffee, let's say — could be totally irrelevant to another. Noise level, the presence or absence of natural light, room temperature — each of these factors may or may not matter to each person on your team. Do your best to touch base with every member of the team and understand each individual's concerns and desires, and work to make the environment as comfortable and conducive to productivity as possible.

The second factor here, and this will also be explored later, is more intangible. Is it a competitive environment? What happens when someone isn't pulling their weight? Is there a feeling of urgency or over-the-top pressure, brought on by an overly aggressive schedule or an underfunded project? All of these

factors can contribute to whether or not a team performs at its highest possible level.

The Process

What about the mechanics of the day-to-day processes of creating games? What are the things that high-performing teams tend to do as part of their development process? We'll look at this question more closely in Chapter 14, 'Applying These Learnings to Your Game Projects.' Here I will highlight a few of the best practices that seem to be a part of each and every high-performing team I spoke with in researching and writing this book.

Constraints

Yes, there is such a thing as too much time or too much money. Making games, at the end of the day, is a business. Sure, there are exceptions to this rule — serious games, training simulations, etc. — but for the most part, if you are setting out to make a great video game it is with the intention to sell it for profit in one way or another. There are oodles of stories of game projects gone awry for any number of reasons. One illustrative example in terms of constraints, or lack thereof, is *Duke Nukem Forever*. Based on the remarkable success of the *Duke Nukem* series, the developer, 3D Realms, had oodles of money and high expectations for the sequel. Announced ship dates came and went as fans waited for the game, which kept getting revamped and retooled in an attempt to keep up with the incredible progress made in the realm of shooters. Take Two Interactive, who were slated to publish the title, finally pulled the plug after no less than 12 years of development at 3D Realms.

Use constraints as a tool. Box in your design and make sure that you are setting out to make something that can be great given the parameters you have to work with. This applies to the budget as well as to the schedule. One way to gauge this is by comparison. Are you making a PC downloadable casual game? Okay; what is the average timeframe and budget for a project like yours? Are you working on a driving sim, or an MMORPG? Comparisons can start to give you a sense of where your constraints should lie — where you'd like to draw your lines in the sand. Just as realtors and home buyers use 'comps' — a history of comparable property transactions in the neighborhood — so should you do research to help establish baseline parameters for the kind of game you're setting out to create.

Perhaps you're being backed by a large publisher, and the goal is to really blow the doors out on a massively multiplayer,

intergalactic fishing simulation, so your project demands a relatively higher budget. More likely, you're trying to improve on an established genre, so the goal is often to find creative ways to do something better, faster, and/or cheaper. Whatever the circumstances, high-performing teams lean into constraints and view them not as limitations but as challenges to overcome in their process of making great games.

Testing

Players bring all kinds of things into their experience of your game, and emotions and reactions are triggered by a combination of factors. Only through extensive testing can you confirm or deny your beliefs about what your game is and is not doing. High-performing teams welcome and seek out the opportunity for testing at every phase of development and work diligently to analyze the feedback they receive and incorporate changes, based on their analysis, back into the design and development of the game. From high-level, 'focus group' concept testing, all the way through to instrumented 'first look' style controlled beta programs, test at every step along the way. Be honest about the results of your testing, and don't deny or discount whatever you discover. Put testing on the critical path, and ensure it is an important and respected part of your process.

Communication

Among any group of any size, many problem areas can be traced to issues surrounding communication. It is remarkable how true this is across the board. Bad blood between development and marketing? Executives dropping in and canceling a project seemingly out of the blue? Wasted work because the updated engine no longer supports certain aspects of the level file format? The number of problems, large and small, that crop up during the course of a game project that boil down to one factor – poor communication – is mind-boggling.

My suggestion? Overcommunicate. It is always better to hear something too much rather than too little. Follow up and close communication loops to make sure that your message has been heard and understood. This is particularly important with good news, which tends to be overshadowed and underemphasized. As Blue Castle Games' Robyn Wallace points out in her interview, she is always amazed at how far simple praise can go, even beyond more tangible rewards, in terms of motivating people. Let the people on the team know what's going on; let them know when they are doing good work, and openly appreciate their contributions.

Reflection

Somewhat related to communication, another factor that seems to be part of every high-performing team is their eagerness to self-reflect and their willingness to tune into the results of this reflection and do something about it. If there's bad news, and there's always some, get it out on the table early. Acknowledge the issues, which is the first step in doing something about them. Far too often, I have seen Producers not trust their gut feeling on a feature that is somehow missing the mark, telling themselves, 'Oh, it's probably just not quite done yet' or 'Maybe I'm the only one who has a problem with this; I'm new around here: I don't want to make waves.' Chances are if there's something making you uncomfortable, it will make someone else uncomfortable as well, and that someone else may very well be a potential customer who just decided to try another game after experiencing this feature in your demo. Air the dirty laundry. Ask the difficult questions. This is the way high-performing teams deal with the issues that inevitably arise along the way.

At the end of a project, complete a thorough postmortem in order to learn from the process. Build upon all that went right, and try to course-correct those areas that caused unneeded problems along the way. Be willing to take a step back regularly and examine your processes and ways of doing things. Is it still necessary to have a weekly meeting with this particular group of people? Would a shorter, daily 'stand-up' meeting better serve the goals of this particular get-together? Does the latest round of decisions match up with the overall vision consensus for the project? If the answer is no, you must be willing to press pause, and reconsider either the decisions or the vision – but the two should always be in sync.

Several project leaders reflected on the difficulty of making changes. High-performing teams must also be willing to meet change head-on, and again with the benefit of clear, open communication, justify the change, engender buy-in from all stakeholders, make the change, and move forward.

Being Bold

Another common factor among these teams making great games is a sense of adventure, coupled with a sense of optimism. I don't know how else to put it, but one can sense a shared purpose and enthusiasm when interacting with a team that is firing on all pistons and on the path of doing something cool together. It's almost like they're on a journey together to a strange new land, and in a way, of course, they are. Remember, making video games is a creative process, and the market responds positively to creative risk. Recall the comments of Media Molecule's Siobhan

Reddy, who spoke of the excitement of building their studio and their first game at the same time, as they all felt they were charting a brave new world. Rich Curren, Art Director on *SSX On Tour*, echoed these sentiments, as did Gamelab's Eric Zimmerman and several others — the market is hungry for new ideas successfully executed. Indulge your passions. Take risks and swing for the fences. This is what high-performing teams do, and you only live once.

Wrap Up

No two game projects are the same, and no two teams are the same. It is not possible to create a checklist of all the elements required to establish a high-performing team. However, we have looked at some common traits that emerge among teams that perform at an extremely high level. We have examined both tangible and intangible factors that seem to contribute to the ability for teams to consistently create great games.

Look closely at these factors that seem to be part and parcel of high-performing teams working on a wide range of video game projects, and strive to incorporate as many elements as possible into your own game development projects.

APPLYING THESE LEARNINGS TO YOUR GAME PROJECTS

No two game projects are alike. Each comes with its own unique set of challenges, which vary by the intended game's size, platform, and goals, as well as by the development studio environment, team dynamics and experience, and a host of other internal and external factors. Are you launching new intellectual property, or producing the tenth game in a series? Are you a seasoned team and part of a large corporation that's produced hundreds of games, a well-funded startup comprising industry veterans, or a brand new indie shop, wet behind the ears with loads of ideas but scant resources or experience under your collective belt? With such a wide variety, there is simply no such thing as a 'typical' game development cycle.

At the same time, in order to investigate where specifically we can plug in some of the learnings from this book, it will be helpful to unpack and consider an imaginary video game development cycle. For simplicity's sake, we'll stick with round numbers: our game will have a 12-month development cycle and grow to a maximum team size of 100 people. To be clear on terms, I'll provide a brief definition of the roles on our team. Then we'll look at the game's development process phase by phase, with brief definitions of each of the phases of design and production, to explore timely best practices and specific tools that you can apply to your game projects during each of these phases of design and development.

Team Roles

Again, game development team roles are called different things at different companies, and there are multiple ways to organize a game development team, but something close to the following is what you'll usually find on a high-performing, mid- to large-scale video game development team.

Production

Called Producers, Project Leaders, Creative Directors, these team members are ultimately responsible for the overall quality of the

Making Great Games. DOI: 10.1016/B978-0-240-81285-4.10014-5
Copyright © 2011 Elsevier Inc. All rights reserved.

game. I like to think of Producers as the 'eyes and ears' of the game's eventual player. The Producer needs to make sure that the entire project hangs together and is polished and shiny. This is a leadership position, often with the responsibility for other people's work. Frequently, this responsibility is without authority, meaning that Producers are responsible for the output of other team members, but are not those other team members' manager. In teams without specific Designers or Writers, these responsibilities are often handled by production as well.

Design/Writing

Game Designers and Level Designers are in charge of the moment-to-moment experience of playing the game. Their output usually consists of documentation, and sometimes prototypes, early in the project and, as pieces of the game get built, they transition into playing builds and providing feedback and course correction to Production. Level Designers working on a level-based game may do the scripting that actually controls the interactivity of the game — in a first-person shooter, for example, the level script might define how many enemies are found where, how they behave, what events are triggered in the level, when and how, etc. These team members are making contributions where the rubber meets the road.

Writers, well, write. Back story, character dialogue, tutorial instructions — there can be huge amounts of text and/or dialogue found within many types of games, and the Writer's job is to write all of this text. As games become more complex and intricate, writing is taking on a more and more important role in the world of video game production, and games are being recognized for the strength of their writing and story. More and more, games are being optioned and translated into major motion pictures — certainly an incredible feather in the cap of any game writer.

Project Management

Development Directors, Project Managers, sometimes called Producers just to make things really confusing, these are the women and men who look after the project schedule and budget. Filling an operations role, they are focused on the bottom line, and often on the day-to-day mechanics of the operation of the team. Staffing is a key part of their role — making sure that the right people are in the right roles and that groups are working together effectively and efficiently to continue marching forward and meeting milestones. Project Management and Production work hand-in-hand to make sure the project vision syncs up with committed resources and that milestone are delivered and adequate progress is being made on a day-to-day basis.

Art

Artists are the individuals generating all of the art assets used in the game. This can be all 2D, all 3D, or some combination of both. This includes in-game art such as characters, environments, weapons, ships, cars, and furniture, as well as all of the presentation elements such as the user interface, heads-up display (HUD), and front end of the game. The title screen, in-game noninteractive sequences, and cutscenes are also created by the Art team. Oftentimes, Art is also called upon to create assets for Marketing as well as for the game.

Programming

Programmers write the code that makes the whole thing go. There are often several teams of programmers, some responsible for the core game engine, some for ports to specific platforms, some for integration with an underlying technology or service, as well as some tackling specific areas or features within the game. Programming is ultimately directly responsible for how the game behaves, as well as how it feels in the hands of the player.

Tech

Often teams will have other technical people to help integrate and tie things together. An example of this is an Art Technician, whose responsibilities include taking all of the output of, for example, the Character Animators, and wiring these up so that they can be driven by scripting files so that they appear in the game. These folks are kind of like intermediaries that coordinate between Programmers and Artists. Another typical position in a similar function is a Build Engineer — a Programmer responsible for assembling all the pieces of what can become a fairly massive code base in order to generate the actual build for a specific platform so that the team, QA, marketing, etc. can play the game.

Others

Most often, but not always, the following contributors are external to the core development team, and in large companies these resources are often shared across multiple game projects.

- Audio: This group is responsible for all sound effects and music composed and recorded for the game.
- QA/Testing: This dedicated group is tasked with finding, logging, and classifying defects in the game and communicating with Production on strategy for how to best address defects.
- Marketing/PR: This group is in charge of positioning, promoting, and selling the game.

Development Phases

Now let's examine our imaginary game development project phase by phase to see where we can implement specific best practices, based on the case studies from Part 1, to benefit your current and future game projects.

12 Month Video Game Development Cycle

Rough Project Schedule, With Milestones

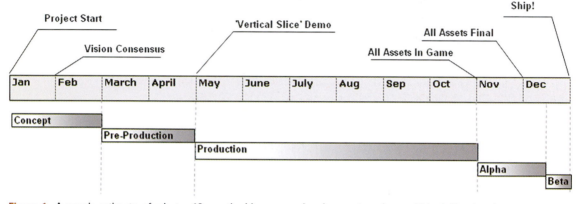

Figure 1. A rough estimate of what a 12-month video game development cycle would look like, by phase.

Concept

This is the earliest phase of a project, in which the overall direction and goals for the game are set. The team is usually very small at this point — four to ten people, perhaps one stakeholder from each functional area, or perhaps just a Producer/Designer, a Development Director, a Technical Lead, and an Art Lead. In a 12-month cycle, this phase would be about 2 months. During concept phase, the vision for the project is established.

The concept phase is extremely critical, as it sets the tone as well as the direction for your entire project. If a game project is a marriage, the concept phase is the courtship phase. The difference is that marriages can recover from bad weddings, but projects can't recover from fuzzy concepts or a failed concept phase. It is crucial that a clear vision is engendered during this period and that all team members are given an opportunity to believe in that vision.

A process that can be very useful for these purposes is a formalized vision consensus meeting or set of meetings. Essentially, the idea is to gather all the project stakeholders and spend time together hammering out a vision consensus document. The process should start with an open-ended brainstorming session, in which you collect all of the ideas, from story

to visual style to mechanics. Everything is fair game — just be sure to capture everyone's hopes and dreams and creative ideas for the project, without discounting any during this part of the process. Get everything up on a whiteboard. Once the brainstorming energy has been exhausted, it's a good time to take a break.

For the next session, reconsider and sort through everything you've got up on the whiteboard. Start to tag the ideas with keywords — 'story,' 'visuals,' 'goals,' 'competitive advantages' — whatever 'buckets' for these ideas that makes sense. Basically, the aim here is to start to group the ideas thematically. During this stage, you may also decide, as a group, that certain ideas don't quite fit. The goal of this phase is to pare your list down and figure out what you are going for. This part of the process takes time and energy and may require multiple sessions. Try to build consensus with the group in terms of the core goals for the project. Once there is general agreement in terms of the buckets for the ideas, and for which goals will stay and which will be shelved, you're ready for the final phase.

The final step is to draw up a vision consensus document. This is composed of key statements of the underlying goals for your game. These statements should be specific and concrete. A couple of examples might be, "Game X is visually stunning, and sets a new bar of realism for driving simulators" or "There will be 5 main game areas, with 5 levels in each area, for a total of 25 levels in Game Y." If necessary, these statements can be followed by bulleted lists of specifics that tie back into the overall goal. The point is to come out of the process with a clear set of vision points and goals for your game that can be used to bring new team members up to speed as well as to make sure that decisions along the way are aligned with the core goals for the game.

Too often, there is a terrific vision consensus session that produces a wonderful document, and then the project starts, and the process and vision documents are shelved and forgotten. Decisions made along the way — and sometimes they are good decisions — may be counter to, or compromise, some of the vision points for the project. I recommend a monthly stand-up meeting in which the entire team takes a step back to evaluate the status of the game, review the vision consensus document, and confirm that the current direction still aligns with your original goals from the vision consensus process. If this is not the case, use this opportunity to alter either the vision or direction for the game. This ensures that all working groups — be they functionally arranged, or cabal-like smaller groups working on a specific area of the game - are in sync with each other as well.

Think of this process during the course of development as surprise discovery. You're trying to tease out any surprises internally, instead of reacting to them from external sources. This

also provides a good opportunity and fodder for communicating to higher levels in your organization any significant changes to the project goals or direction. And, hopefully, avoiding that uncomfortable occurrence when showing your game to the executive team: "I thought you were making X, but this looks more like Y to me." Make sure that there is time built into the schedule, especially once the grind of production is underway, for this process.

Pre-Production

In our imaginary game project, we're ramping up to about 25 people during the pre-production phase, which will also take about 2 months. We've added two to three more Producers, two more Development Directors, several Artists and Programmers, and an Art Tech. The project has also been assigned resources from Audio, QA, and Marketing, although none of these will be solely focused on our game just yet.

During pre-production, several core kinks need to be ironed out, and these relate directly to some of the best practices and common pitfalls we've heard about in the case studies and earlier chapters:

1. Staffing: Who's in the band, or who's on the bus? How many people are we going to need to be able to meet our vision objectives, preferably while maintaining a reasonable work–life balance? Who are the players in each of the key roles? Chemistry and passion are the critical, intangible factors here.

2. Organization: Related to staffing, what is our plan for how to organize the team? Are we going to implement our own twist on the cabal structure, or arrange ourselves more traditionally, with core sub-teams of artists, engineers, etc.? These sub-teams are starting to take shape during pre-production.

3. Visual targets locked down: Specific examples of the look and feel for the game are essential in this phase in order to set the direction for the team, as well as to communicate what your game will be to executives, marketing, etc.

4. Technical approach locked down: Analogous to visual targets, game feel must also be proven and established during pre-production. Are we using an off-the-shelf engine, or rolling our own? What new mechanics are we employing in the game, and how will these actually work and feel to the player? What new mechanics will be required for the game to meet our goals? Are there infrastructure issues that need to be sorted out? All of these questions need to be answered in pre-production.

5. Story, other 'framing elements': This area of focus is highly dependent on the type of game we're building. If the game

is story-driven, the entire story should be written, at least as a draft. Each level of a level-based game should be defined and sketched out. If the game is going to include an online player-created level exchange, this technology needs to be proven. Essentially, if there are any thorny questions, from a visual, technical, story, or infrastructure angle, they should be asked and answered in pre-production. We want a complete set of blueprints for the game we are setting out to build.

Taking a step back, you can see that this phase is really about proof of concept. What will the game look like, really? What will it feel like to play, really? What new technologies are we going to employ, really?

The best way I have seen to answer the above questions is through the production of a 'vertical slice' demo, which I recommend as a gating milestone for your team to come out of pre-production. The idea is to fire up everything you will need in production and to crank a small piece of the game through the entire cycle, albeit writ small. The output of this process is a playable piece of the game that presents one level, one area, one chapter, one what-have-you, completely fleshed out, from soup to nuts. This demo gives players a sense of the feel of the controls, the look of the world, the underlying story — everything about the game that will be part of the final product. With a successful vertical slice demo, production is a matter of creating the remaining elements of the game in line with the vertical slice presented in the demo and tying everything together.

Documentation is also an important part of the pre-production phase. Game design documentation is an inexact, evolving science. Many teams are leaving the days of the encyclopedic, 200+ page design bible behind. These have often proven to be a useful exercise, but quickly become out of date, and something that no one reads once production is in full swing. The other extreme — working without any documentation whatsoever — certainly saves trees but can have disastrous consequences as well.

A better approach I have seen is basically a compromise — design or feature briefs that describe the vision for a particular feature, mechanic, or area of your game. These documents are short, two to three pages, and are presented in outline form, utilizing bulleted lists of crisp, clear sentences. These have a much better chance of becoming living documents in that their size allows them to be consistently updated as production marches forward. Feature briefs can be a very effective way to strike a balance and find the sweet spot between weighing yourselves down with heavy documents that no one reads and flying blind.

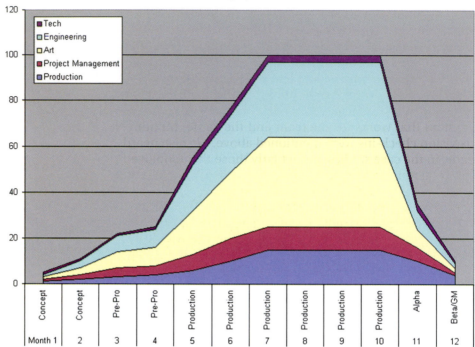

Figure 2. A phase-by-phase timeline of how a game development team might be staffed by functional area.

Production

This is typically the longest phase of a game's development, the meat and potatoes of the cycle, wherein, ideally, the project is completely and adequately staffed, and all groups are synced up and marching toward their shared goals for the game. A well-oiled machine, our team has ramped up to the full core team complement of 100 people. Production will last 6 months – half of our entire cycle – and during this time our core team is made up of roughly 15% production, 10% project management, 40% art, and 35% engineering, plus QA, Marketing, and Audio are fully externally staffed. We are working through it all – characters, environments, levels, UI, music, sound effects, cutscenes or non-interactive sequences (NIS), server technology, simultaneous ports to other platforms, motion capture, licensing, and many other game-dependent areas. Production is where most of the heavy lifting gets accomplished.

During production is where the rubber hits the road, and the fruits of best practices, as well as the hazards of common pitfalls, are surfaced.

Meet

Finding the right balance of meetings and individual work time is a struggle for many teams. Everyone is busy, and meetings without merit can be exceedingly frustrating for team members facing deadlines and other challenges. At the same time, meetings are a necessary evil and the most efficient way to make sure the large group is moving in the same direction. It pays to carefully consider all meetings scheduled during production, and lock down a system that works for the team and the game. Monthly, all-hands vision check-ins were mentioned above. We also heard many teams in the case studies, particularly those that employed a cabal-like structure, talk about their success with 'dailies.' These are brief, small-group 'stand-up' sessions in which you go around the room and each contributor highlights what they accomplished yesterday, showing their progress if applicable, and then syncing up on the plan for today and goals for tomorrow. These sessions should be very quick, and conducted as the first part of the day, allowing problems to surface immediately and be resolved.

Test

By now you shouldn't be surprised to hear me say that the importance of testing can not be overemphasized. It is critical that you put your game in front of players — preferably strangers with no connection to you, your team, your company, or your game (an exception would be for a sequel, where you want to balance fresh eyes with fans who come with their own sets of expectations) — and have them hammer on your creation. Testing sessions are always eye-openers, in both good and bad ways. Certainly, you will see players frustrated at something you thought was painfully obvious. You will learn what is, and what is not, important to the player. You will discover how well you are communicating the story, the structure, the tone, the humor — basically everything that you think you are doing in the game.

Playing a game is an interactive form of communication. Are you trying to frighten the player? Then why are they chuckling? There are, of course, positive surprises within this process as well. I have seen players invest a gameplay mechanic with far more logic and intelligence than was ever conceived of for the system. "Look, that guy is angry at me because of what I did to him before." Actually, that guy has no internal state toward you whatsoever, but I'm certainly glad that you think he does.

As we learned in Chapter 7, *FarmVille* Creative Director Mark Skaggs worried about ongoing issues with the leveling curve in their social game. More frequent testing would have helped address this challenge. The only way to truly influence this aspect

of the game — to get a real read on leveling — is to test. How long is it going to take players to get through the first level? What about from level 4 to level 5? Watching the person who made the level, or someone else from the team, play the thing just doesn't work. You need to observe actual players.

Testing should be built into the schedule at all phases of development, and the type of testing needs to evolve with the game. In basic terms, testing should evolve from more observation-based, focus group style sessions, where representatives from the target player audience are shown art or told the story, to hands-off, automated, and directly reported playtesting sessions. Ideally, once we're deep into production we want target players to play our game in the exact same environment that they will play the game in when it is released — in their home, for instance, and the game simply tracks and reports what they are doing for our analysis later.

I prefer instrumented builds with closed testing sessions, meaning the game code itself is implemented with tracking as well as data collection code. An instrumented build tracks all player activity for each individual player, and posts this data to a hosted database on your server. This type of testing isn't appropriate for all types of games, but is really the best way to get good data on how your game is being played. Data wrangling and analysis can go a long way in helping you tune your game and experience.

Make Cuts

Many seasoned games professionals believe that all games, to achieve a certain level of polish, need to experience cuts. Cuts can be made to entire features, levels, or even concepts that don't add as much as they could or achieve the requisite quality level. Cuts are always difficult, but recall the *World of Goo* creators describing how less than one-third of the levels they finished for their game made it into the final product. Again, this boils down to the reality of the huge number of uncertainties that surround creating interactive experiences. It is, for all practical purposes, next to impossible to predict how players will behave. This is especially true when you are presenting them with novel material to experience, in your story, game mechanics or underlying technology.

Testing is one of the tools you have at your disposal to tackle this phenomenon. Cuts are another arrow for your quiver. In a nutshell, some amount of experimentation is required to discover how players will react and what they will do, and often it is not until the game experience is fully built out that conclusive results can be evidenced. This is the reason that Producer Tim Fields tells us we should ideally plan for a year between alpha and

ship. Thus it stands to reason that not all efforts will be of the requisite quality, and planning for — by this I mean scheduling and budgeting for — cuts is a way to ensure that a high quality bar will be achieved with our game.

Expect the Unexpected

If there is one other consistent message that emerges from the case studies and interviews it is this: no matter what you do, things will come up. Perhaps executives suddenly want to understand where things stand with our game and have decided to fly in for a dog and pony show next week, or a competitive game is released out of the blue that implements one of our core features. Now, the world is a huge pit of unknowns. Certain surprises just can't be planned for adequately and cause products to go south and experience delays, cancellation, and other nightmarish scenarios. The point is that production must include time and space for us to be able to react to unknowns that crop up during this phase. Any group of 100 people working over 6 months is going to experience the unexpected — as best we can, let's try to be prepared.

Alpha

Our game is declared 'alpha' once all features and assets are in place. Some assets may be placeholders in that they are not the final versions, but everything needs to be there. The goal of the alpha phase is to replace anything temporary with something final, and to complete final tuning of the experience. In our imaginary project, we've scheduled 6 weeks for this phase, with the team ramping down to about 35 people. QA is now fully engaged, logging defects. PR and Marketing are in full swing, asking for regular builds. Our team is either cranking out final assets, be that art, audio files, levels, or code, or addressing 'showstopper' defects that prevent the game from being played in one way or another.

In terms of best practices, alpha is really a continuation of production as it concludes and the game starts to be closed down in order to be shipped. We should be doing loads of end-user testing, if only to confirm that any tweaks we are implementing are addressing any issues uncovered by the earlier testing process. Alpha is where many teams experience crunch. It is often the most stressful phase of development, particularly if there have been any missed milestones with a bit of 'We'll take care of that before we ship' syndrome. Typically, this causes production 'overhang' — work that was not completed for production milestones has accumulated and now all must be wrapped up for the game to get into beta. Hopefully, our team has avoided this pitfall.

Beta/Gold Master

During the game's beta phase, nothing new is added. The entire effort is focused on triage and addressing defects. This phase should be the shortest of development — around 2 weeks in our 1-year cycle — and the team is down to about 20 people.

The final hurdle is assembling the gold master — the final package of code and assets that will be shipped as our game. This should take about a week, and our team is down to 10: Production, Project Management, our Build Engineers, and a couple of representatives from each functional area to fix any remaining defects. This is the march to the finish line, followed by some much needed rest and recuperation.

Post-Launch

At this point, it probably goes without saying, but a thorough postmortem is crucial to our continued success. Once everyone has had a chance to catch their breath, it is critical to gather the team back together for a postmortem session. This process is a kind of mirror image of the vision consensus process from pre-production. It may not make sense for all 100 people to participate, but everyone should be given a chance to contribute their thoughts and feedback, so that all opinions from everyone on the team are at least represented in the process. Just like the vision consensus process, this usually can not be completed in a single day — plan and give yourselves adequate time and space for this critical part of the game development process.

As individuals, as a team, and as a studio or company, there is no substitute for experience. Learn from your successes and your mistakes. Take a step back and understand what went right and what went wrong and bring these learnings forward into making your next great video game.

Wrap Up

Entire books have been written about the process of developing video games. This chapter was not meant to cover the entire game development process in great detail, but rather to examine an imaginary video game development cycle in order to highlight where, specifically, we might be able to plug in the particular tools and tricks of the trade described elsewhere in this book. Take from this chapter the learnings that make sense for your studio or game team and apply them to your game projects. Focus on the things that you can do in order to help set your game team up for success.

HIRING AND MANAGING FOR SUCCESS

This chapter will be most useful for Producers, Project Leaders, Development Directors, and other hiring managers — those who work directly on recruiting, hiring, and managing members of game development teams. Entire volumes have been written about effective strategies for hiring great people and managing high-performing technical teams. Two classics that remain among my favorites are *Hiring Winners* by Richard Pinsker and Jim McCarthy's *Dynamics of Software Development*. Lou Adler's more recent book, *Hire with Your Head*, is another terrific volume focused squarely on the challenges of effective hiring. This brief chapter is not meant to present a comprehensive discussion of these realms of games creation, but rather to revisit some of the best practices discussed elsewhere in this book, and to show where you might apply specific strategies for making sure the right people are hired and kept on board in order to create great games.

Hiring

Game teams often struggle to staff up to needed levels across a variety of functions. This is, in most cases, not due to practical issues like lack of budget or inadequate overhead staffing. There is a seeming paradox within games studios: there are thousands of capable, eager people out there seeking opportunities in a creative, vibrant, and growing industry, yet one hears a common refrain from hiring managers — that they 'can't find the right people.' Several years ago, Electronic Arts reported over 1,000,000 hits to their jobs website during a single 12-month period, yet they continue to struggle to fill roles on their teams. Why is this so hard? Are there any tips or tricks we can glean from the case studies and interviews in this book to help assuage some of the specific challenges in the process of ramping up a team to make great games?

In his recent book *Outliers*, Malcolm Gladwell touches on how difficult it is to predict success, as well as personal happiness, in

Making Great Games. DOI: 10.1016/B978-0-240-81285-4.10015-7

future employment. Gladwell relates statistical analysis that points out that, for example, among law school applicants, performance in college is a solid predictor of a person's performance in law school, but a poor predictor of a person's relative success or happiness as a lawyer. He suggests that there are certain baseline criteria that may be requisite for success, but that beyond that you might as well use a blind lottery system among all qualified applicants to admit candidates into competitive programs like college or law school. He argues, effectively, that you'll have equally good results by rolling the dice, rather than trying to nail the inexact science of predicting future success based on what you know today. He posits that random selection would be just as effective as careful consideration, once baseline criteria have been established and met among the candidate pool.

While this may be true, and may even be fairer than the actual law school admissions process, it would not *seem* fair to all those aspiring lawyers, all of whom want to feel that they are being carefully judged and compared on the basis of their own merits. This is heightened among job seekers in a highly competitive industry like video games development, and the process of screening and selecting candidates for roles on game development teams presents an enormous challenge. Hiring managers and human resource departments are deluged with too much data. As noted above, the problem is not that there are not enough applicants — rather, there are too many, overwhelming the process of weaning and filtering to those appropriate, and making the hiring process that much more of a challenge.

All of this is exacerbated by the fact that, as we have discussed extensively in this book, hiring the right people is clearly one of the most important things you can do to have any hope of creating a great game. Interviewee after interviewee in this book points to the right people as the critical success factor in shipping winning games. In Chapter 1, Media Molecule's Siobhan Reddy recalled their struggles as a new studio to hone their hiring process. Even well-established studios are continually trying to find new and better ways to feed the machine. So, what tends to work effectively?

Setting aside the entire process of recruiting and screening applicants (again, a subject that merits its own book), let's focus on the crux of the hiring process — the interview. In the context of this book, the goal of the interview is to try to ascertain whether or not the candidate is going to increase your likelihood of making great video games. You are looking for those intangibles we have highlighted, such as passion, creativity, analytical skills, and interpersonal skills. You are also trying to imagine what the chemistry will be like between the candidate and the people who you already have on your team. Your best hope of successfully

teasing some of this out through an interview is by the use of probing, open-ended questions that allow candidates to expound on their ideas and show you their thought process, rather than allowing them to simply answer questions.

Here are a handful of examples of open-ended questions I have had good results with in the past — feel free to pick and choose whichever match your personal style:

- What is a favorite game you've been playing lately? What, to your mind, makes it a great game?
- What is your least favorite part of this favorite game, and why? If you could change one thing about the game, what would it be?
- Tell me about a project that went off the rails. Looking back, what do you think happened? What might you have done differently, had you been in charge?
- Recount a good experience you've had working as part of a team.
- On the flip side, how about a bad experience on a team? What happened, and why?
- Tell me about your favorite experience making games.
- Describe your idea of the perfect team. How you would fit in, and what role you would like to play?
- What sorts of people do you enjoy working with?
- What issues have surfaced between you and your teammates, and how have you resolved these issues?
- What motivates you to want to create great games?

We have talked a lot about testing in the context of testing your game during development. I am also a firm believer in the value of testing job candidates in their specific fields of endeavor. By administering a test on-site during the interview process, you can get a much better sense of the candidate's working style, process, and, most importantly, working speed. Make the test relevant to not only the candidate but also the project — the basic idea is to try to come as close as possible to having the person do the job they are interviewing for. Testing should be a standard part of every on-site interview for game designers, artists, techs, and engineers.

We also keep coming back to the extreme importance of intangibles like chemistry and passion. Despite your best efforts, these kinds of qualities and factors are, at the end of the day, simply very difficult to ascertain. It is only through getting into the thick of things together on a project that a team can start to sense whether that passion or chemistry is evolving. For these reasons, I am also a strong advocate of a probationary period for permanent employment. If someone seems like a great fit, sign them on for 6 months, with a joint, clearly communicated understanding that it's a trial run for both parties. If it works out,

wonderful, and if not, no hard feelings. This is not mean-spirited or harsh; it simply boils down to the studio or game team believing very strongly in finding the right chemistry, and recognizing that it takes time for some of these intangibles to emerge, and that not everyone is going to work out in the long run.

Managing

On the management side of the coin, the goal is ludicrously simple: keep your good people happy.

We've talked about the concept of keeping high-performing teams together, due to the belief that teams are more than simply the sum of their parts. Recognize that high-performing teams are the result of a certain magic, and don't mess with that magic. Far too often, short-term objectives cloud the judgment of key decision makers, and they lose the forest for the trees. It is worth absorbing short-term consequences in the interest of the long-term goal of developing and maintaining high-performing teams — these are the teams that turn out great games, and they should be kept together and allowed to evolve together if at all possible.

There is another perhaps unexpected conclusion that rises to the surface when taking stock of all of the opinions presented throughout the postmortems and interviews: people's feelings are ultimately more important than more plebian concerns like salary, vacation time, etc. Basically, high-performing teams come to feel like families because of the strong interpersonal connections that grow out of their digging in, working hard, and striving toward a shared goal. Like a military or athletic endeavor — and we've all seen those movies — there is something that emerges and kind of takes over the process, compelling individuals to make extraordinary contributions, and even sacrifices, for the good of the group.

Engendering this is important, and seems to be a component of high-performing teams making great games. However, this can definitely be taken way too far. We are, after all, talking about making an entertainment product here, not defending the homeland, and extreme cases of 'battle fatigue' are an all-too-common problem among game development teams. Massive burnout, months of accrued, untapped vacation days, and a horrible work—life balance are significant problems that have plagued our industry for far too long, and game development team drivers need to be mindful of the dangers of pushing too hard and the havoc this pushing can wreak.

Environment is clearly a significant factor in how people feel about their work. Think carefully about the physical spaces your

team members are working in. Are people comfortable? Is it too quiet, or too noisy? Do your contributors prefer natural light, or a dark corner? It is important to take steps to ensure that both each individual and the team as a whole are physically set up for success. It may not be possible to please everyone, but this should be strived for.

I do not mean to imply, by the way, that salary is unimportant. On the contrary, salary is often a key yardstick for people to measure their worth to the team and organization, and making someone feel underpaid is a quick way to deflate enthusiasm and motivation. One major challenge inherent to this discussion is salary compression. People are recruited with aggressive salaries, but once in the role and on the team for a while, they are counted on to stay put, and, frankly, are often taken advantage of as they are not given raises over time adequate to keep pace with salaries for identical roles at competitor studios. This makes sense from purely economic, theoretical terms, as people are resistant to change and risk, and so can be compensated at a lower level in these circumstances. Taken together with the factors discussed above of people valuing intangibles as well as the benefits of keeping teams together, the result is that salary compression is especially prevalent with high-performing teams. Make sure that you conduct salary surveys and keep competitive with what you are paying your team, especially key performers. It is much cheaper than losing them and starting again from scratch to fill their roles.

There is one other, perhaps uncomfortable, related fact of life to point out here. Certain companies are more likely to fire people than others. Of course, this is a generalization, but there are marked differences among companies in terms of their willingness to let people go. Forgive me if this sounds harsh, but here's something I've seen first-hand: high-performing teams are much more likely to be found in more competitive studio environments. And by more competitive, yes, I mean ones that are more willing to fire people. As discussed above, chemistry is important and is not something you can necessarily test for or even discover in a couple of weeks. It really takes the better part of a production cycle in order to suss out how the chemistry is working and evolving among your team members. As long as there is a clear understanding up front that the first project is a trial run — in fact, it might make sense to share some historical, statistical data, for example, explicitly letting new team members know that only 50% of hires work out — it is more likely that you'll be establishing an environment where high-performing teams can emerge and grow. Is there a downside? Absolutely. It is easy to get carried away, especially in a difficult economy where job seekers so highly outnumber positions. Again, you

need to strike the balance that works for you, but I firmly believe that willingness to make difficult decisions is one of the keys to managing for success.

A Word on Outsourcing

Video game development projects are growing in new directions, as well as in complexity. Higher-end distribution systems such as game consoles and faster PCs have upped the ante in terms of production quality and consumer expectations. With such heavy investment being made to bring new intellectual property to market, companies are also justifiably interested in maximizing revenue by releasing games simultaneously on a wide range of platforms. How can you keep up with these ever-increasing demands, especially given some of the challenges we've considered above?

One effective strategy is outsourcing, which allows you to do more with less staff, less overhead, and less risk. Distributed development is the way of the future. Pick up a copy of *Distributed Game Development* by Tim Fields, whose interview follows this chapter, for a thorough, insightful treatment of the topic of harnessing global talent to help create great games.

Wrap Up

To reiterate, we have taken a look at some specific areas, related to hiring and managing high-performing teams, where we'll be able to lean into some of the key takeaways from this book. In black and white, a lot of this boils down to simple common sense. At the same time, you'd be amazed at how many game development teams and studios ignore many of these 'common-sense' best practices.

The point is to step back and look at your processes and practices, and consistently try to improve what you are doing. This will stand you in good stead in your attempt to create an atmosphere where high-performing teams can be recruited, evolve, and hopefully create great games.

Team Role Interview: External Producer

Please introduce yourself and your current role.

My name is Tim Fields. I've been making games for about 16 years now. Currently, I'm the Director of Business Development for Certain Affinity, a boutique software development firm headquartered in Austin, Texas. While we do make our own games, we are probably best known for our contributions to some of the great first-person shooter franchises out there, including Valve's *Left 4 Dead*, Activision's *Call of Duty*, and Microsoft's *Halo*.

How did you get your start in the games industry?

I got a Commodore 64 when I was about 8 years old and really began programming my own games on that machine. When I was 18, some friends and I started working on a game called *Smash the Police State* out of my apartment near the University of Texas at Austin. This was your classic 'garage' game shop, and I taught myself character animation on 3D Studio (the precursor to 3D Studio Max). Imagine my surprise when I learned that companies in Austin would actually pay me to do what I was doing in my spare time anyway!

I became a Character Animator for Eclipse Entertainment. I eventually moved into a game designer role, working as a Designer and then Producer at Microsoft and later Electronic Arts, where I worked on the *SSX* and *Need for Speed* franchises, as well as working to bring new IP to life.

What was your role on *Need for Speed: Undercover*?

As a Producer, I was responsible for working with the team to define the unique vision and specific feature sets for the game. It's worth mentioning that this was the 13th version of the game, so 'franchise fatigue' was a real challenge for us, in trying to get users excited about the new features we were building for the game. In any event, my role was to work with a large number of teams literally all over the world to implement that vision. On bigger games these days, where you are releasing simultaneously on a wide variety of platforms, it's seldom done with just one team. We utilized a distributed development model, where a number of teams, located in different parts of the world, were each working on one or more components of the game. These components can be a particular SKU — say the PSP version — or perhaps a feature, like multi-player. Once we had designed the core product, my job was to locate and manage many of the various external development houses that contributed to the project. I worked hard with some great people in different parts of the planet to make sure the game was as good as it could be, and came out on time and on budget, with a feature set on each platform that would give players what they expected from a *Need for Speed* game.

This book is about making *great* games. I am interested to hear what an External Producer can do to ensure that the game you are working on is great. What is your part of the process, and how do you make sure that you're contributing to a great game?

This is a huge topic, and one that I've written about extensively and still not been able to cover entirely. But a summary for me is: The first and most important thing is having a crisp, shared vision among all of the various development teams working on the project. Until everyone understands what they're trying to do, and why it's a good idea, you have almost zero hope of achieving greatness. To my mind, the single most important aspect of managing external developers is communicating this vision for the project, and building consensus around the vision. At its core, this is really a feat of communication. Second, give yourself sufficient time for iteration. It is my belief that you do not ever create something great with your first draft. Greatness in a product of any sort is about having a vision, and having the time to iterate on that vision to realize quality. The way you get enough time to iterate towards

(Continued)

Team Role Interview: External Producer—Cont'd

quality is to make sure that you are using the time you have wisely. As a Producer, you're making bets every single day on what's going to give you the greatest return for the time and energy your teams are investing. The investment you make is the time and money it takes to run a team; the return is the sales and product quality. When you are successful enough to have made the right trade-offs, and have the right teams in place, you might end up with one of those rare 'great' games — games that investors and fans remember for years to come.

What was the strangest or most unexpected part of working on *Need for Speed: Undercover*?

The most unusual was a photo shoot that I did in Los Angeles for the game. I was very surprised to receive the assignment to go to LA, find a bunch of beautiful women, and direct them in a crime-themed photo shoot for *Need for Speed: Undercover*. I did the shoot, and it was a lot of fun, although I think my wife might not have been too happy with me!

What was the most satisfying aspect of working on *Need for Speed: Undercover*?

This sounds cliché, but getting to know brilliant people in many different parts of the world, and working with them across cultures and languages to produce something that you can all be proud of at the end of the day was by far the most satisfying part of the job.

What about the least satisfying aspect?

Working on annualized sequels in which you have very little time to iterate towards quality because you have a fixed ship date is frustrating. You know that you only have time to get it good enough — and almost never time to get it great. As a game creator, you never want to release something that isn't great.

Have you seen any common pitfalls for External Producers?

I have often seen negative consequences of holding onto the mistaken belief that you can compress your game development schedule between alpha and certification. It's tempting every time. You think: we'll make smart decisions. No one will get sick. Our external providers will deliver when they say they will, and everything will come together at the end. Well, people do get sick. Your teams are already working hard to meet deadlines. There are always unknown 'gotchas,' and anytime your plan relies on everything going right the first time, well, it's a broken plan.

Until you hit alpha, you don't really know how big your game is, or how long it's going to take to close it down and get it out the door. Yes, you've built a vertical slice, and perhaps you have a pretty good idea of scope and scale, but you haven't seen the whole picture. Before you get to alpha — the point where you can play through the entire game — you can't really tell what's missing. Ideally, with a large-scale, AAA blockbuster type game, give yourself as much as a year between when you hit alpha and when you put your game on the store shelf. Use this time to iterate towards greatness.

Any parting thoughts?

Look, nobody ever set out to make a crappy game. Market realities — budget, ship windows, and the like — these are the sorts of things that make games not great. It's never about the desire of the team; it's about their abilities and the market and financial realities that create the ecosystem around your game development. When all these things line up, you get the kinds of games you talk about in this book: games that people will remember a decade from now.

INDEX